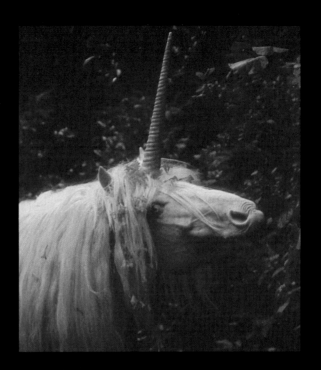

Alice could not help her lips curling as she began: "Do you know, I always thought Unicorns were fabulous monsters, too? I never saw one alive before!"

"Well, now we have seen each other," said the unicorn, "if you'll believe in me, I'll believe in you. Is that a bargain?"

Lewis Carroll
Through the Looking-Glass

UNICORNS I HAVE KNOWN

ROBERT VAVRA

WILLIAM MORROW & COMPANY, INC.
New York 1983

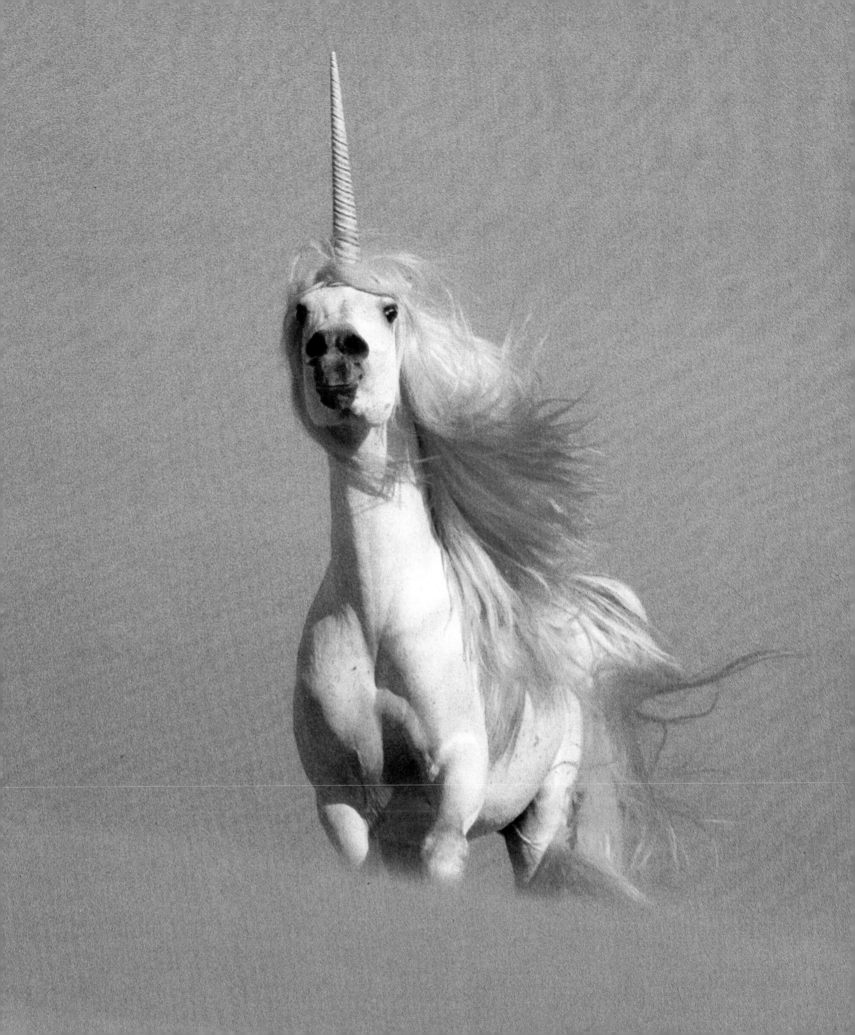

This book is dedicated to my father, whose nobility of spirit and purity of heart are almost as difficult to encounter in this world as is the unicorn.

Library of Congress Catalog Card Number 83-61566
ISBN: 0-688-02203-0

Color reproductions by Cromoarte, Barcelona, Spain

 3 4 5 6 7 8 9 10

Printed by Imprimeries Réunies, Lausanne

Endpapers after a print by Nicolas Reusner (1584)

Drawings by Barbara Funk
Designed by the author

Printed in Switzerland

MY FIRST face-to-face encounter with a unicorn took place in a Mexican jungle near Tamazunchale in the spring of 1968; and while the story of that meeting has been left to the Author's Notes at the end of this book, the one photograph that I was able to snap is reproduced on this page. This picture, as the reader can see, is so blurry and nondescript that had I attempted to publish it at the time, I would have been considered as much a crank or hoaxter as those persons who occasionally submit to the press out-of-focus, suspect photographs of the Loch Ness monster, Big Foot, and the Abominable Snowman. However, during the fifteen years since that magical but frustratingly brief experience in the jungles of Mexico, I have studied unicorns in six distinct habitat zones. And after hours, days, and months of continued contact I was eventually able to gain their confidence, using methods similar to

those employed by George B. Schaller with gorillas and Jane Van Lawick-Goodall with chimpanzees in central Africa. The photographs that appear in this book are testimony to that good fortune.

Rather than the scientific approach, however, believing is often the key to enjoying and experiencing some of the most fascinating and lovely mysteries of the universe. As a child I had been told of fireflies long before I knew anything about unicorns. But until I actually saw them (also in Mexican jungles) it was impossible for me to believe in living dots of nocturnal luminosity capable of lighting paths through the darkest forest. They seemed more like something dreamed up for Walt Disney's *Fantasia* than insects of reality. It was the firefly, in fact, that would later indirectly lead me to my first glimpse—and photograph—of a real unicorn.

The world's unicorn population is minute. Along with other endangered creatures they have been pushed deeper and deeper into the seas, forests, dunes, and mountains by encroaching civilization. Thus arises the question: If the unicorn is in such peril, have I placed him in even greater danger by proving his existence and revealing the secrets of his private life?

> The shark is killed for its fin
> The rhino is killed for its horn
> The tiger is killed for its skin
> What price the unicorn?
>
> ANON

No, I publish this book with a clear conscience, for if the unicorn's magical qualities have protected him for thousands of years, there is little reason to

believe that evidence of his existence might lead to extinction now. Since he can disappear as if by magic in the forest or other places he inhabits, it is logical to assume that he could just as easily vanish from these pages were it not his wish to be seen here (and indeed in at least one case he has; see page 91).

When one studies the four photographs on this page, it seems absurd that the Arabian oryx, the rhinoceros, and the goat have been mistaken for the protagonist of this book. There is little doubt as to which is the unicorn. It is not difficult to understand how an adventurer who had heard of unicorns, in times of ancient travel and communication, might have excitedly mistaken for the real thing any of the two-horned beasts shown above, if the animal were seen in profile at great distance, at dusk, or after the observer had flamed his imagination with plum wine or hashish.

In the past, unicorns have been seen and/or described by Job, Isaiah, Aristotle, Julius Caesar, Aelian, Pliny the Elder, the mother of Confucius,

Genghis Khan, and Marco Polo, along with numerous less famous persons. Today the secret of their existence is shared by many men and women and even by some children. I happen to know that in January of 1982, some two dozen boys and girls in a school bus saw a unicorn playing in the snow in central Colorado. Unicorn sightings are more common than one would imagine. It is the idea of being thought a crank or, nobler, of not wanting to reveal such information to the impure of heart that has kept reports out of the newspapers.

For persons interested in truths about unicorn behavior, some rather brief notes, coupled with drawings taken from field sketches and from photographs not used in these pages, have been provided at the end of this book.

ADVICE to the pure of heart: Watch carefully, entering each forest glade as though you were the first human to set foot there; take time to sample pollen carried on a golden breeze; follow instructions given in Author's Notes (do not use deodorants or insect repellents or wear leather shoes, belts, etc.); and believe. Yes, above all, BELIEVE, and you will surely meet as lovely and noble and snow-white a single-horned creature as any who pirouette upon the pages of this book.

ROBERT VAVRA
Villa Santa Cecilia
Sevilla

November 23, 1982

UNICORNS OF THE FOREST

Unicornuus memorensis

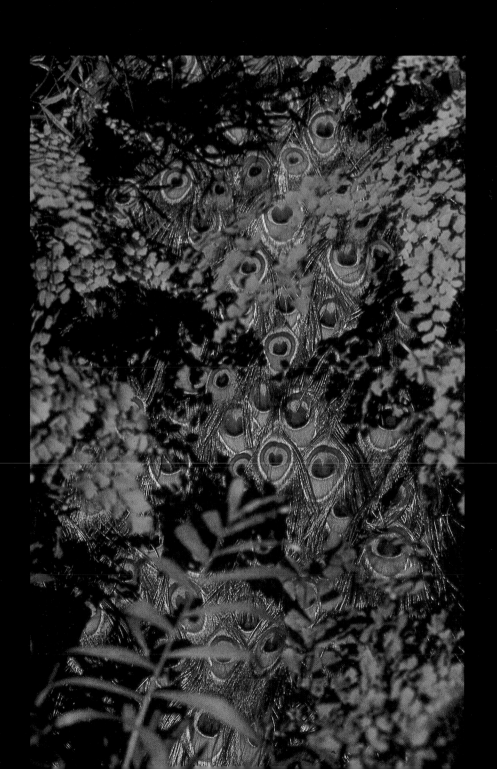

I am the owner of the sphere,

Of the seven stars and the

solar year,

Of Caesar's hand and Plato's

brain,

Of Lord Christ's heart and

Shakespeare's strain. . . .

Ralph Waldo Emerson

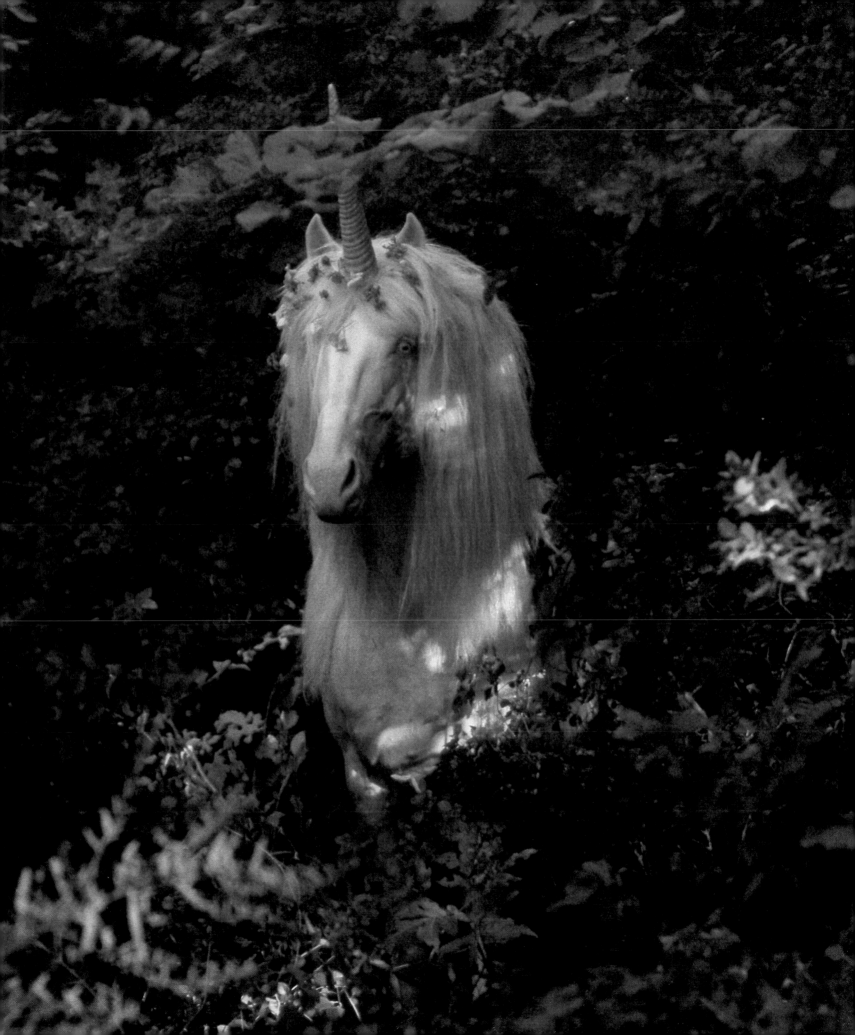

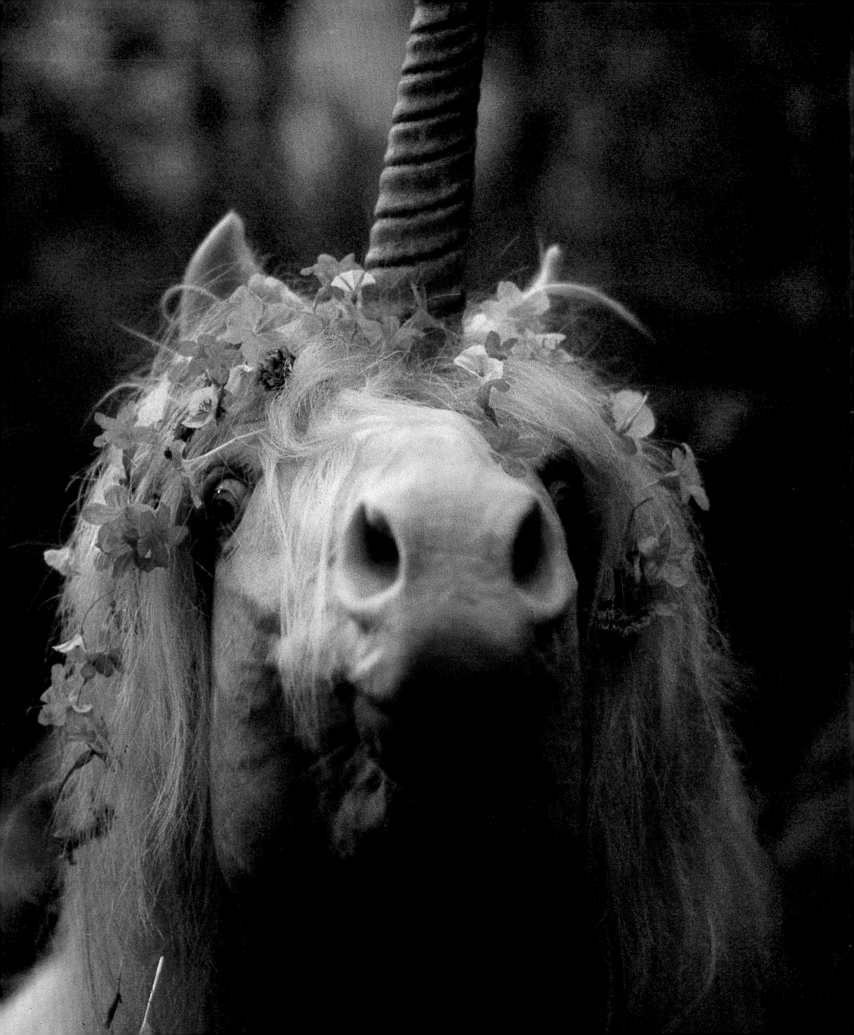

Their bodies are white . . . and their eyes dark

blue. They have a horn on the forehead which

is about a foot and a half in length.

Ctesias
Indica, 416 B.C.

O unicorn among the cedars

To whom no magic charm can lead us,

White childhood moving like a sigh

Through the green woods unharmed in thy

Sophisticated innocence . . .

W. H. Auden

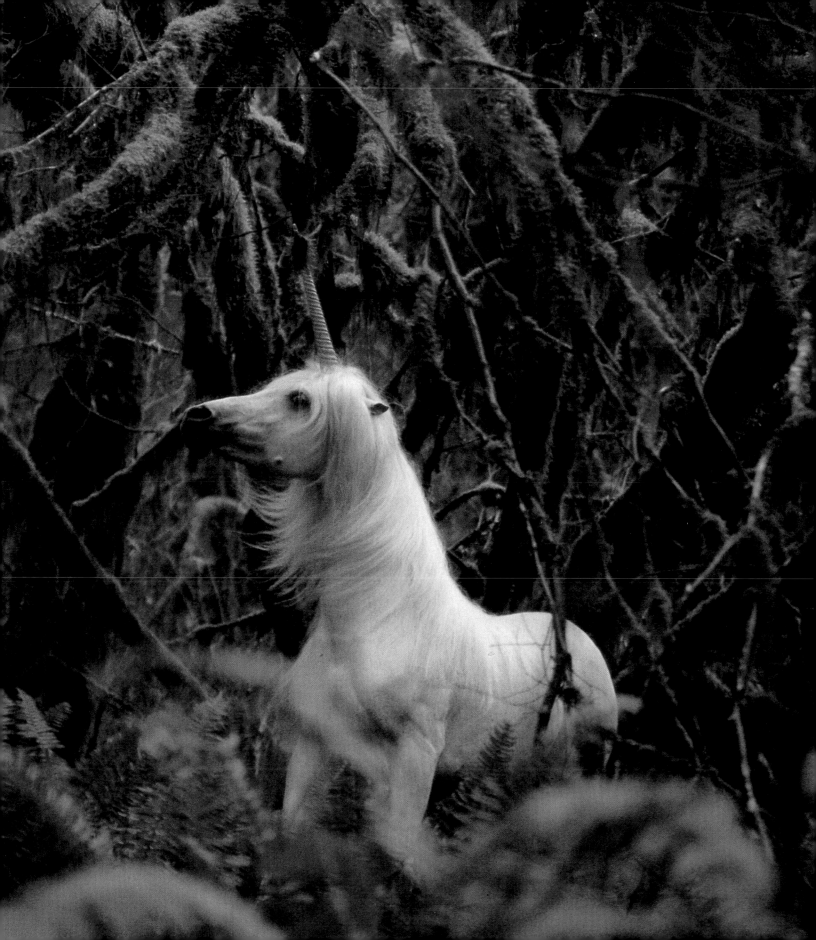

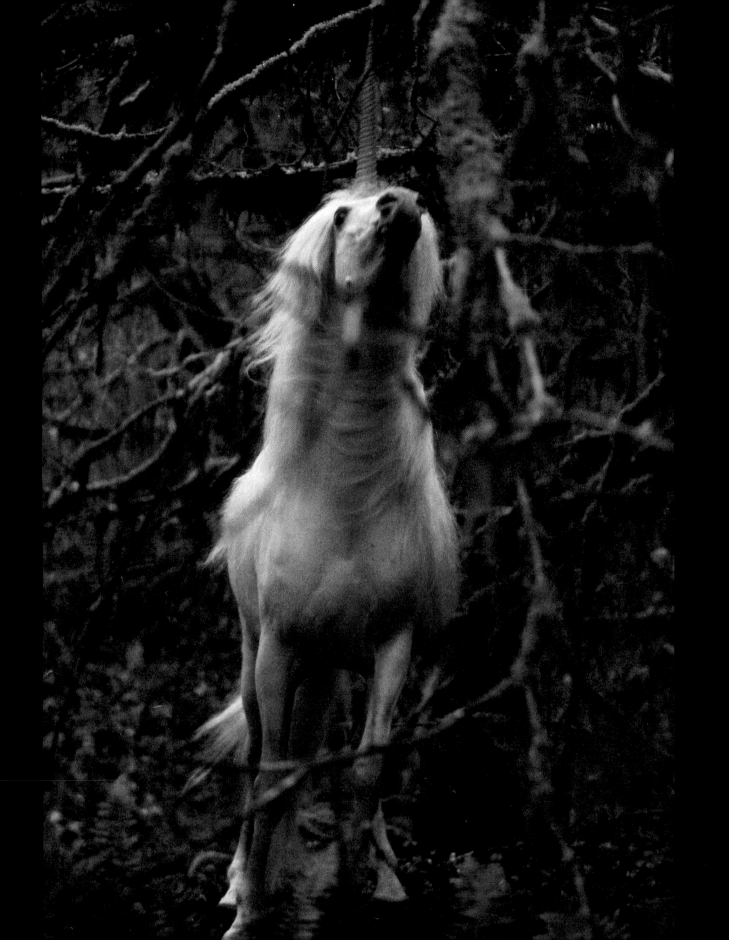

With forest branches and the trodden weed,

Thou, silent form, dost tease us out of thought . . .

"Beauty is truth, truth beauty,"—that is all

Ye know on earth, and all ye need to know.

<div align="right">John Keats</div>

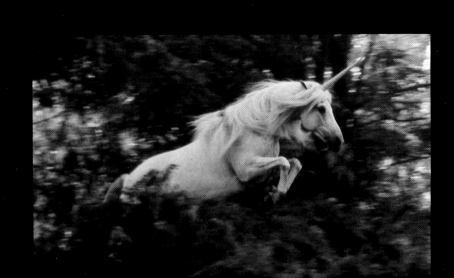

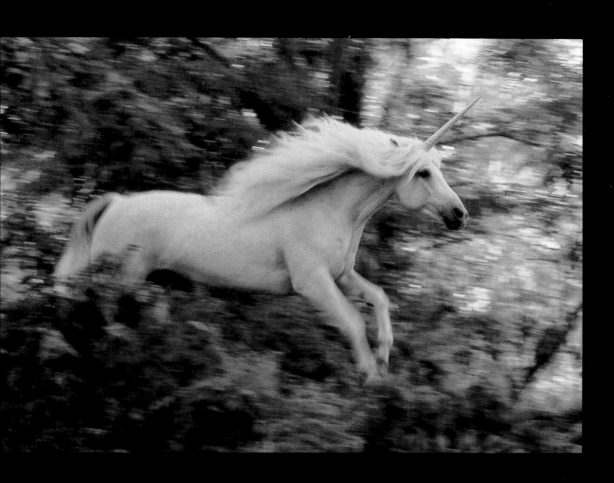

He gallops across the forest green

So quickly that he's seldom seen

Where Peacocks their blue feathers preen

And strawberries grow wild.

William Jay Smith

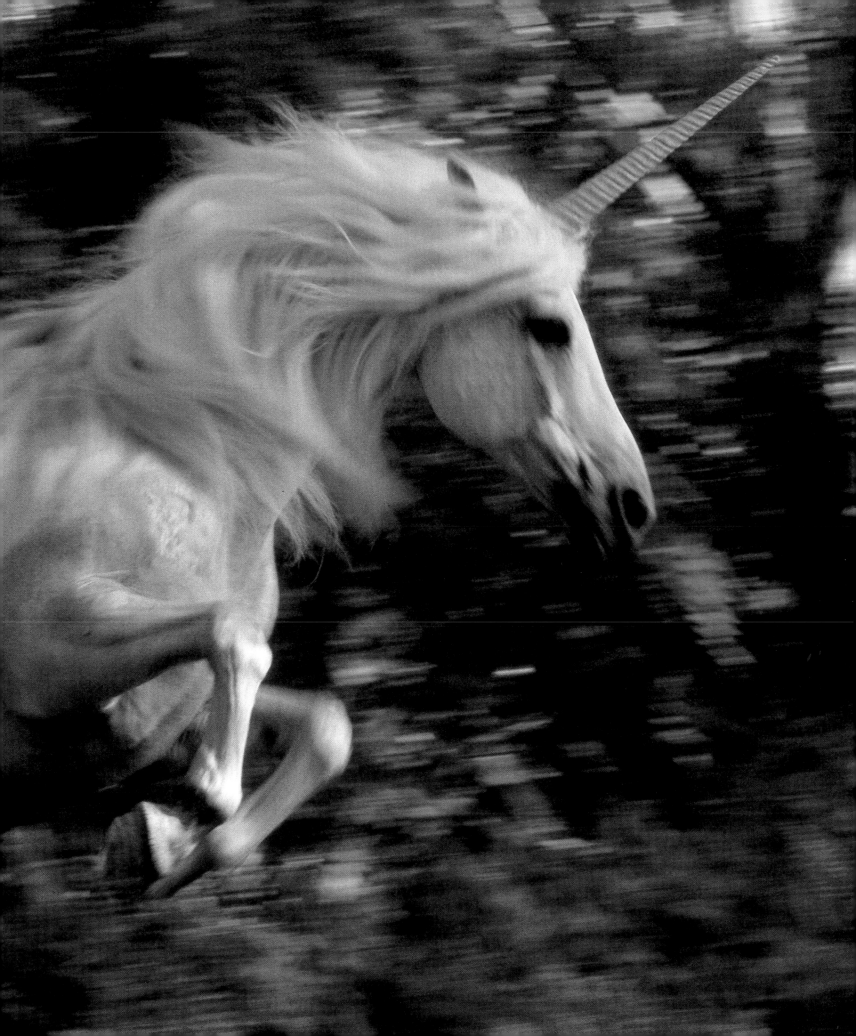

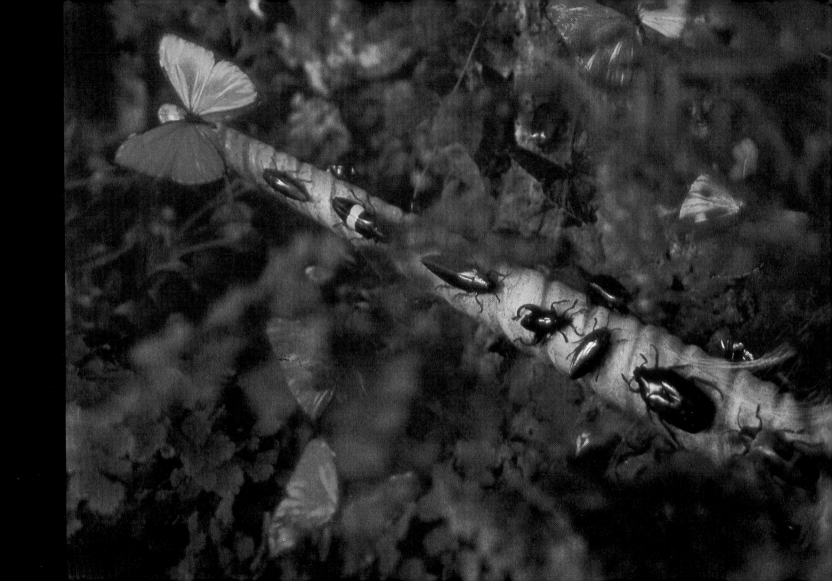

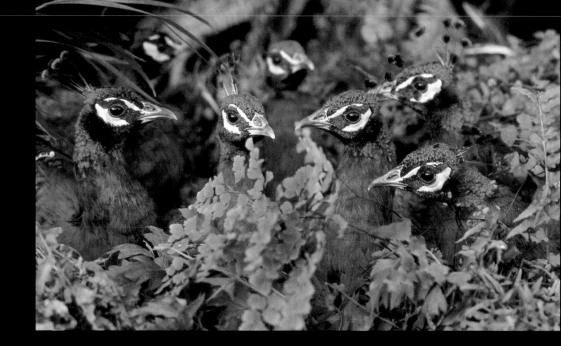

In every living thing there is some marvel.

The emerald itself is vanquished by the

marvelous green of certain beetles; no

jewel and no work of man's hand can be

compared with the living gems.

Andrea Bacci
1566

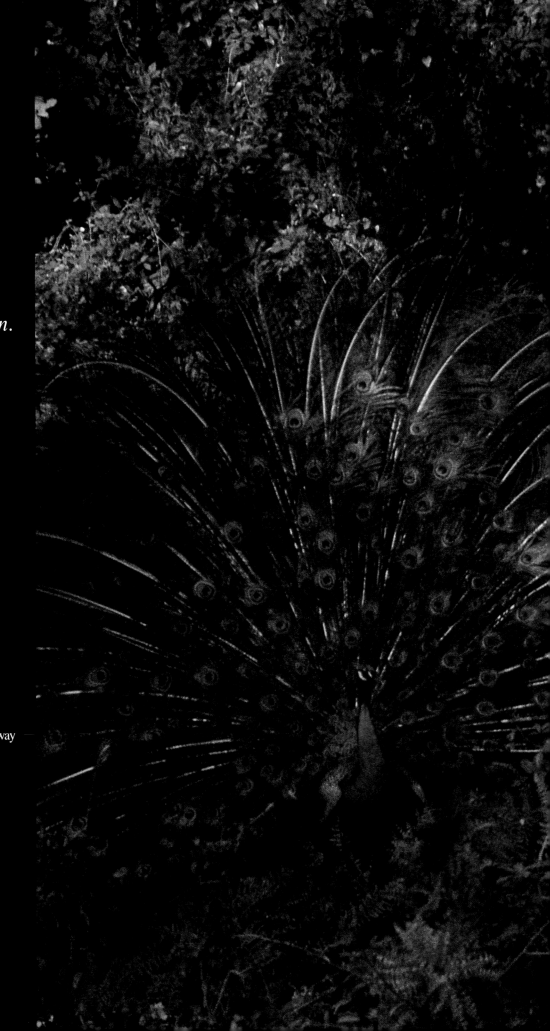

When God created the earth,

he made a river which flowed

from the Garden of Eden. . . .

Then God told Adam to name

the animals. . . . And the first

animal he named was the unicorn.

When the Lord heard the name

Adam had spoken, he reached

down and touched the tip of

the single horn growing from

the animal's forehead. From

that moment on, the unicorn

was elevated above other

beasts.

Nancy Hathaway

22

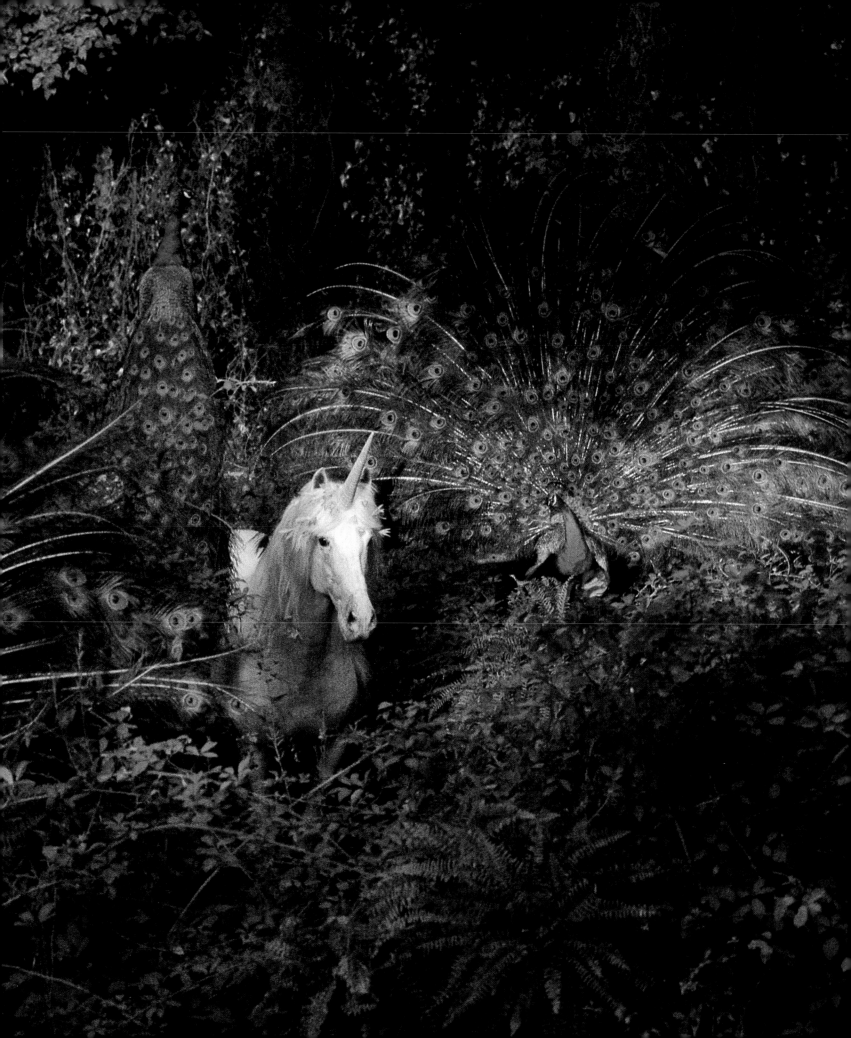

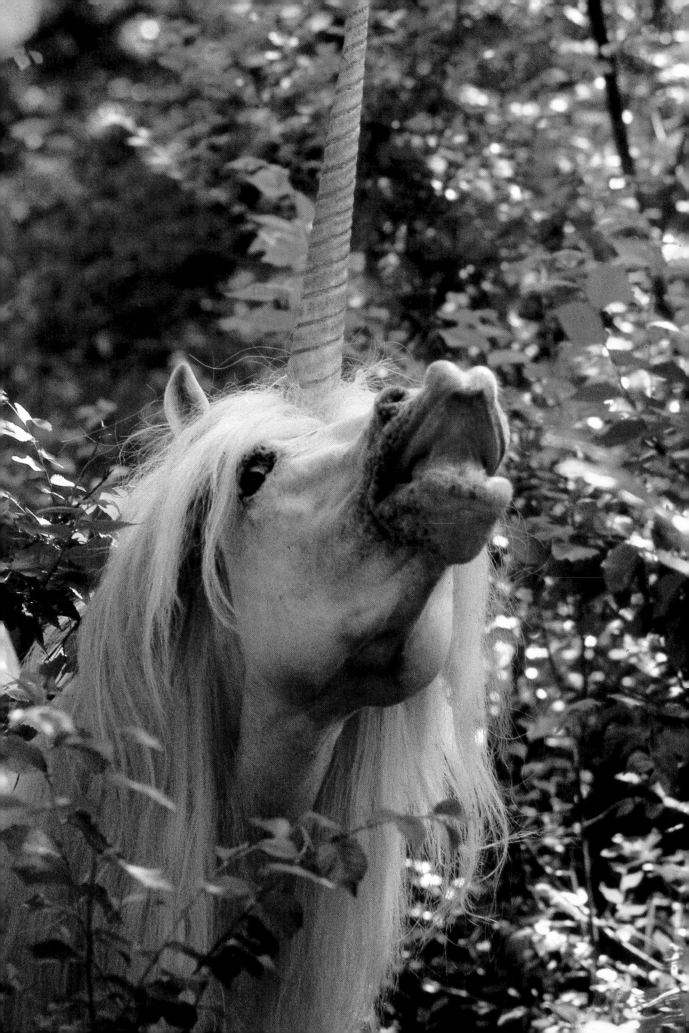

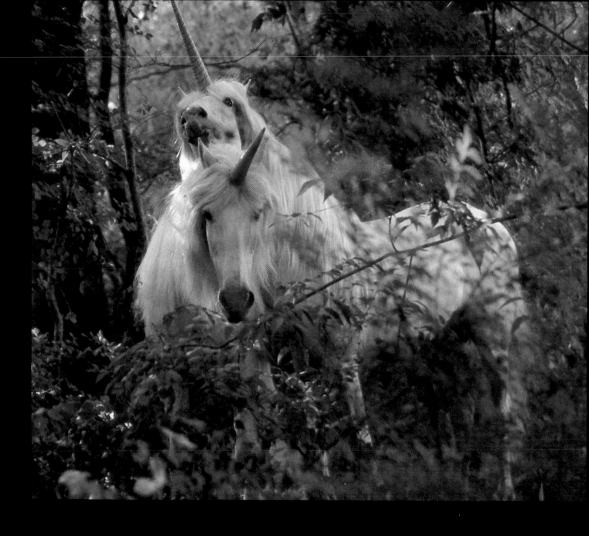

It makes a deep lowing noise. . . .

Pliny the Elder
A.D. 23

In the seasons of the rut it grows gentle

towards the chosen female and they pasture

side by side, but when this time is over

he becomes wild again and wanders alone.

Aelian
A.D. 200

The unicorn was white, with hoofs of silver and graceful horn of pearl. . . . The glorious thing about him was his eye. There was a faint bluish furrow down each side of his nose, and this led to the eye sockets, and surrounded them in pensive shade. The eyes, circled by this sad and beautiful darkness, were so sorrowful, lonely, gentle and nobly tragic, that they killed all other emotions except love.

T. H. White

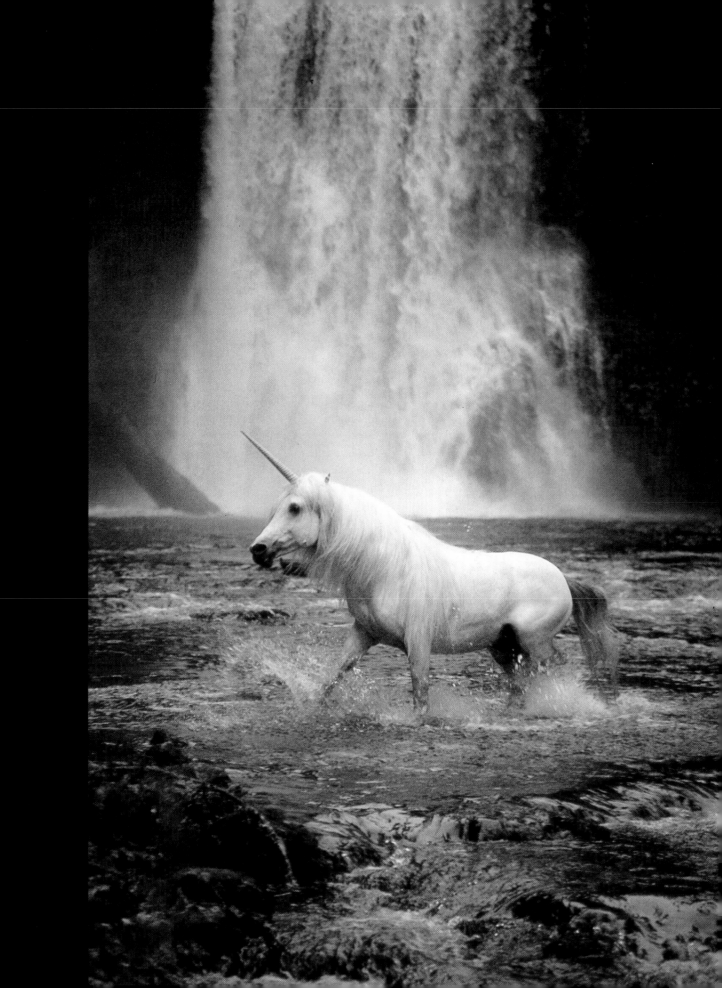

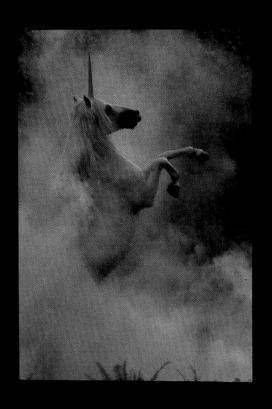

In the midnight forest the dark oak trees are still

under the stars. The pale wildflowers in the clearing

have furled their petals for the night. Suddenly he

appears, a milk-white creature with the proud form of a

horse. you see the curved neck, the silver mane, the

graceful tail. Then he moves his head, and the moonlight

runs like sea water along the pearly spiral of his horn.

There is no sound, but at the next heart-beat the clearing

is once again empty of all but night.

Georgess McHargue

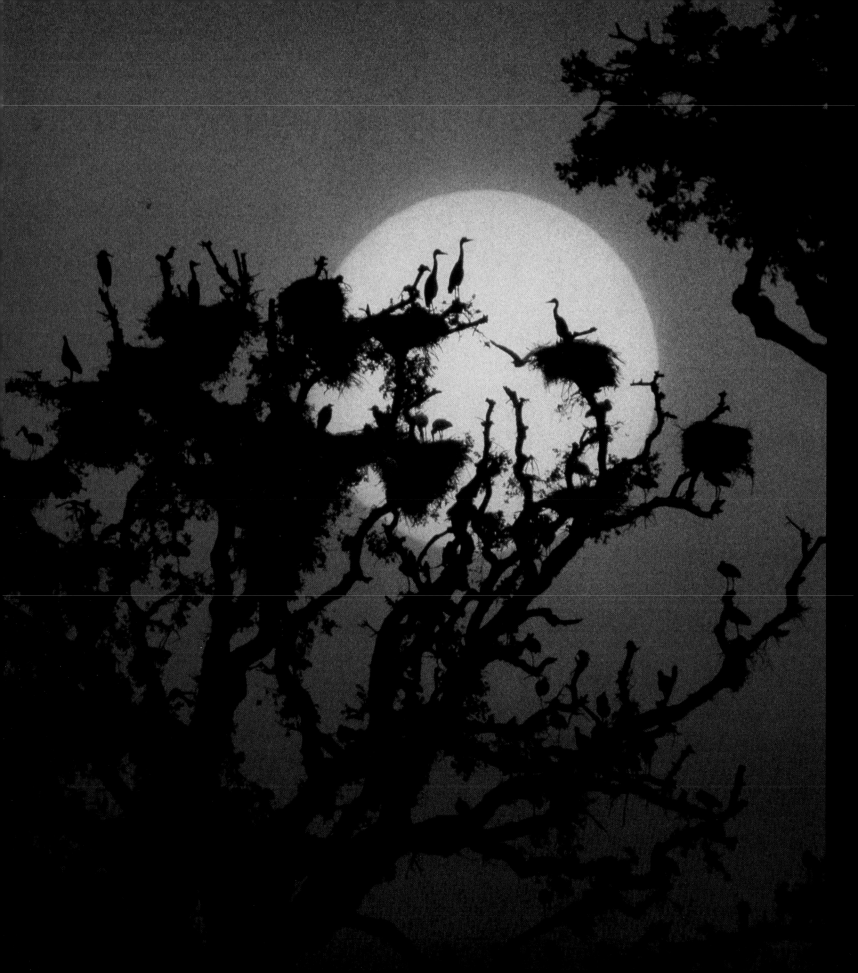

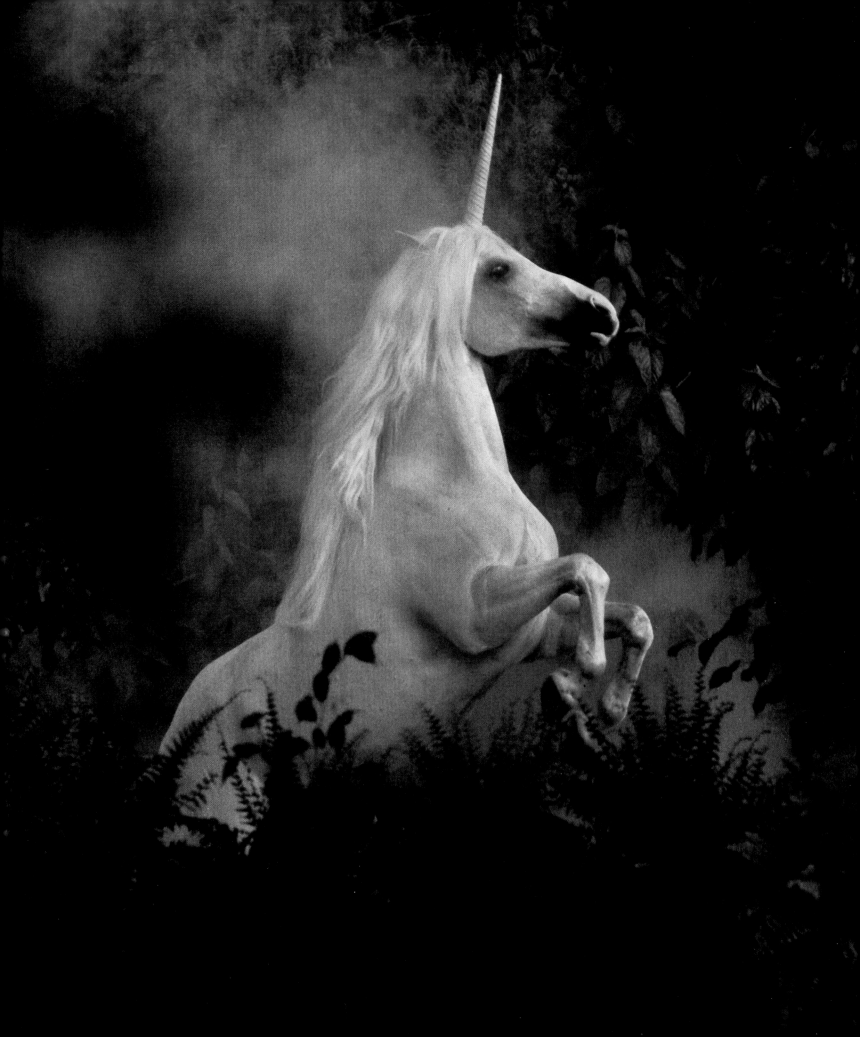

With the sun rose the stag's horn and call, celebrating

the arrival of the fawn that lay white and wet at its

mother's side in a nearby thicket of blackberries.

Robert Vavra

. . . no place is more enchanted than where

a unicorn has been born.

Peter S. Beagle

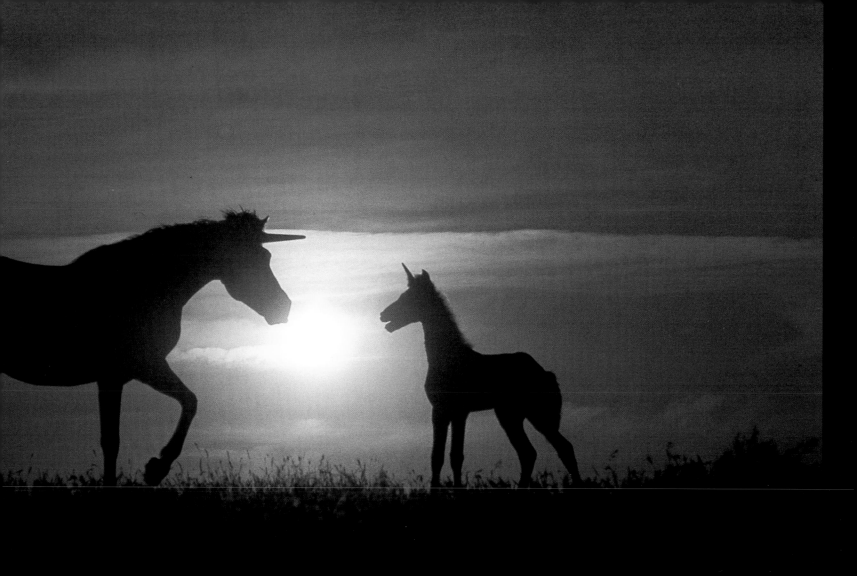

*The trees hold gentle branches
around it; the forest pool guards
its secret. . . . Among the silent
spaces of the trees it grows
protected, nurtured by sunlight;
watched over by the winds and
softfooted shadows.*

Josephine Bradley

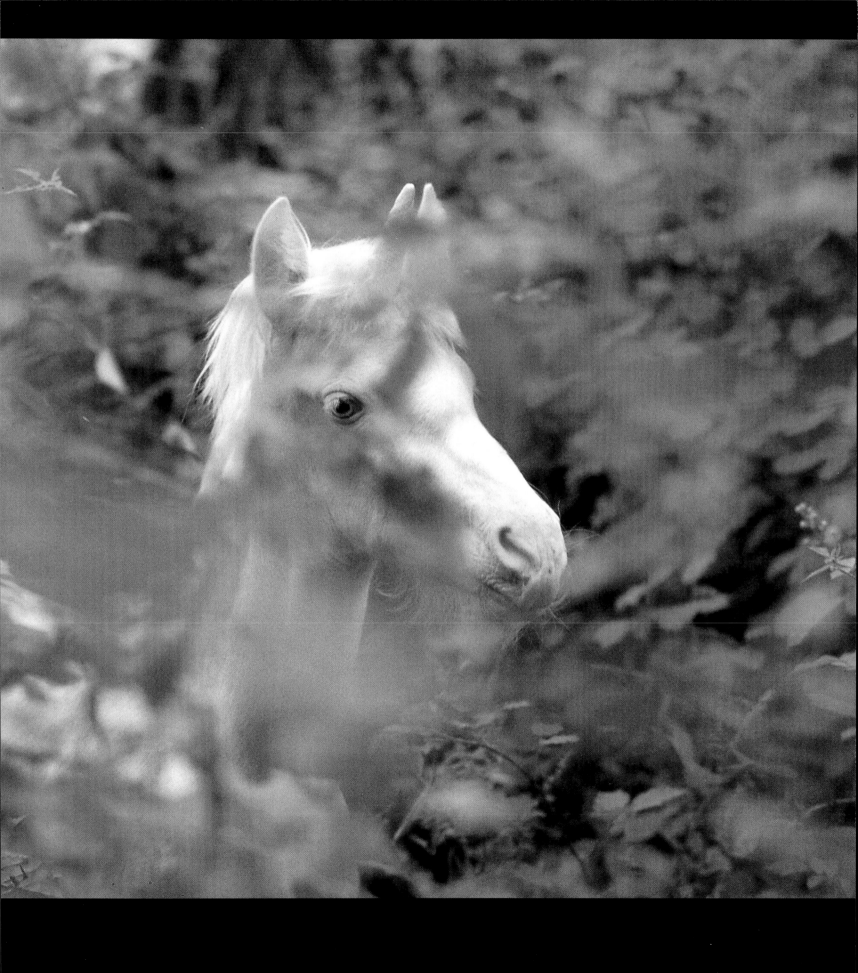

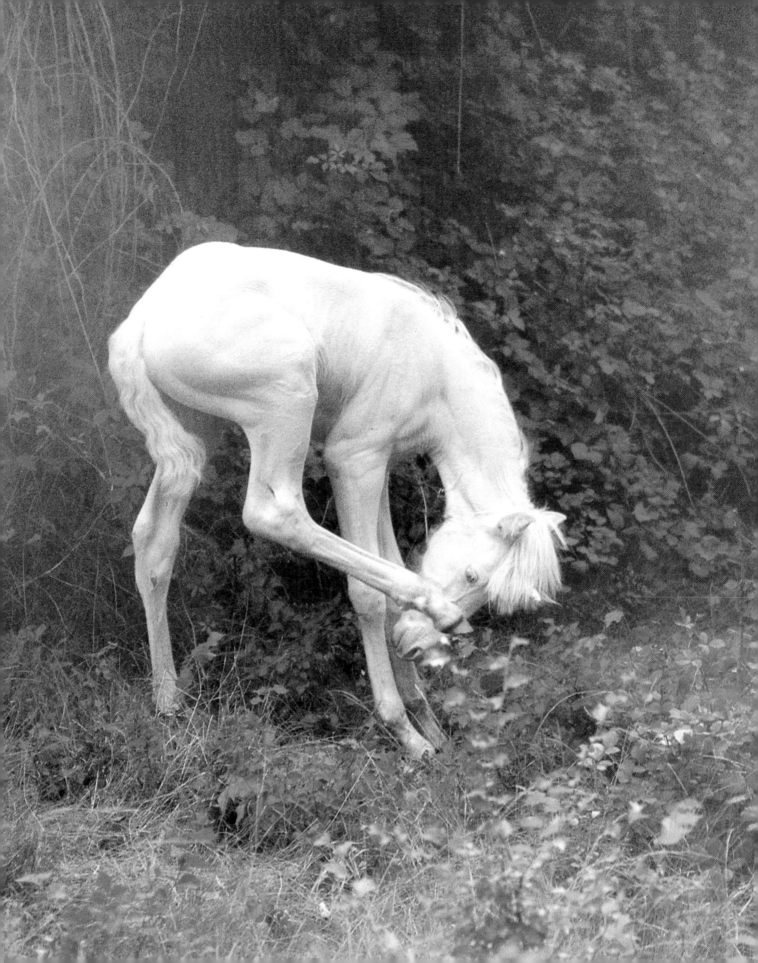

Unicorns, aren't they extinct in the modern world?

Poor little fellow, he must feel sort of lonesome.

In the early morning thou wouldst call me from my sleep . . .

and lead me running from glade to glade.

Rabindranath Tagore

. . . there is fitness in the association of the unicorn with the enormous mountain ranges of Abyssinia. The Queen of Sheba is supposed to have

hidden her treasure somewhere in those terrifying gorges, and they

are a good place in which to hide precious things.

Odell Shepard

The unicorn is noble;

 God keeps him safe and high

 Upon a narrow path steep

 Climbing to the sky . . .
 popular German ballad

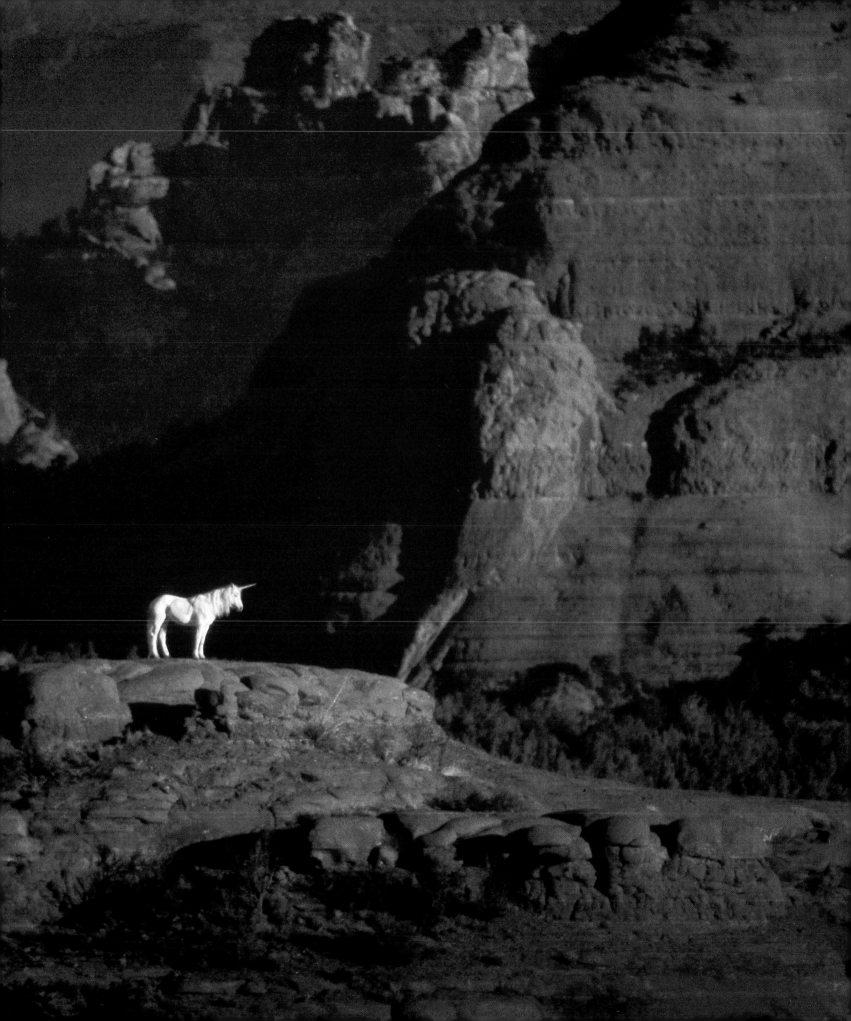

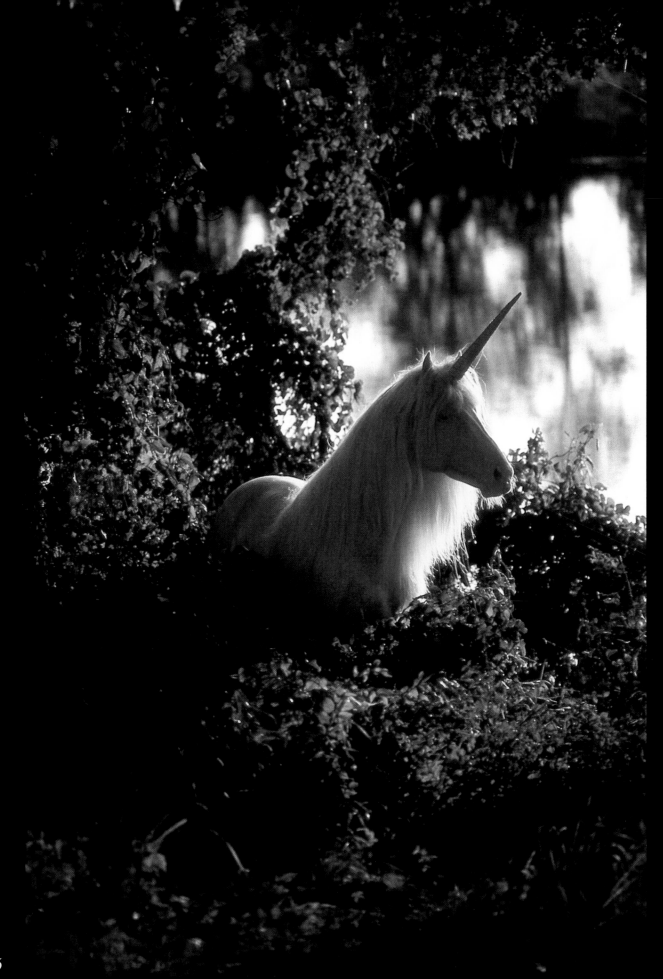

Like a lion, without fear of the howling pack,

Like a gust of wind, never trapped in a snare,

Like a lotus blossom, never sprinkled by water,

Like me, like a unicorn, in solitude roam.

Hymn of Buddha

Toward noon we spotted an animal gazing down at us from a sterile mountain peak of red and black rocks. . . . Our guide stated that the animal must certainly be a unicorn, and he pointed out to us the single horn which jutted from its forehead. With great caution we gazed back at this most noble creature, regretting it was no closer for us to examine still more minutely.

Friar Faber
1438

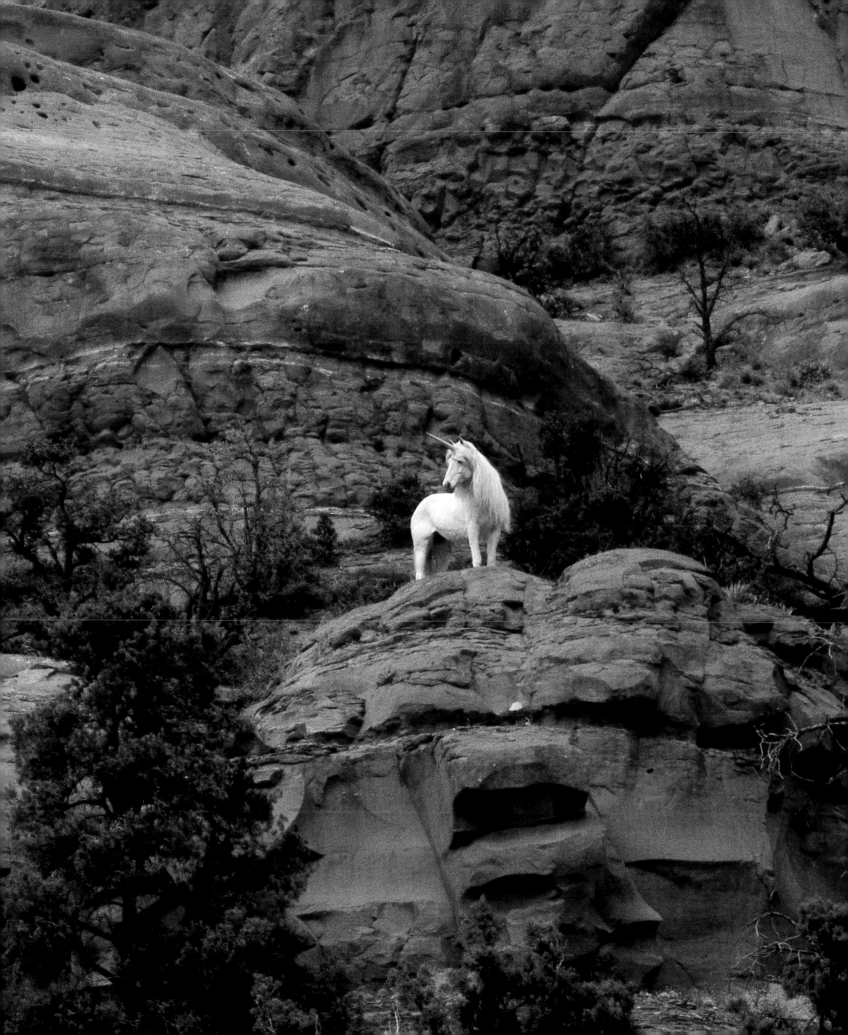

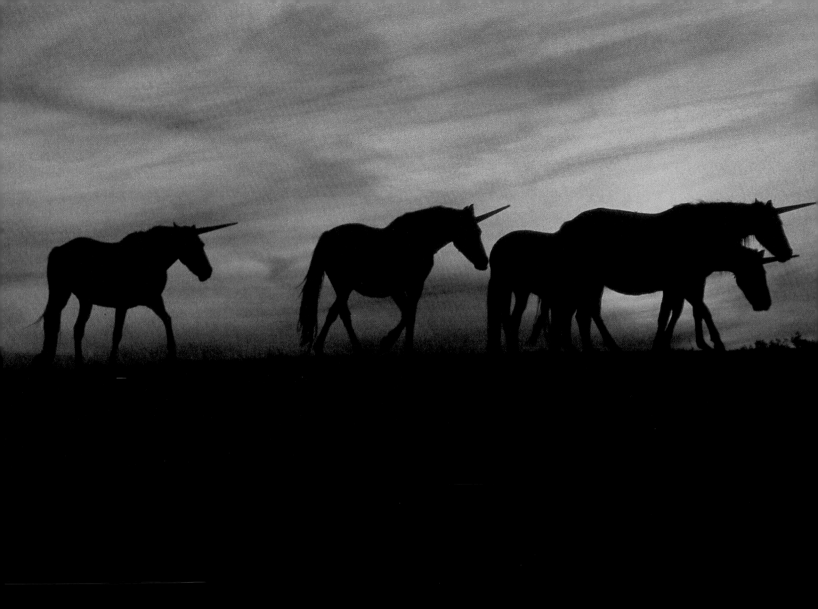

That music. I must go nearer—sweet marvelous music . . .

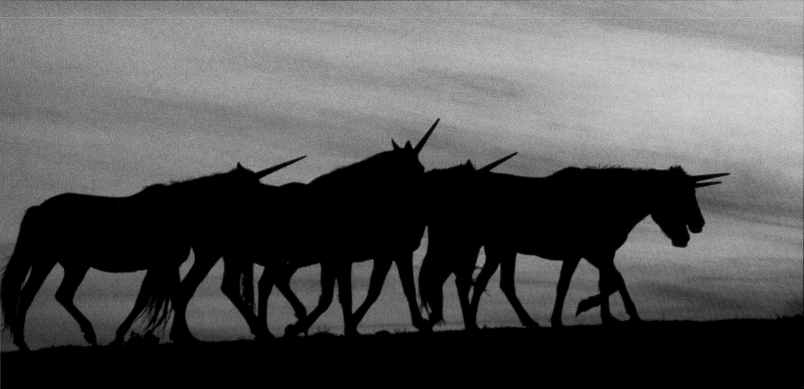

the tramplings of unicorns . . . the mountain is shaking with their feet.

W. B. Yeats

It is a noble beast, a most religious beast . . .

and it dances in the sun.

W. B. Yeats

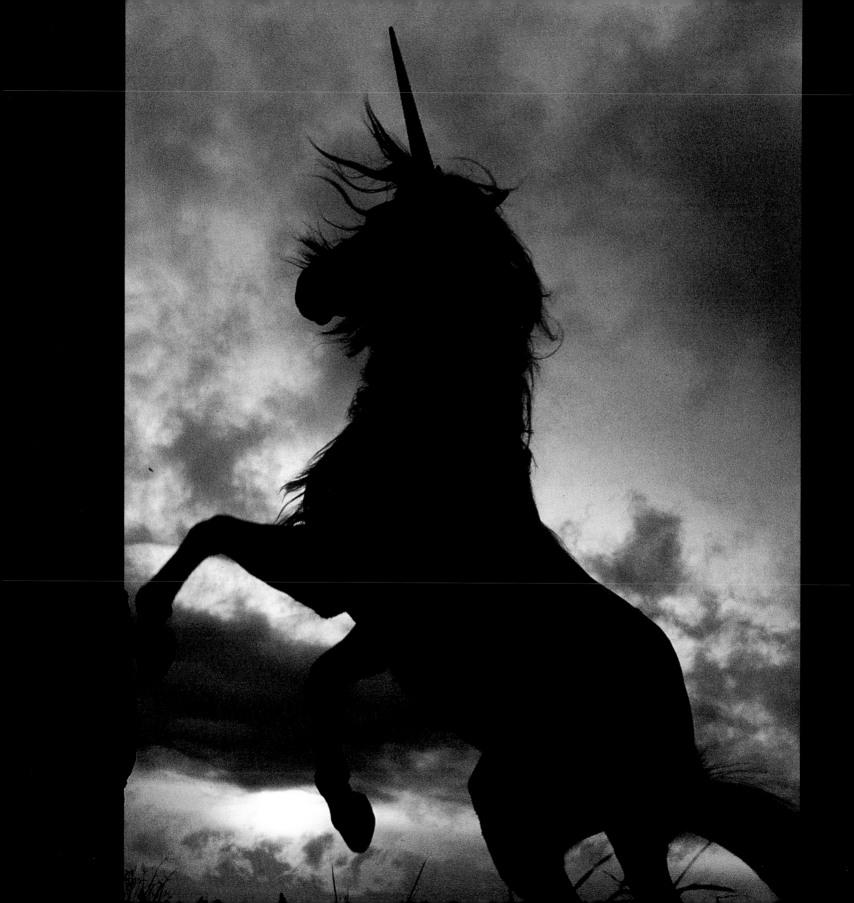

All the beasts obeyed Noah when he

admitted them into the ark. All but

the unicorn. Confident of his own

strength, he boasted, "I shall swim."

Ukrainian folk tale

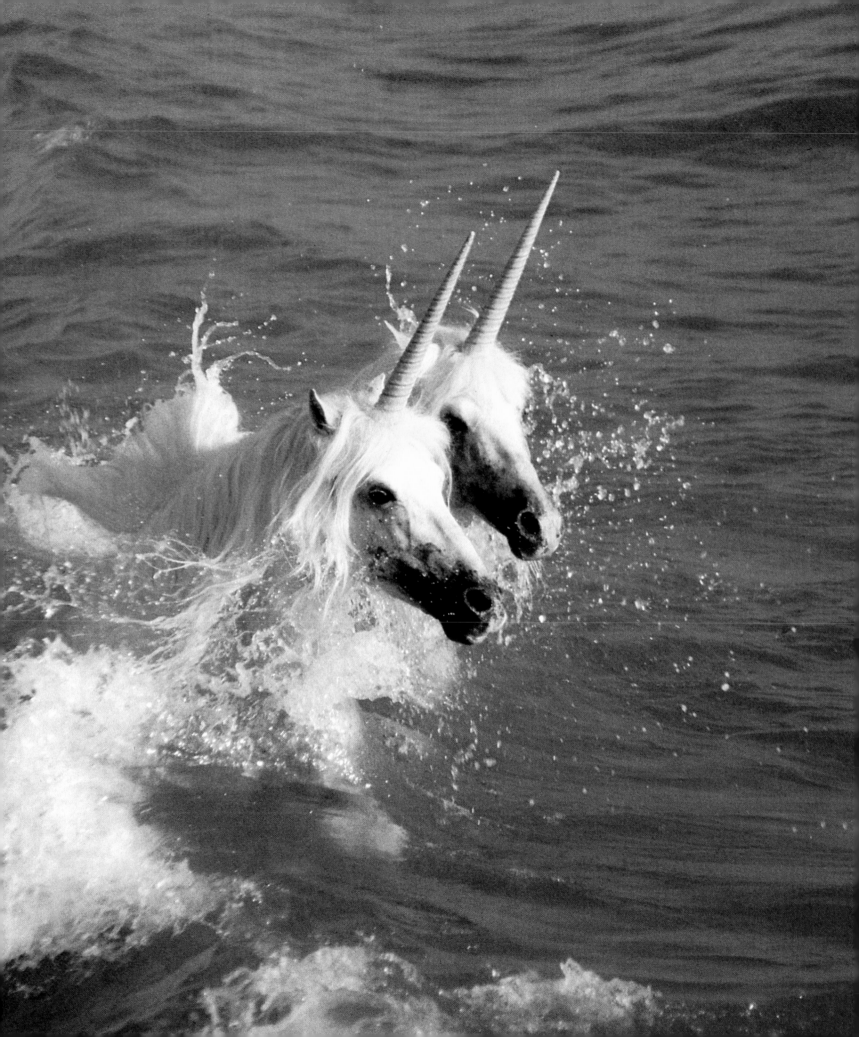

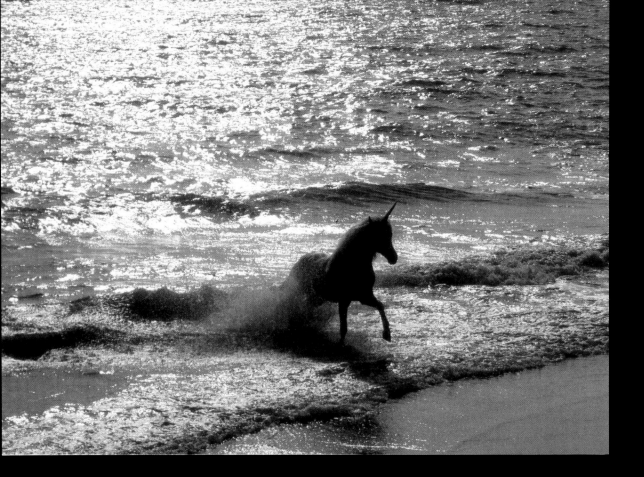

I must down to the seas again, for the call

 of the running tide

Is a wild call and a clear call that may not be

 denied . . .

<div align="right">John Masefield</div>

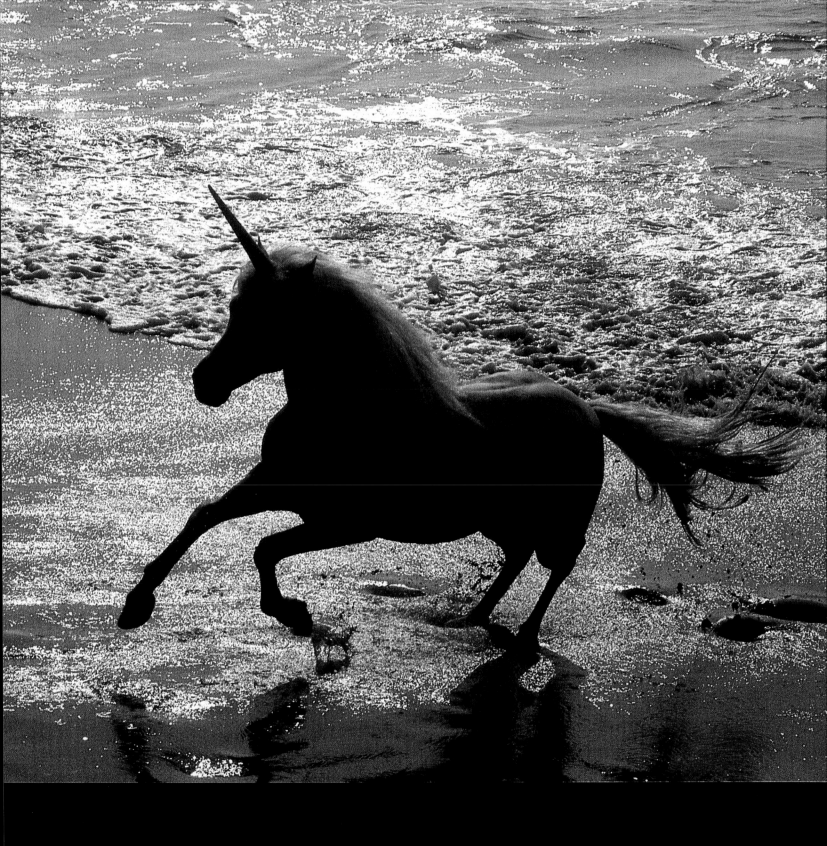

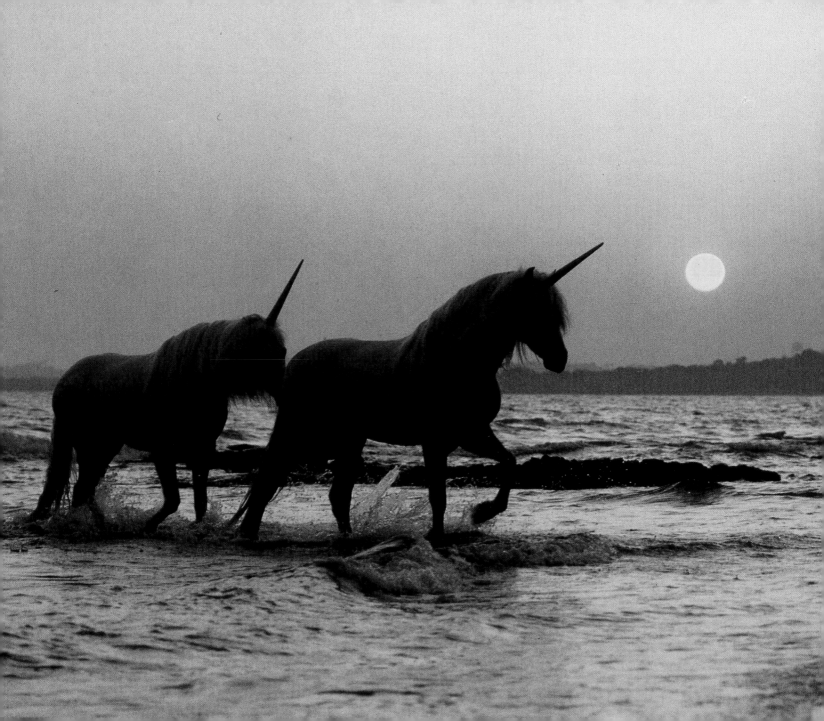

. . . there are to be seen certain

animals that live on the land

yet take pleasure also in the sea.

Although they are certainly not

sea-horses, they have equine heads

and manes. The beast has a horn

two palms in length.

Garcias ab Horto
1567

. . . and in the whiteness of the white,

flowering in the tattered water, their

bodies arching with streaked marble

hollows of waves, their manes and tails

. . . burning in the sunlight, their eyes

as dark and jeweled as the deep sea—

and the shining of their horns! The

horns came riding in like the rainbow

masts of silver ships.

Peter S. Beagle

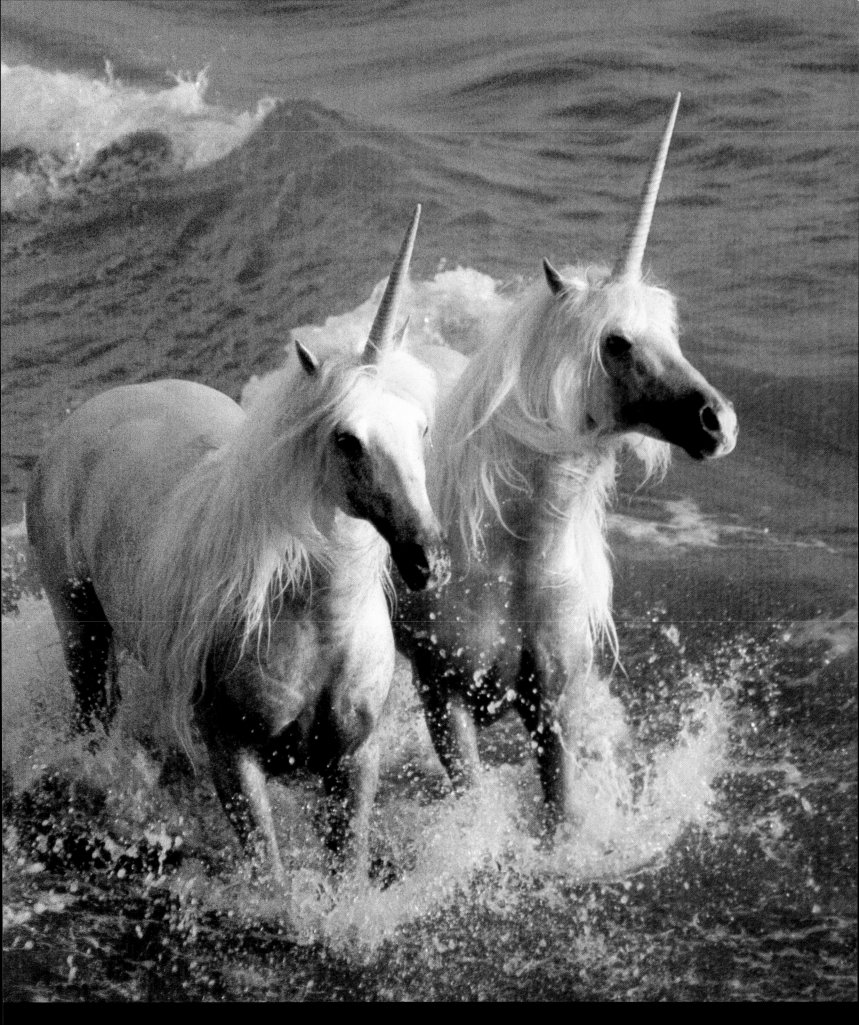

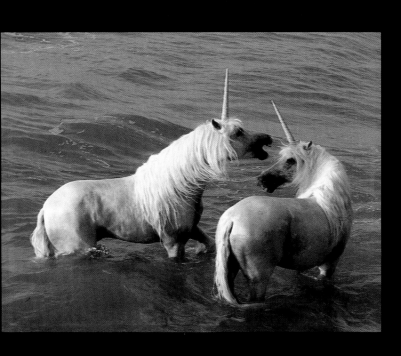

Unicorns fight with horn, teeth

and heels.

Ctesias
416 B.C.

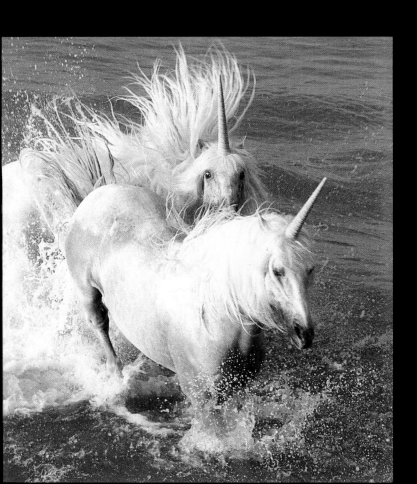

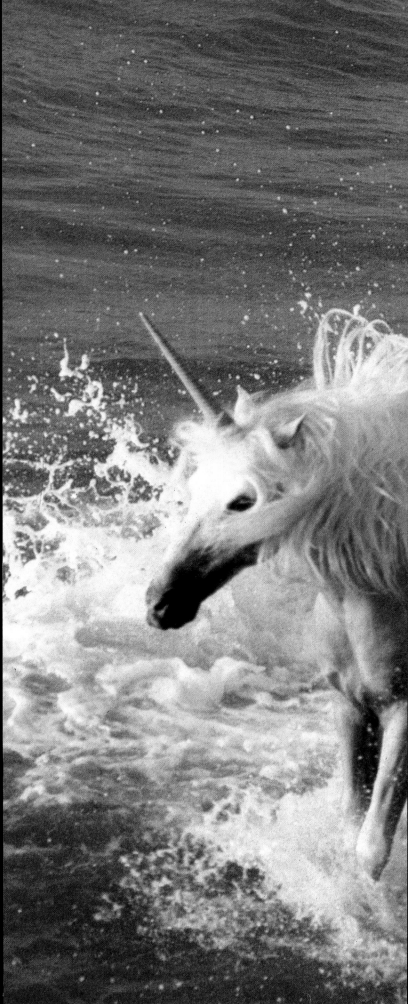

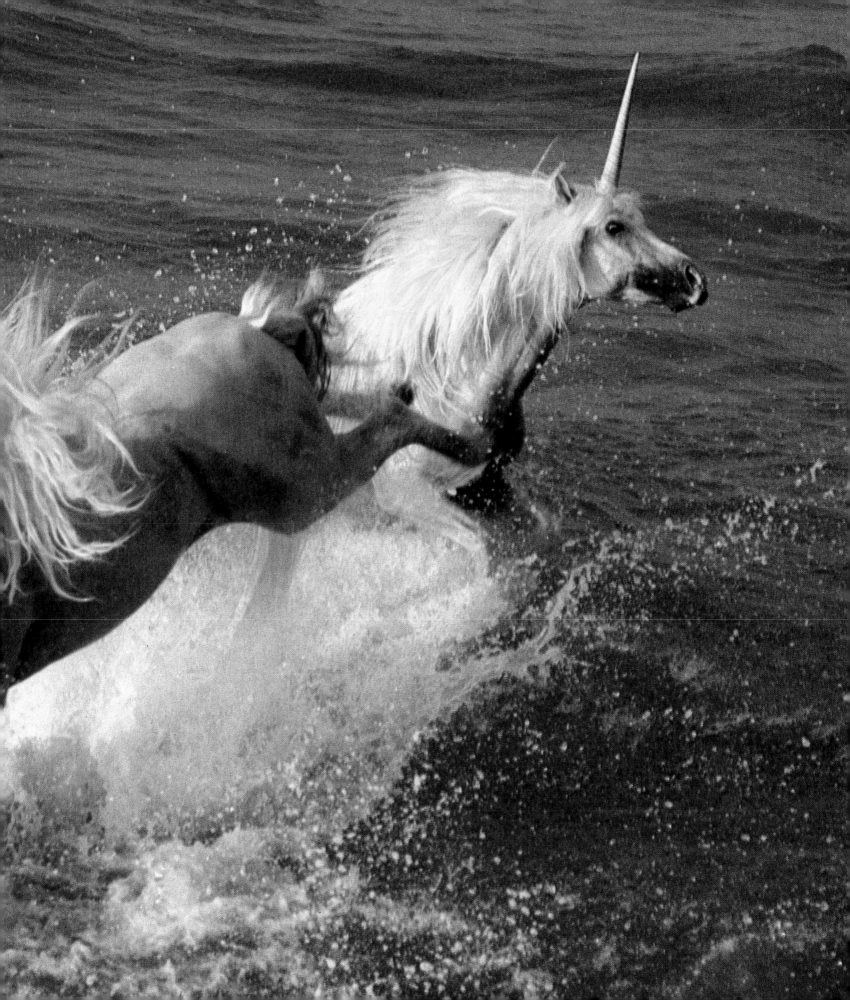

It has milk-white skin and milk-white horn and . . .

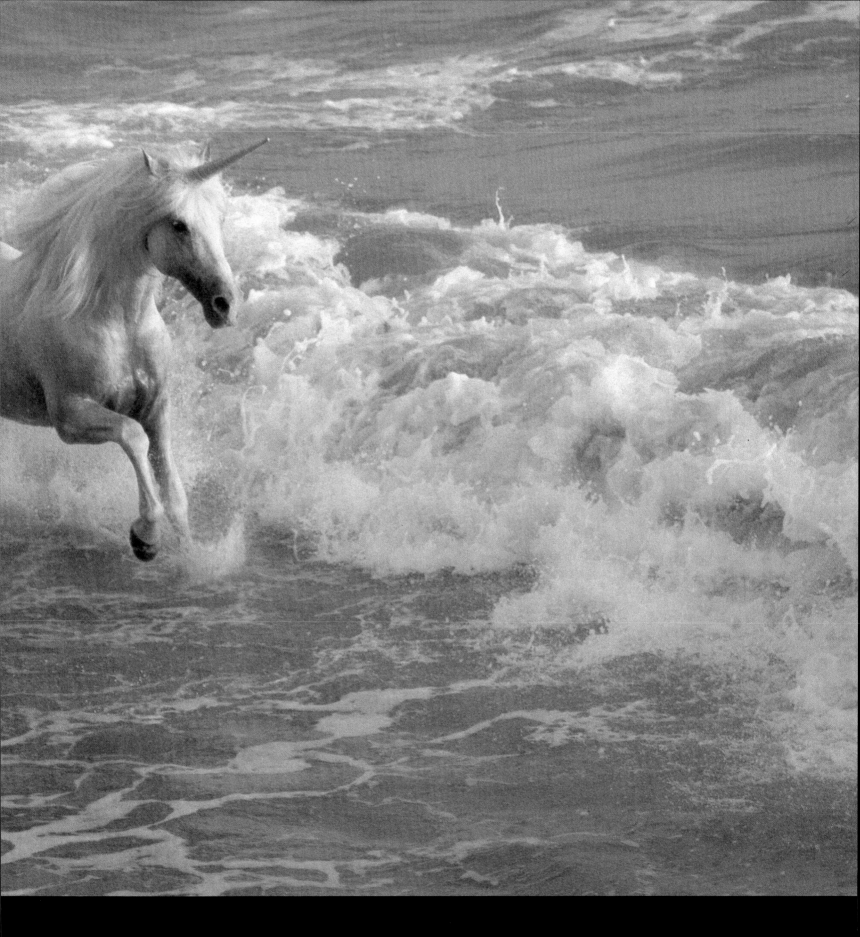

bathes by the sound of tabors at the rising of the sun.

W. B. Yeats

To this day, it is said, malicious animals poison

this water after sundown, so that none can thereupon

drink it. But early in the morning, as soon as the sun

rises, a unicorn comes out of the ocean, dips his horn

into the water to expel the venom from it so that the

other animals may drink thereof during the day. This

as I describe it, I saw it with my own eyes.

Johannes van Hesse of Utrecht
1389

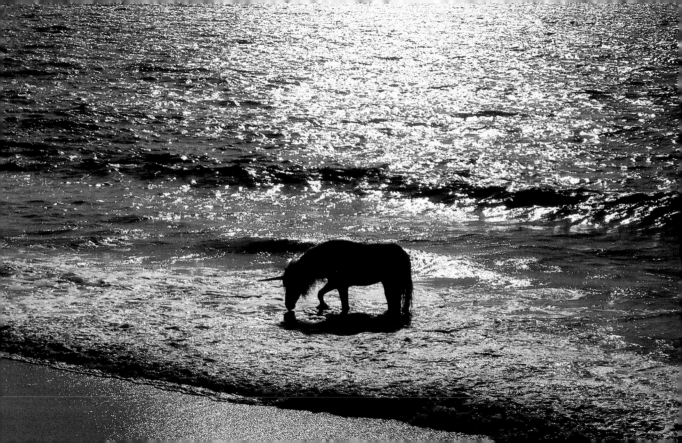

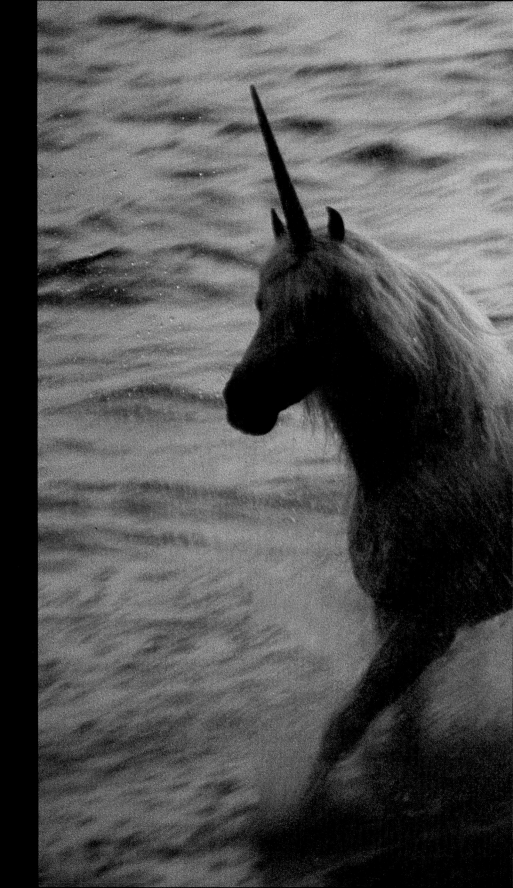

I saw the unicorns trampling,

trampling . . . strength, they

meant virginal strength, a

rushing, lasting, tireless

strength.

W. B. Yeats

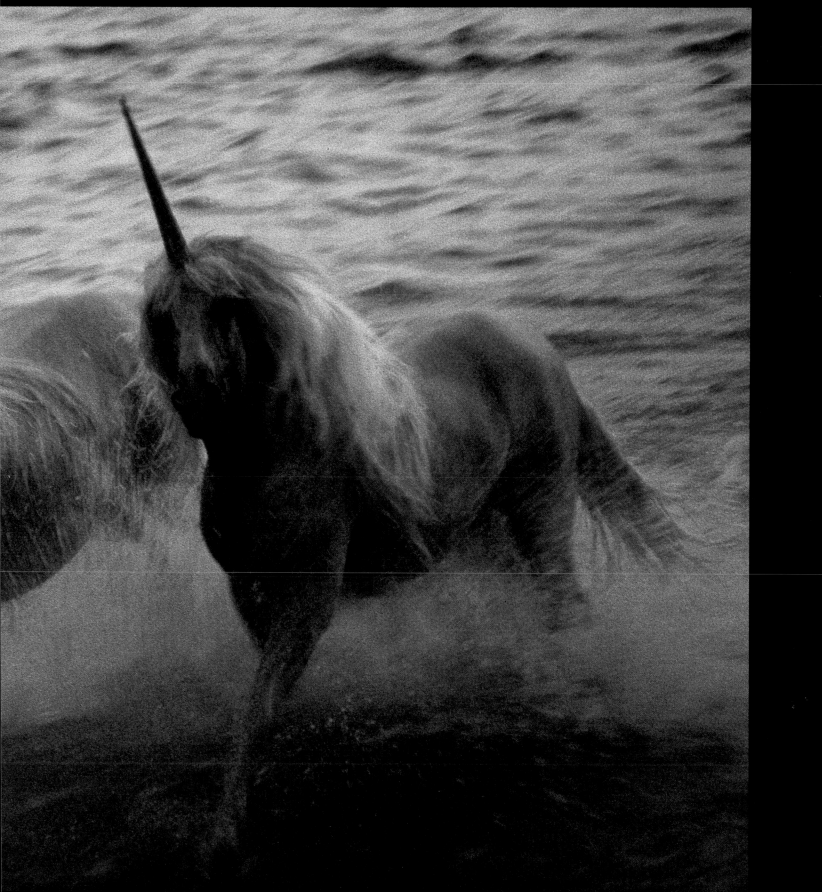

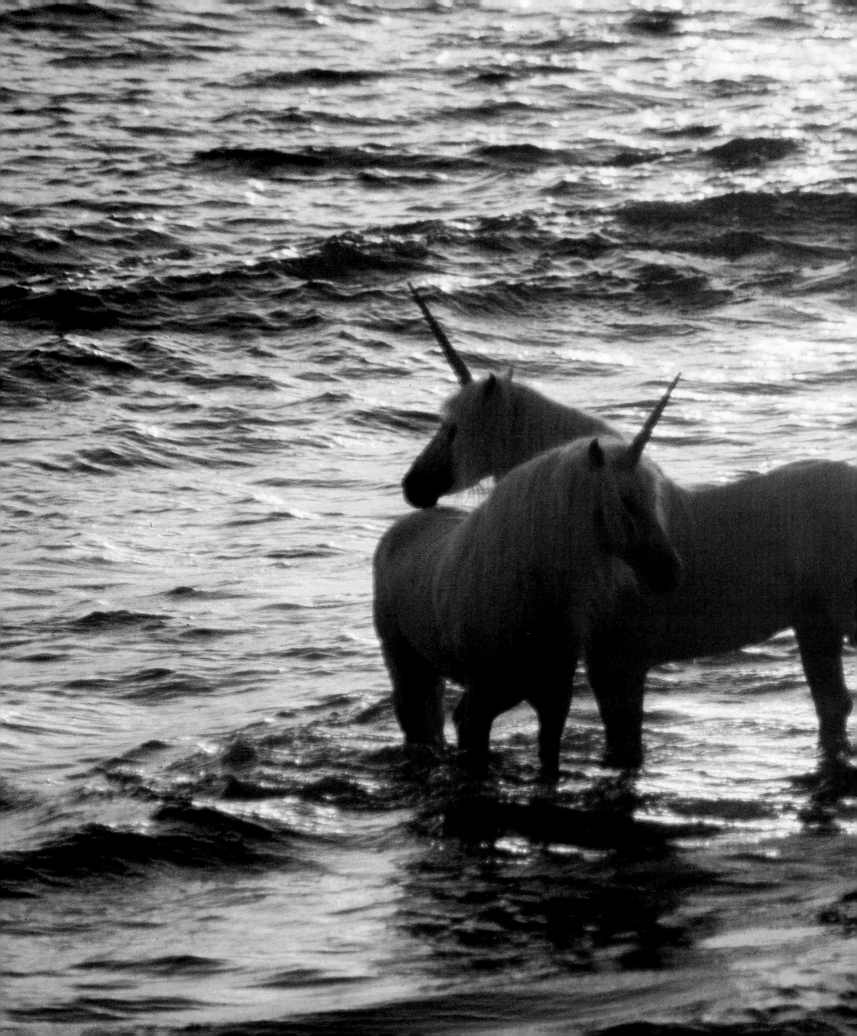

As the tide comes in

we caress each other. . . .

Many times have I

danced around mermaids

As they rose from the

depths and rested

Upon my crest to watch

the stars.

Kahlil Gibran

73

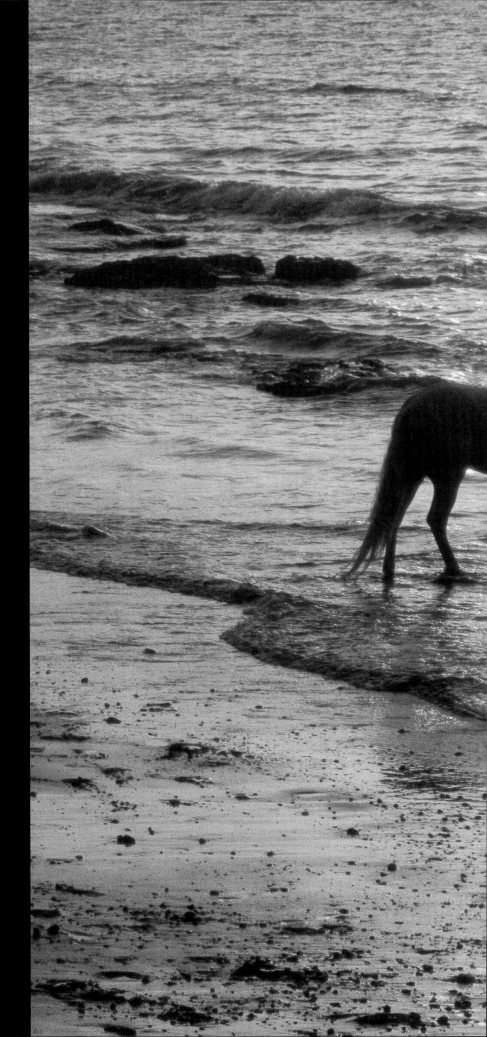

Ah! seaweed smells from sandy caves

And thyme and mist in whiffs,

Incoming tide, Atlantic waves

Slapping the sunny cliffs,

Lark song and sea sounds in the air

And splendor, splendor everywhere.

John Betjeman

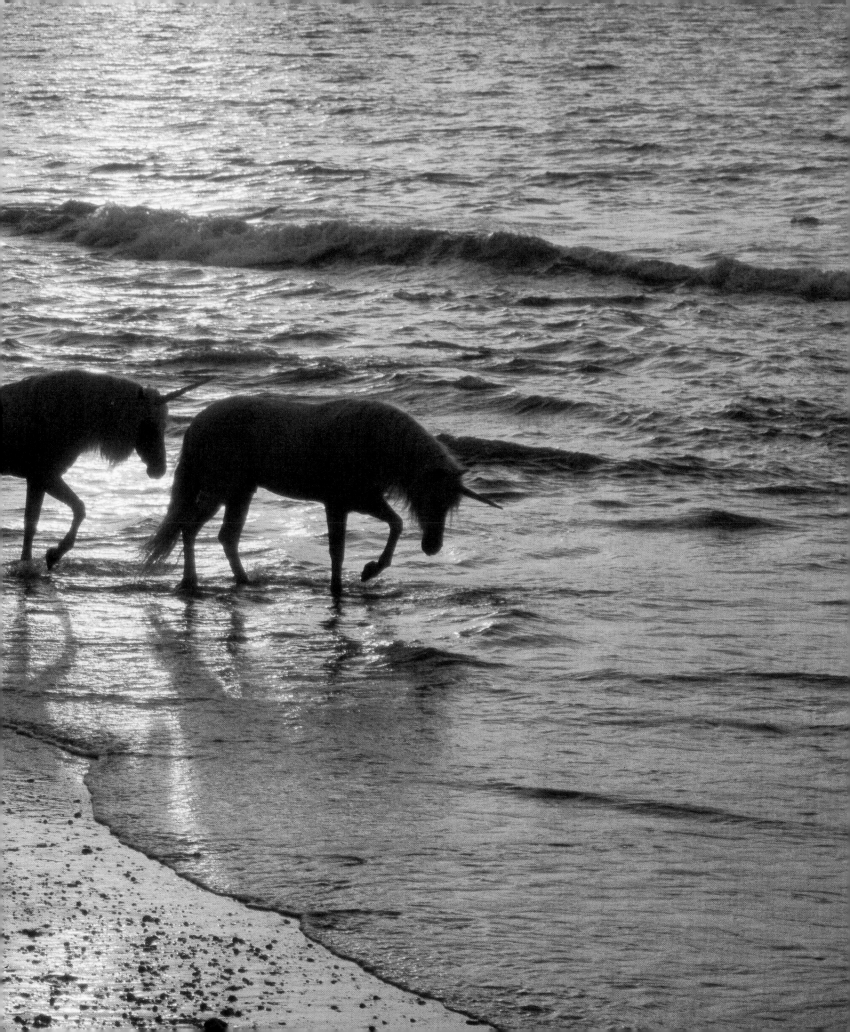

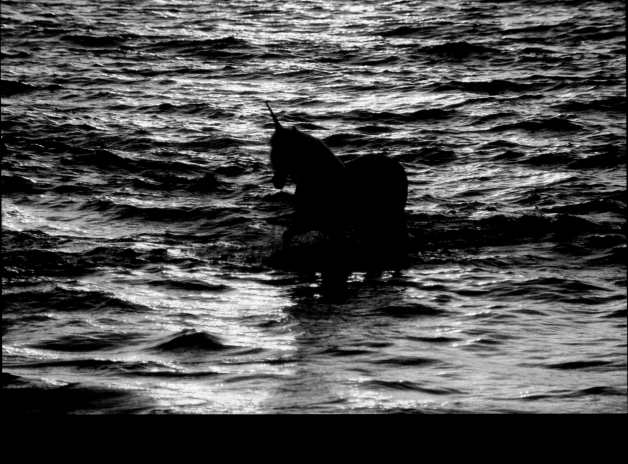

The shark is killed for its fin

The rhino is killed for its horn

The tiger is killed for its skin

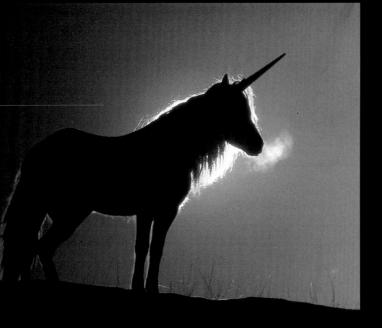

With Unicorns we feel the nostalgia of

the infinite, the sorcery of dolls, the

salt of sex, the vertigo of them that

skirt the edge of perilous ravines, or

straddle the rim of finer issues. He

dwells in equivocal twilight; and he can

stare the sun out of countenance.

James Huneker

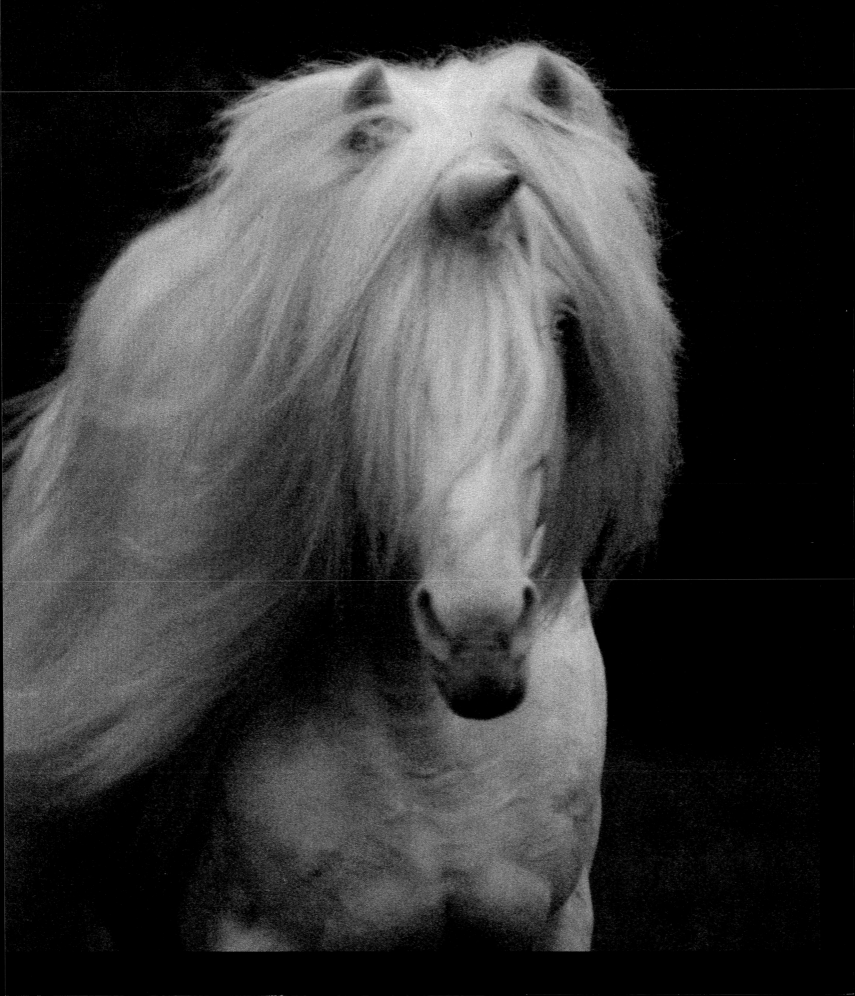

If the unicorn does live

among the snows held up

forever on the line of the

Equator then it is clear

why the world should know

so little about him.

Odell Shepard

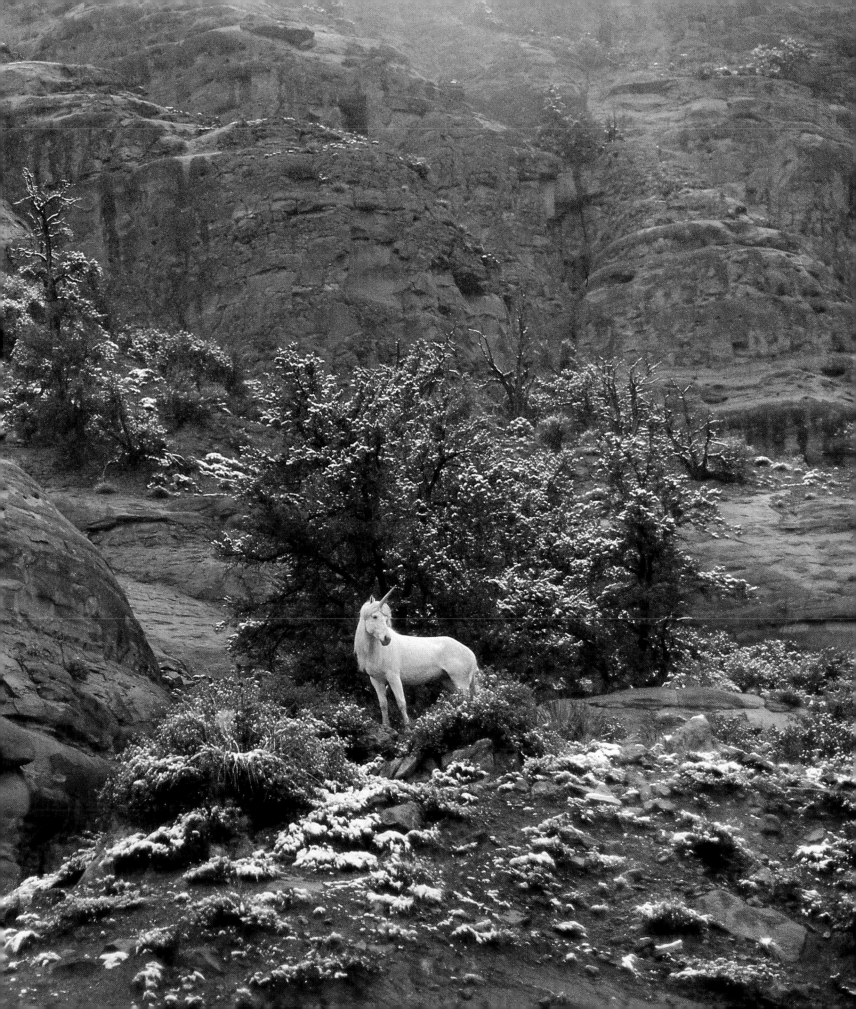

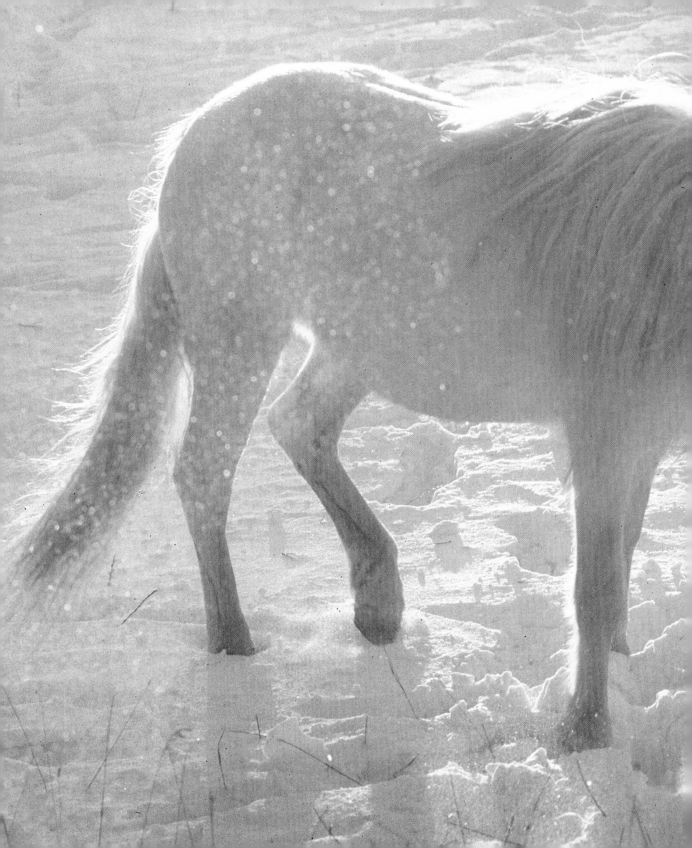

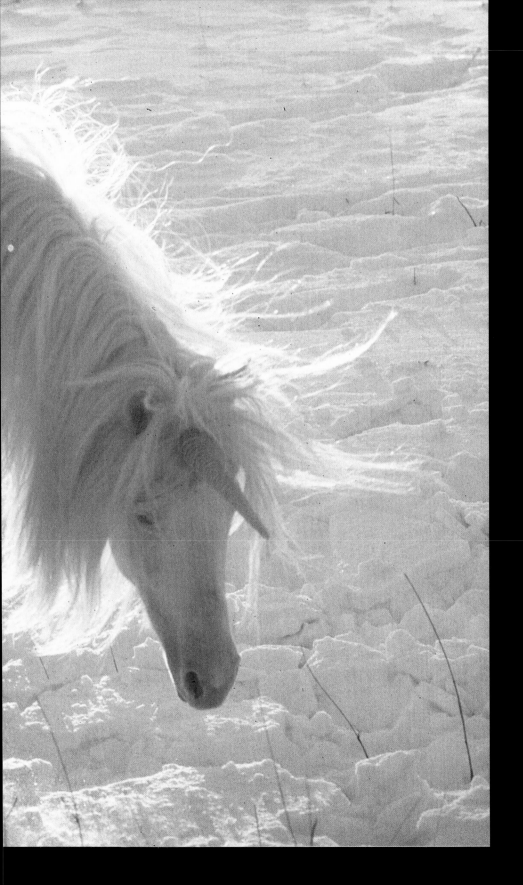

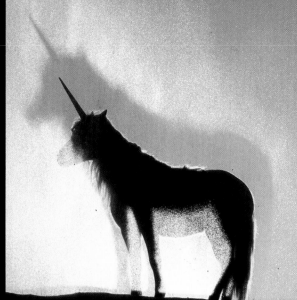

His horn

Bursts from his

tranquil brow . . .

Springs like a

lily, white

From the earth below . . .

To a longed-for height;

Or a fountain bright,

Spurting light

of early morn—

O luminous horn!

Anne Morrow Lindbergh

On the Canadian border there are

sometimes seen animals resembling

horses but with rough manes, and

a long straight horn upon the

forehead. They live in the

loneliest wilderness and are

so shy. . . .

Dr. Olfert Dapper
1673

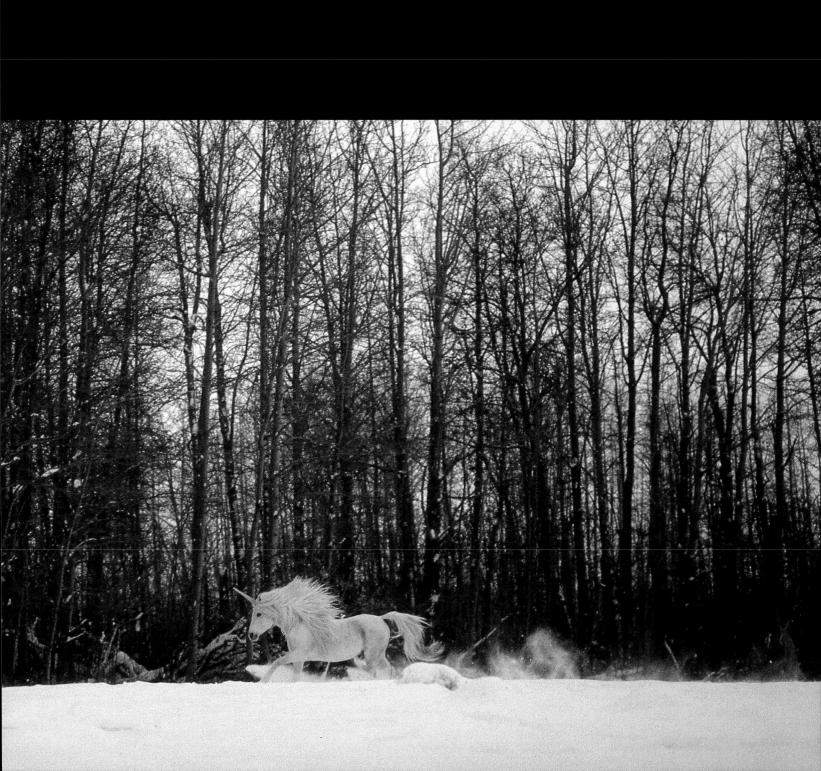

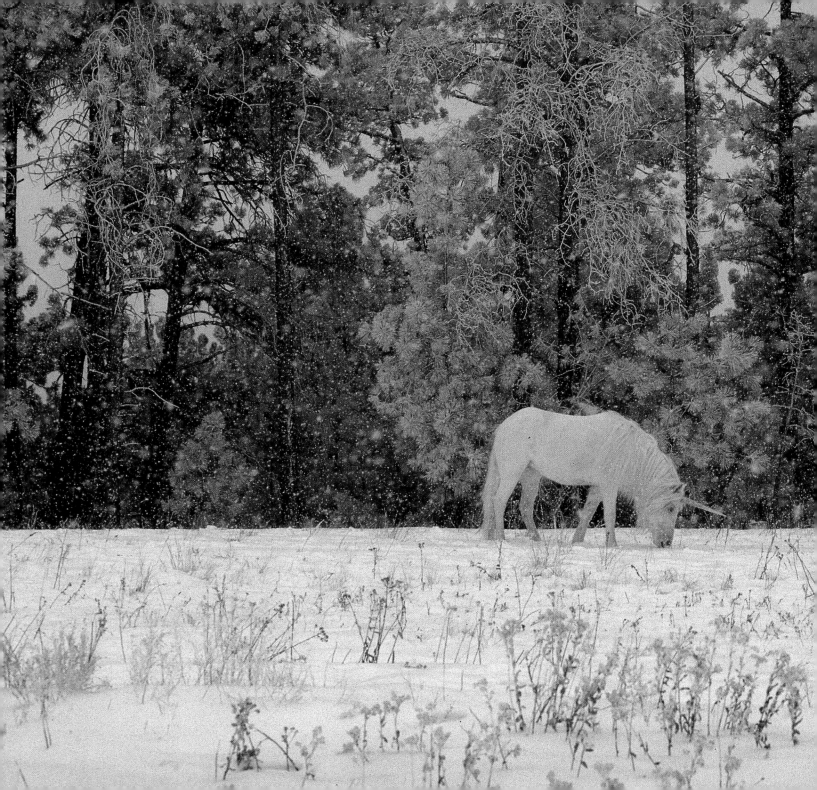

Snow . . .

Blows, whirls and

drifts about me . . .

In this world alone.

Chora
Japanese haiku

. . . her neck was long and slender, making her head

seem smaller than it was, and the mane that fell

almost to the middle of her back was soft as dandelion

fluff and as fine as cirrus. She had pointed

ears and thin legs . . . and the long horn above her

eyes shone and shivered with its own seashell

light even in the deepest midnight. She had killed

dragons with it, and healed a king whose poisoned

wound would not close, and knocked down ripe

chestnuts for bear cubs.

Peter S. Beagle

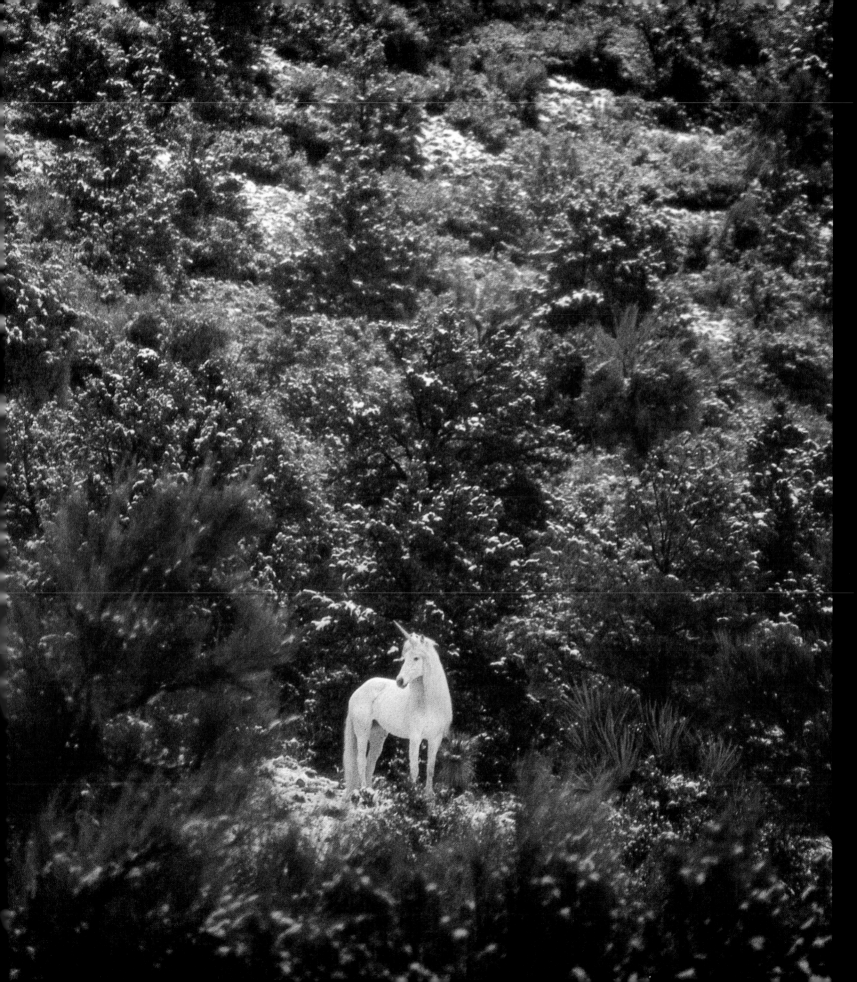

Brave flowers—that

I could gallant it

like you

And be so little vain!

Henry King

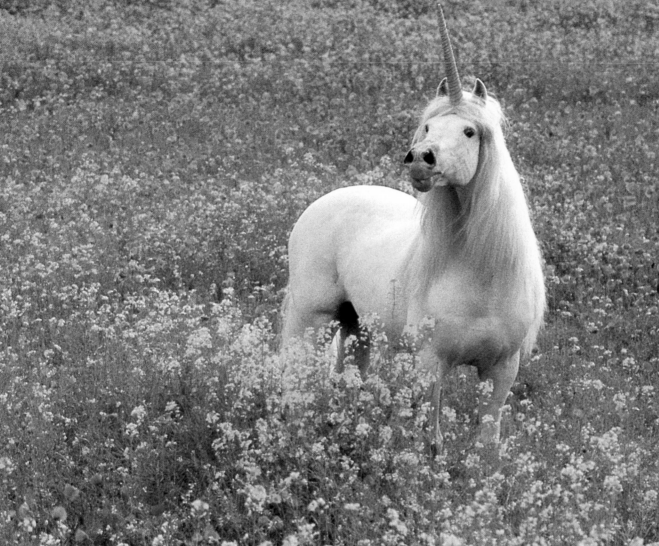

The unicorn has come out of

the Forest

To graze the lush grass in

the heat of the Sun.

All unaware of Passions

arousing,

Oblivious to danger, in

fear of no one.

Francis Lucien
Allegories

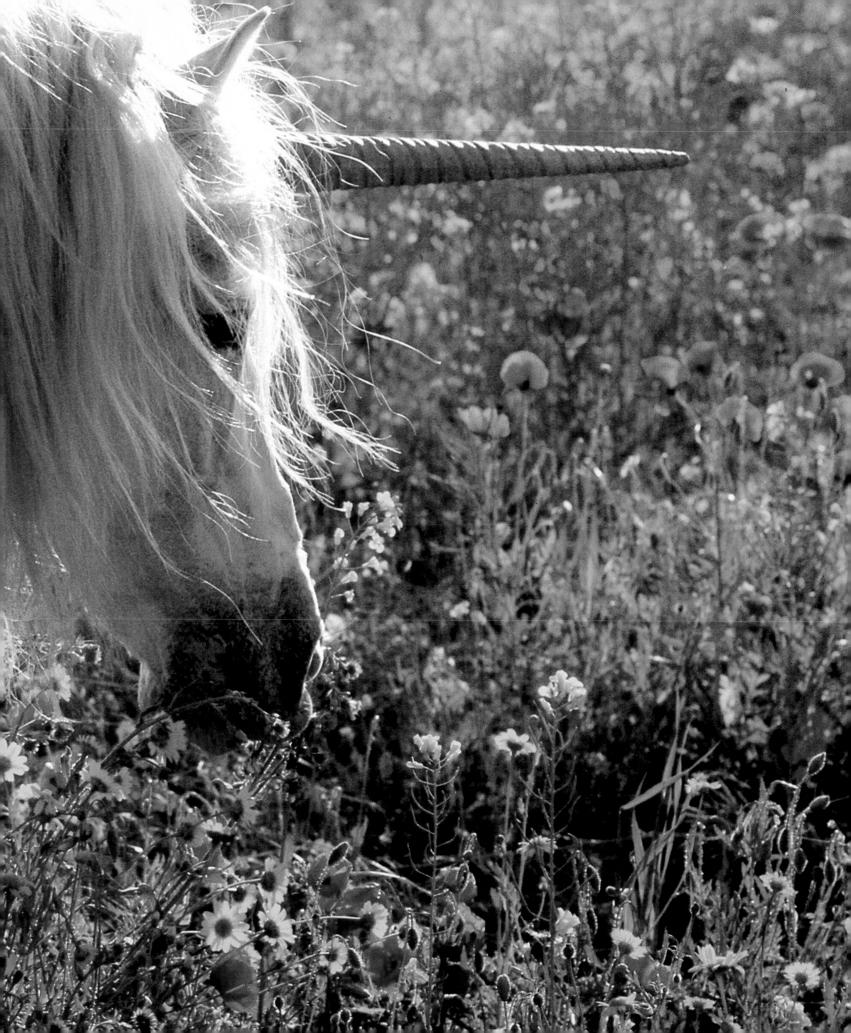

The flashing cascade of his mane,

the curving comet of his tail,

invested him with housings more

resplendent than gold- and silver-

bearers could have furnished him.

Herman Melville

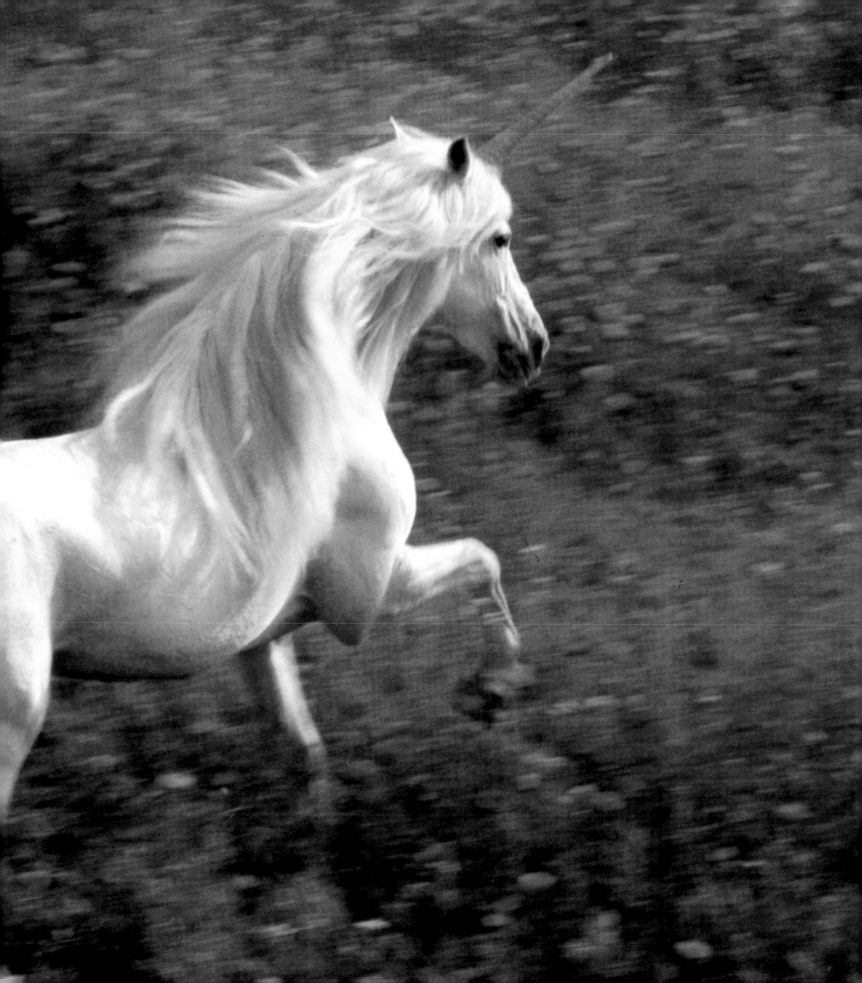

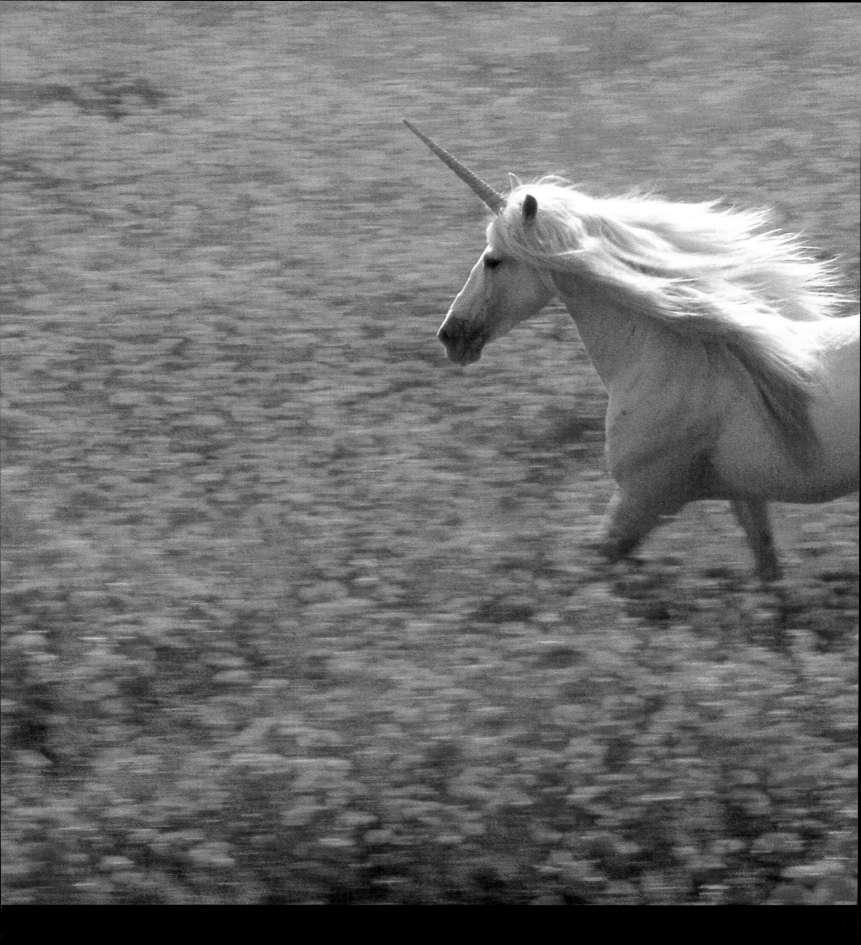

. . . nothing can bring back the hour

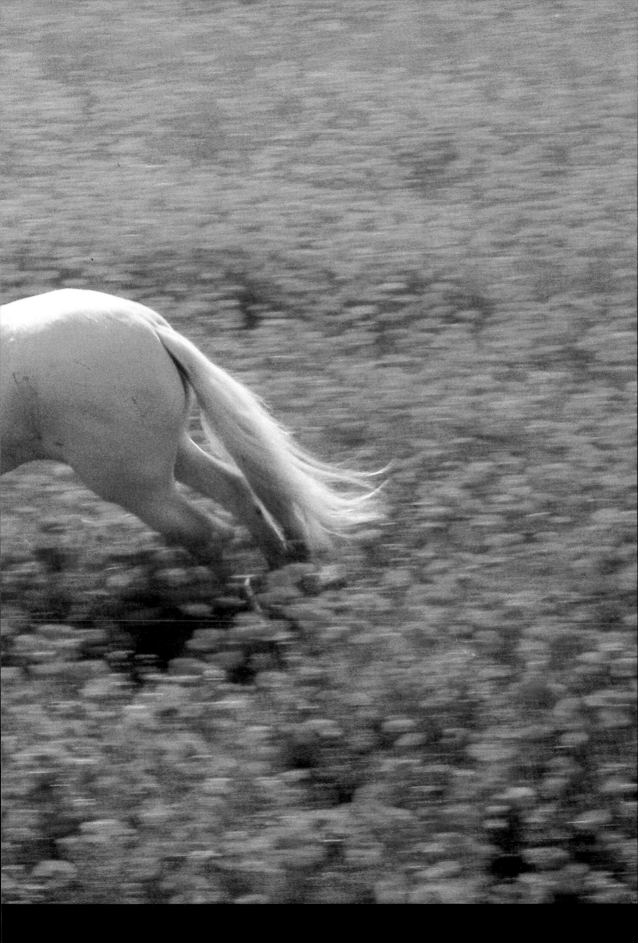

Of splendour in the grass, of glory in the flower . . .

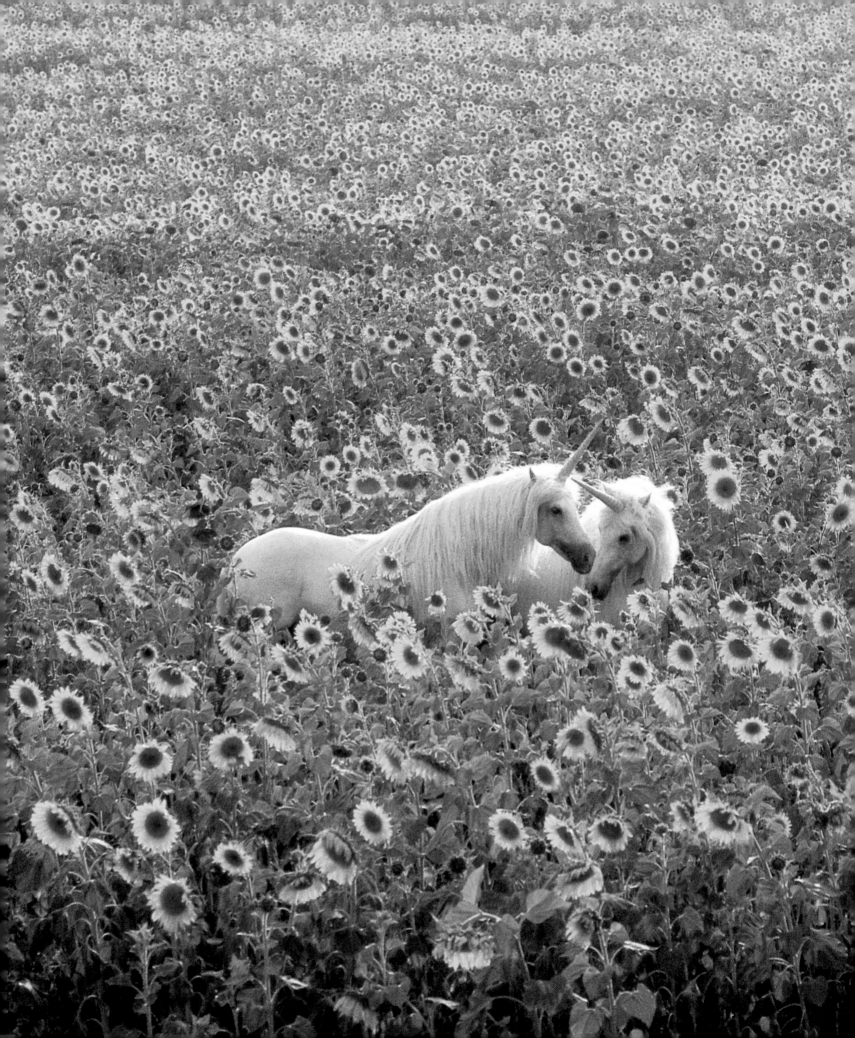

I am gone into the fields

To take what this sweet

hour yields . . .

Where . . . all things seem

only one

In the universal sun.

Percy Bysshe Shelley

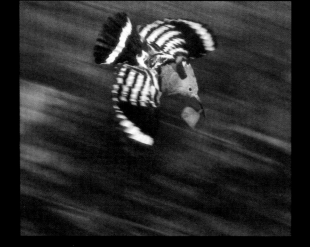

. . . they gathered flowers . . . of every sort,

which in that meadow grew,

Great store of flowers, the honor of the field,

That to the sense did fragrant odours yield,

All which . . . the goodly birds . . . garlands bound,

Of freshest flowers which in the mead they found . . .

a proud rebellious Unicorn . . .

Edmund Spenser

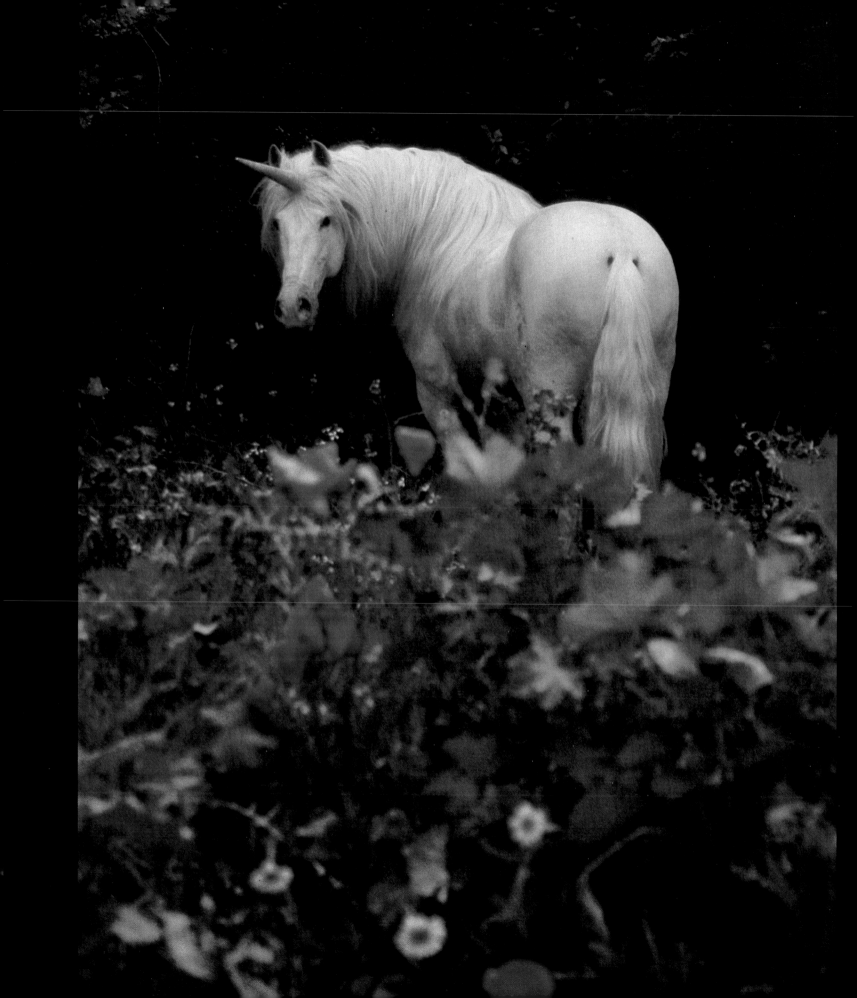

Here sits the Unicorn;

. . . *flowers that rise*

From the velvet field

In which he lies . . .

Do not bind him there

In a kingdom where

He is unaware

of his wounds, of his snare.

Anne Morrow Lindbergh

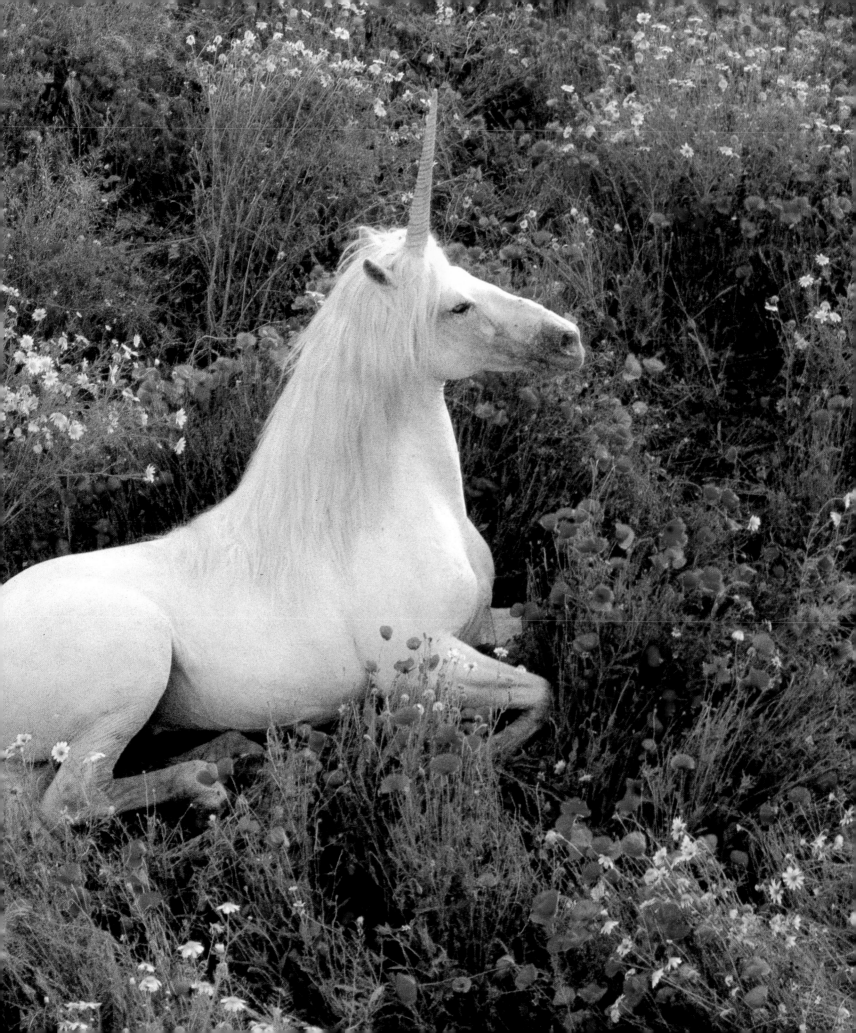

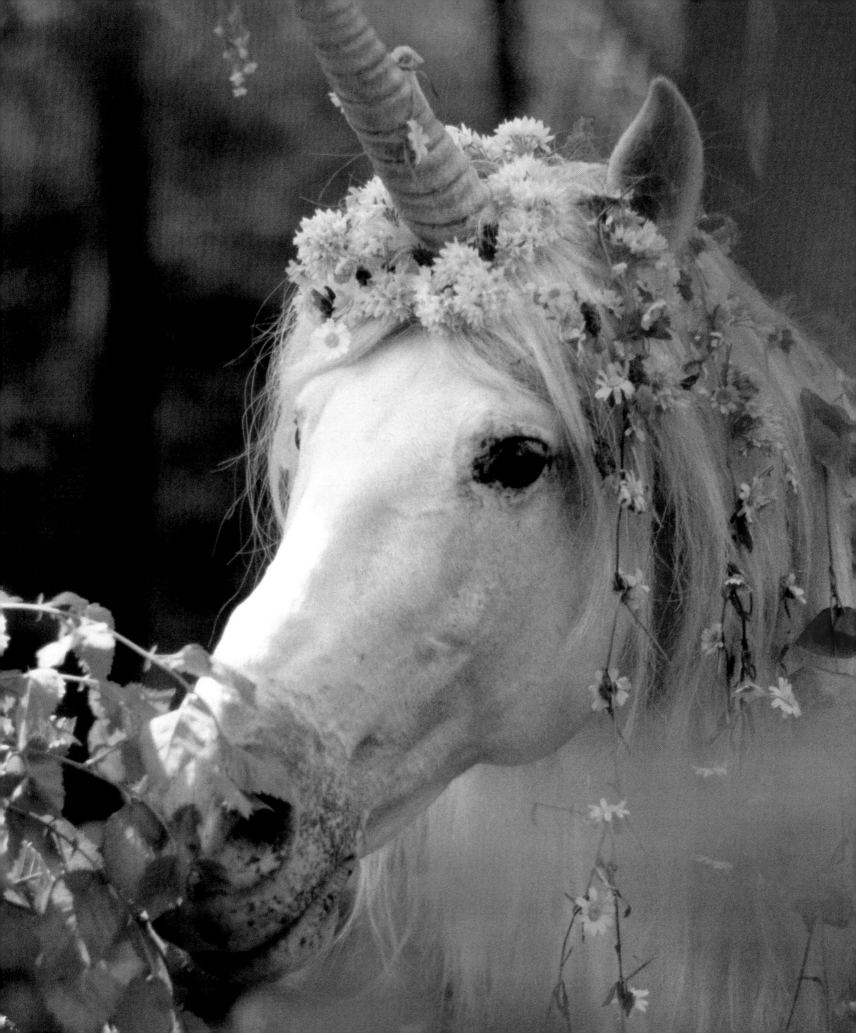

Garland the bright Horn with

wild sweet flowers,

. . . leave him to frolick

alone in the Pasture,

Endure the hot longing of

this summer day.

Francis Lucien
Allegories

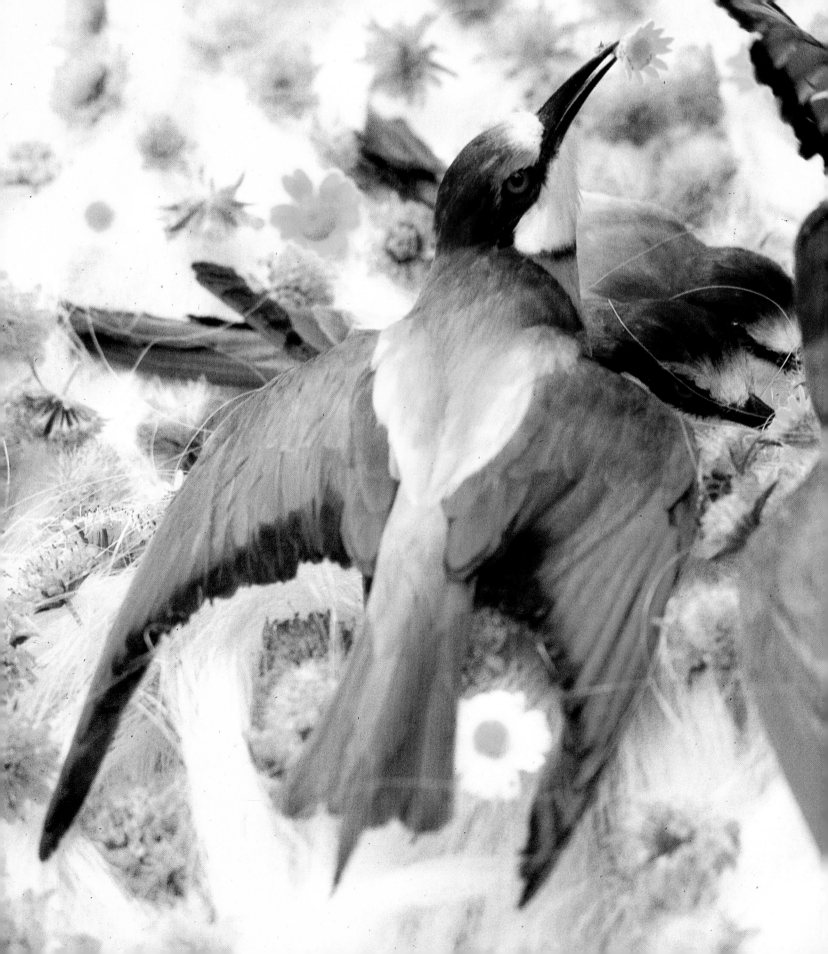

The flower sweetens the air with

its perfume; yet its last service

is to offer itself to thee. . . .

The morning sea of silence broke

into bird songs. . . . Lilies and

jasmines surge upon the crest . . .

the garland is ready . . .

Rabindranath Tagore

What could I compare them to? these petal paintings,

these blossoming tapestries of buds. In the unicorn's

mane and tail each bird had created a design that put

to shame the Flemish floral still-lifes that until

then had so delighted me.

Robert Vavra

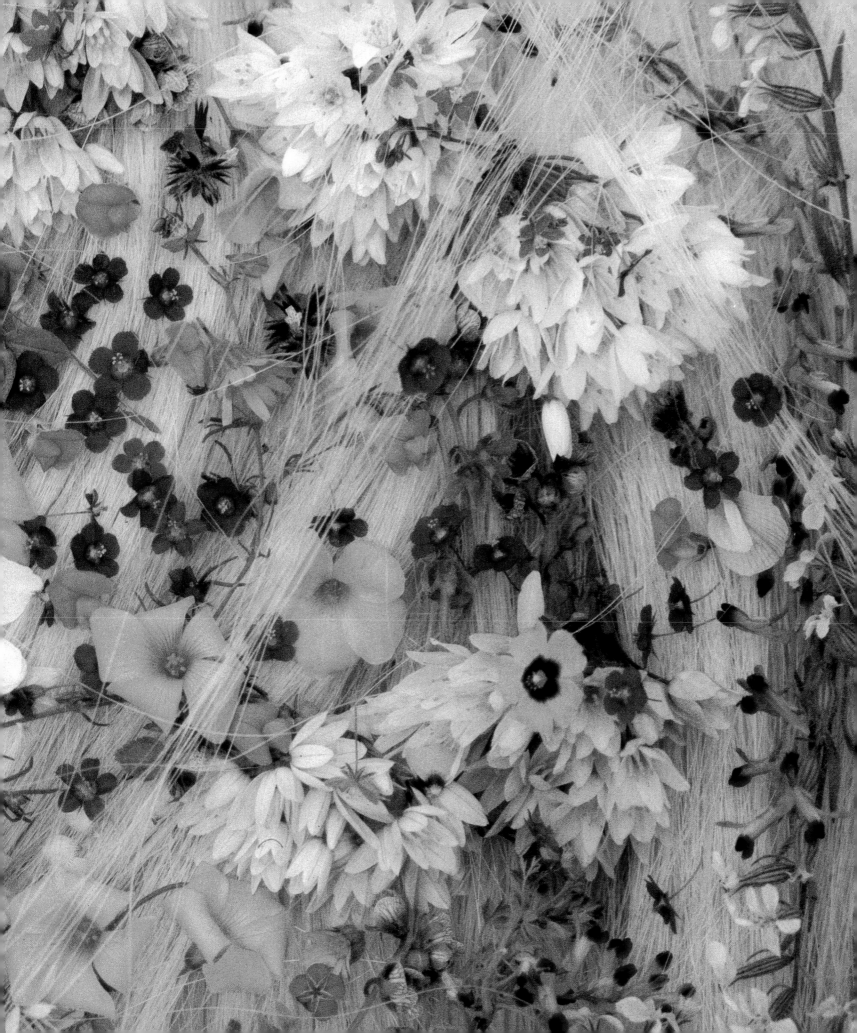

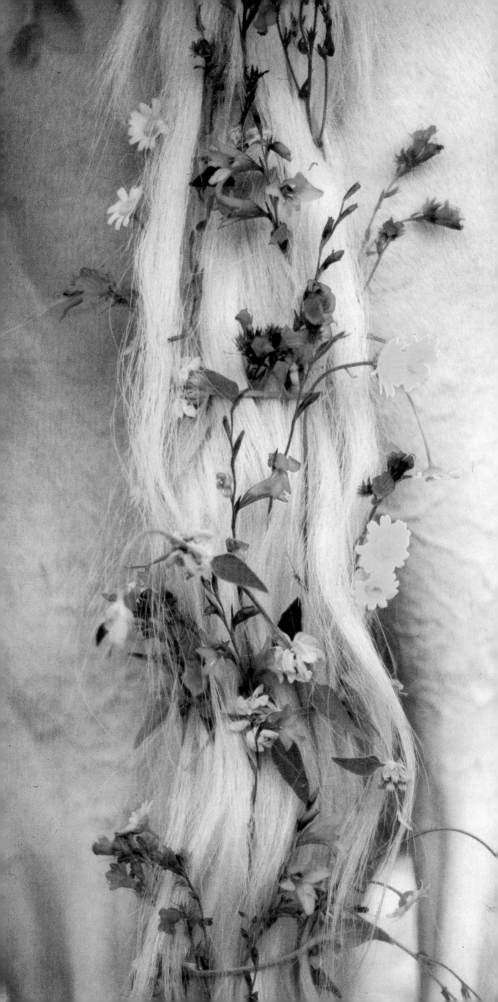

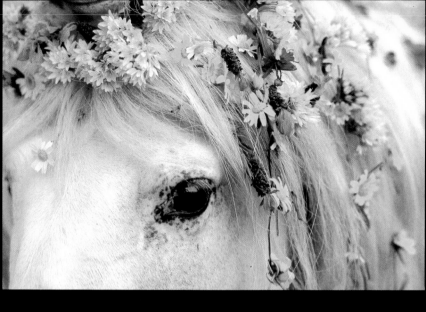

In every part. Of colors most diverse

Were flowers worked, blossoms in many a guise

Placed cunningly: the periwinkle blue,

The yellow flowers of broom, and violets.

No bloom exists that was not woven there

In indigo or yellow or white . . .

A flock of nightingales that flew . . .

would barely skim the leaves

Now there were various birds about:

Besides the nightingales were popinjays

and orioles and larks.

Guillaume de Lorris
1237

The year's at the spring

And day's at the morn . . .

The hill-side's dew-pearled;

The lark's on the wing;

UNICORNS OF THE DUNES

Unicornuus deserti

As nature produces few individuals of the most

wonderful kinds and the highest value—witness

the phoenix and precious stones—it follows that

the unicorn has a strong instinct for solitude,

living in deserts so remote that it seems a

miracle whenever its horn is found.

Andrea Bacci
1566

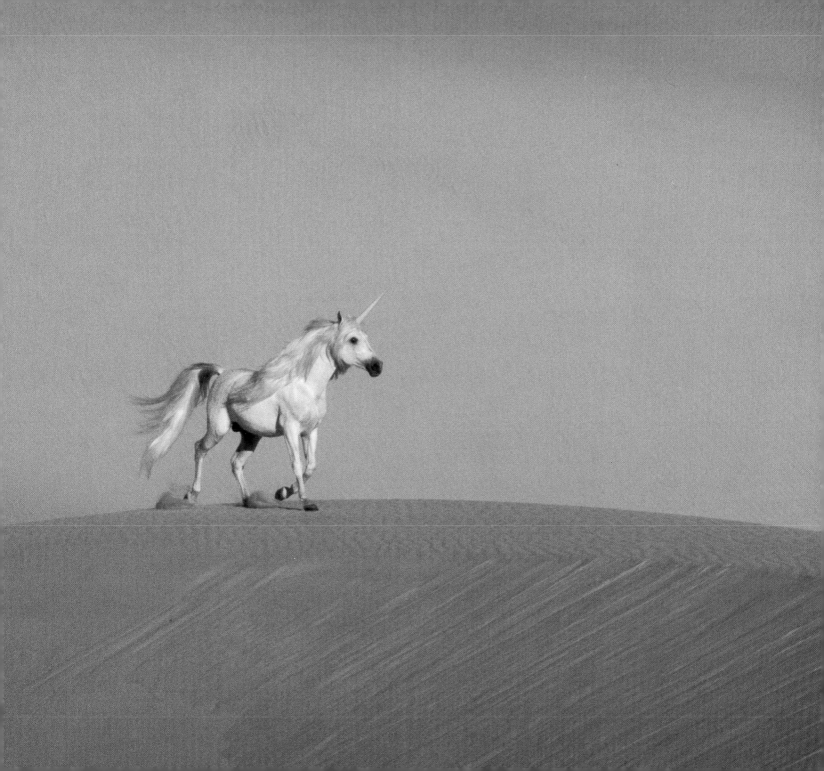

To regard the unicorn as wholly

fabulous and a product of fancy

is an absurd and arbitrary

position, and we do well to

remember that if the elephant

and giraffe and camel should

once die out they too, on

account of their strange forms,

would be thought fabulous.

Joseph Russegger
1843

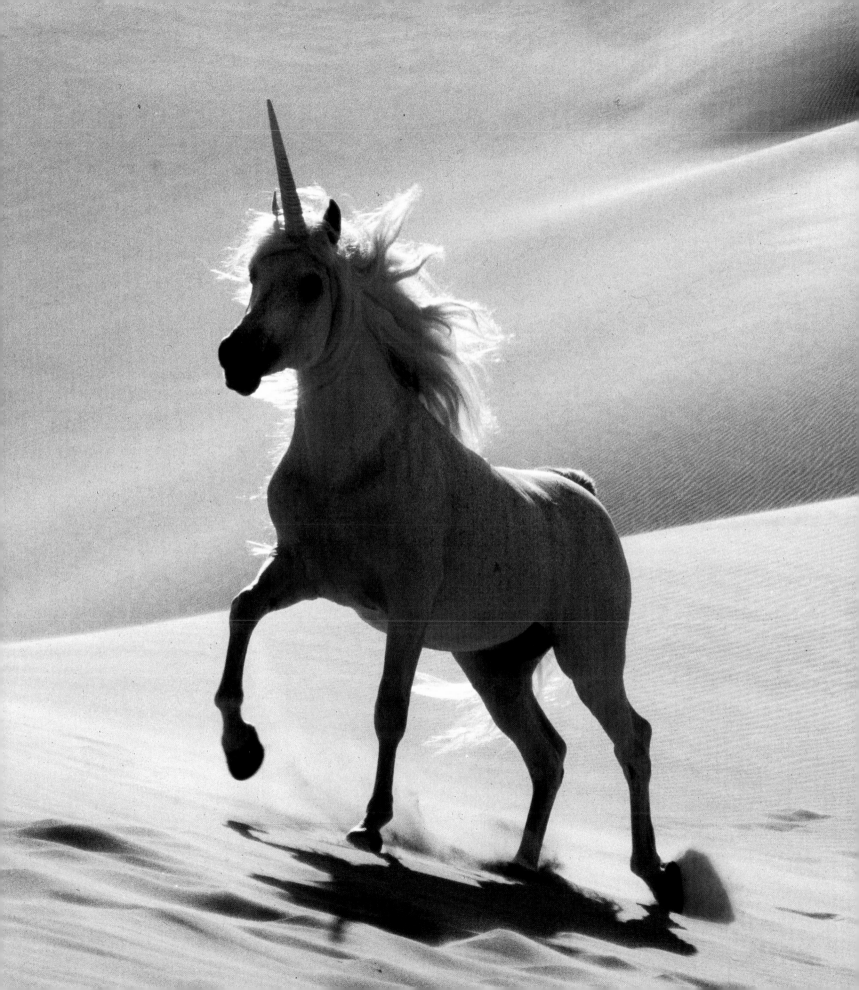

The steed self-armed, the Unicorn!

Ever heard of never seen,

With a main of sands between

Him and approach; his lonely pride

To course his arid arena wide,

Free as the hurricane . . .

George Darley

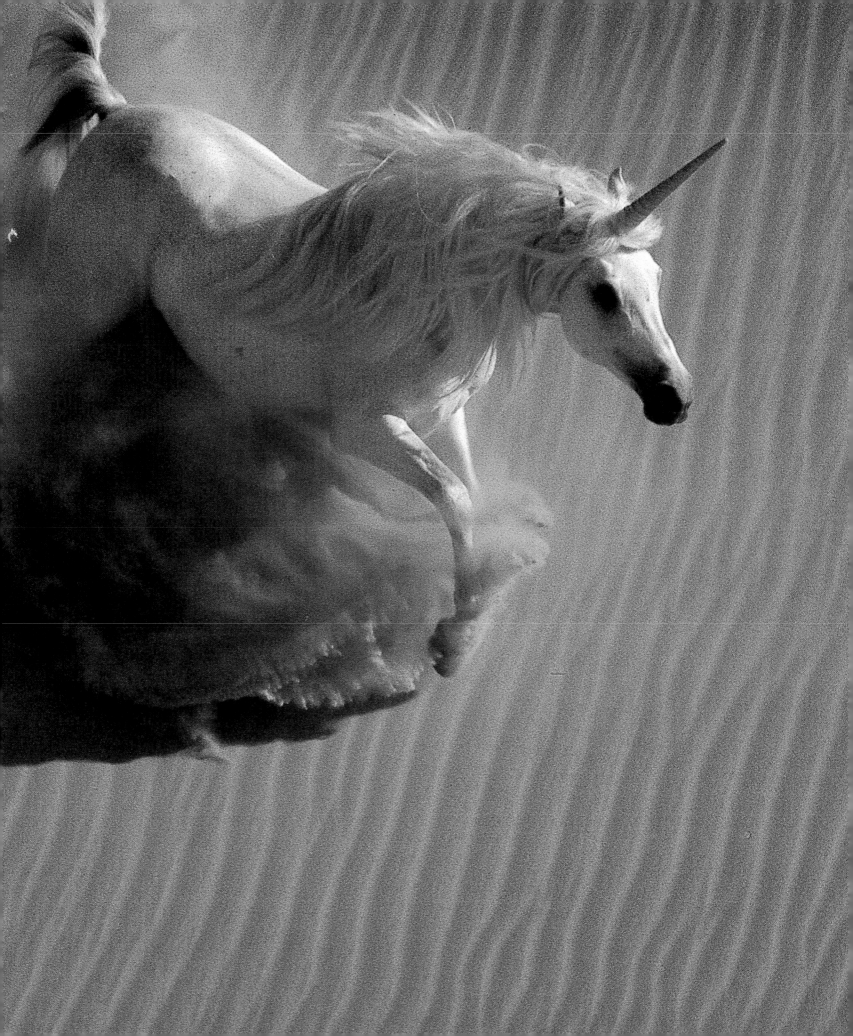

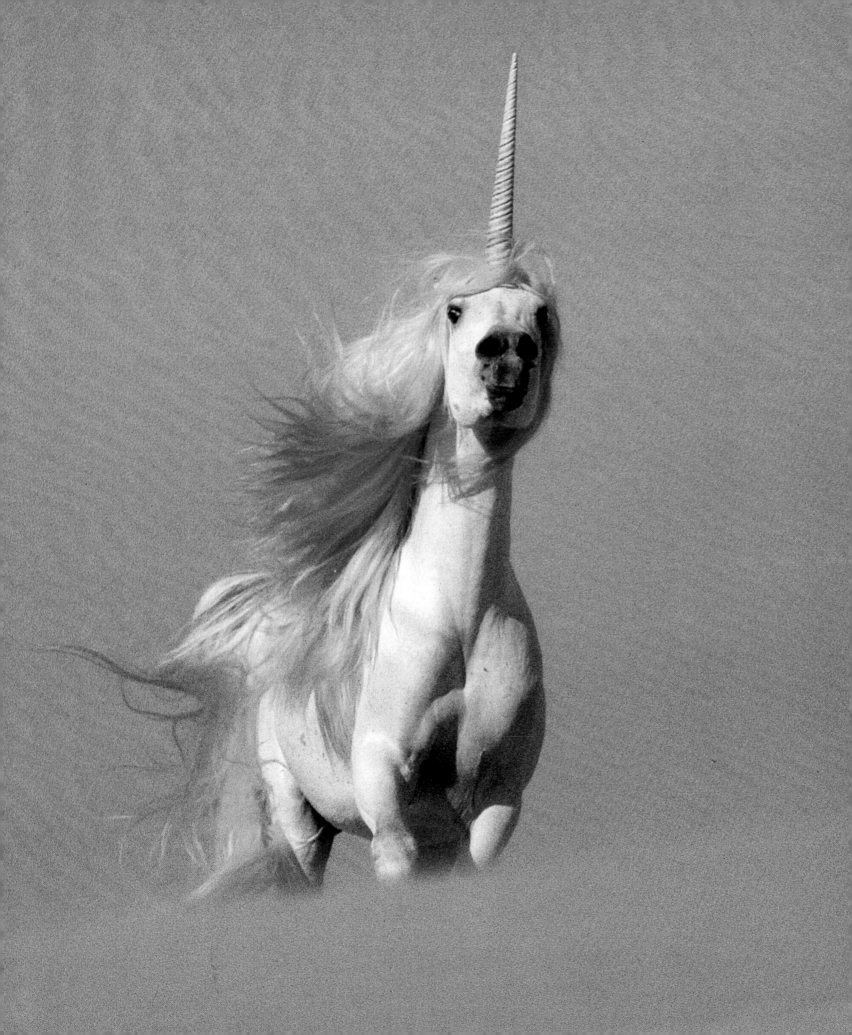

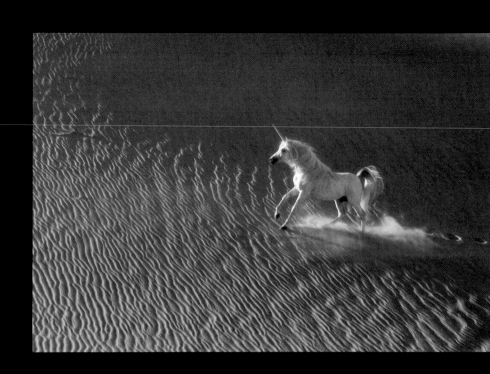

His fell is of the desert dye . . .

Compact of living sands; his eye

Black luminary, soft and mild,

With its dark luster cools the wild;

From his stately forehead springs

Piercing to heaven, a radiant horn . . .

—George Darley

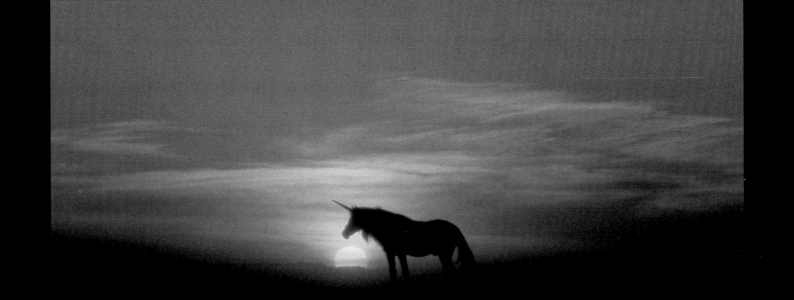

Now I will believe that there are unicorns.

William Shakespeare
The Tempest iii, 3

AUTHOR'S NOTES ON UNICORN BEHAVIOR

Field Notebook
1968-1983
Robert Vavra

Including observations by Rudolf O. Springer 1776-1836

Species observed: unicornuus memorensis, unicornuus montium solis, unicornuus marinus, unicornuus niveus, unicornuus floreus, unicornuus deserti.

MY QUEST for the unicorn began on December 17, 1959, in Surrey at the home of Veronica Tudor-Williams, author of *Basenjis: The Barkless Dogs*. Miss Tudor-Williams, along with the late Dr. James Chapin of the American Museum of Natural History, was one of the first white persons to have studied the Basenji in Africa, where on three occasions she also saw a unicorn roaming the dunes of the Sudan. When she confided her discovery to me this search was instigated, an adventure that fortunately was to take me from England back to Spain, where I found two documents that were invaluable in helping me encounter the world's only large land mammal that—until fifteen years ago—had never been photographed.

In 1960 an American scholar who was doing research at the Archives of the Indies in Seville told me of a letter in which Bernal Díaz del Castillo mentioned having observed a unicorn during one of the Cortez expeditions to the New World. Fortunately, I saw and translated that piece of correspondence (which also contained a sketch of a unicorn in the margin) two weeks before—in a folder of priceless papers, including a Christopher Columbus signature—it was stolen from the Archives.

The second document, and the most important to my quest, was a journal that I purchased for 200 pesetas (about 3 U.S. dollars then) in January of 1961, in the Madrid flea market. As far as I know, this ninety-six-page volume is the first serious complete unicorn behavioral study in existence. Dated "1836, Harar" and signed "Rudolf O. Springer," it is in English, using American spelling, and contains detailed drawings and explicit written descriptions of its subject's history, appearance, and habits. Though Veronica Tudor-Williams's account of having seen unicorns in the Sudan and the words of Bernal Díaz del Castillo were convincing, it was the Springer study that confirmed for me the authenticity of an animal that, until then, seemed destined to remain caged up in mythology.

The information on unicorn behavior revealed in these notes represents only a fraction of the total findings. Secrets are secrets, and there are countless confidences entrusted to the unicorn observer—if he is accepted by these marvelous creatures—that are not to be shared with other humans. Deepest

Unicorn hoofprints are easily distinguished from those of other animals.

horse

mule deer

goat

cow

pronghorn

unicorn

gratitude goes to Barbara Funk, who did the drawings that accompany these notes. Many of my field sketches were so vague and awkward that I am surprised she could follow them. Barbara also reviewed each of the hundreds of transparencies not used in this book so that her renditions would be as accurate as anything I saw in the forest, mountains, sea, snow, flowers, or dunes.

The photographic equipment used included two Nikon F2 cameras with motor drives, together with a 50-300 mm Nikkor zoom lens and two Nikkor telephoto lenses (a 105 mm and a 500 mm). Film shot was Ektachrome 200.

It is hoped that these brief notes on the most basic of behavior will encourage young naturalists (and old ones, if their minds are not already too firmly shut) to do further studies on unicorns.

Page 5 My first unicorn image, taken on April 15, 1968, at approximately five-thirty in the afternoon, a half mile off the old Pan American Highway in a forest near Tamazunchale.

Page 7 Left to right: (1) rearing unicorn; (2 and 3, top) Arabian oryx and domestic goat; and (4, bottom) African rhinoceros. "In the past, the true unicorn has been confused with the goat, the antelope and the rhinoceros, and has even been described as looking like a ram, ox, bull, wild ass, fish and serpent, as well as a beast in which several of these animals are combined," wrote Rudolf O. Springer in his journal:

"Since the beginning of time, a beast of one horn has been a symbol of supreme power and fertility, associated with gods and kings. The vigor and virility related to the two horns of other animals is concentrated into the stronger single horn.

"Though it has little to do with living unicorns, fortunately some time ago a distinction was made in legend between the caprine unicorn, an immense and disgusting one-horned goat, and the equine unicorn, in the form of a horse (which most resembles the true animal as it actually exists and is shown in this journal). The latter, the unicorn *par excellence*, was gracefully adapted by the College of Heralds as a symbol of the 'verray, parfit gentil knyght,' representing the twin virtues of strength and purity—might and right.

"In the Western world, the first writer to mention the unicorn was Ctesias of Cnidos, a Greek historian and doctor, who was court physician for almost twenty years to the kings of Persia. This description is found in a fragment of his book on India (a country he had never visited), written about 398 B.C.: 'There are, in India,' Ctesias wrote, 'certain asses, which are as large as horses, or larger. Their bodies are white . . . and their eyes dark blue. They have a horn on the forehead, which is about a foot and a half in length. The dust filed from this horn is administered in a potion as protection against deadly drugs. The base of the horn is pure white, the upper part is sharp and of a vivid crimson (φοινικοῦν ἐστιν, ἐρυθρὸν πάνυ); and the remainder, or middle portion, is black. Those who drink out of these horns made into drinking vessels are not subject, they say, to convulsions or the holy disease. Indeed, they are immune even to poisons if, either before or after swallowing such, they drink wine, water, or anything else from these beakers. Other asses, both tame and wild, and, in fact, all animals with solid hooves, are without the ankle bone and the gall. This ankle bone, the most beautiful I have ever seen, is like that of an ox in general appearance and in size, but it is as heavy as lead, and its color is that of cinnabar through and through. The animal is exceedingly swift and powerful, so that no creature, neither the horse nor any other, can overtake it.'

"It is quite obvious that Ctesias had never seen in the flesh the subject of his treatise, but had relied on reports from travellers. Thus, the animal he describes seems to be a combination of three creatures: (1) wild ass, (2) rhinoceros, and (3) the unicorn proper. This confusion of the attributes of various mammals and the inability to distinguish between the artificial and the natural is a perpetual stumbling block in the complex history of the unicorn; but, taking into account how rare and seldom seen the real creature was, and still is, this was inevitable in a time when travellers' tales were the only sources of information. It is a logical deduction that Ctesias, having never viewed a rhinoceros, saw a cup made from the rhinoceros horn which had been brought from India, where these were commonly used as drinking vessels by princes and potentates and often decorated with bands of white, red and black paint. Thus, the horn of the Ctesian unicorn has these colors.

"Aristotle (384–322 B.C.) mentions two kinds of unicorns, which modern scholars have interpreted as the Indian ass and the oryx, a kind of antelope that is single-horned in profile. Roman writers Pliny (A.D. 423–479) and Aelian (A.D. 170–235)

both relied, like Ctesias, on the observations of others, so that the creatures they describe are composites of several beasts. Their descriptions, however, did contain two truths. Pliny emphasized the fact that unicorns cannot be captured by men, and Aelian their love of solitude and their indomitability.

"Although the unicorn proper, as anyone who has ever seen one can testify, is the most marvelous of all land and sea creatures, as with other rare little-studied animals, man had to improve upon him. Jewish commentators exaggerated him out of all proportion. A young unicorn becomes as large as Mount Tabor and as high as the sky, with a head almost ten miles long. Because it would not fit into Noah's ark (only the tip of its nose could have been boarded), the unicorn had to be towed by a rope attached to its horn; and another tradition states that it perished in the waters because it insisted on swimming. Talmudic texts link the unicorn with the lion: 'And in our land there is also the unicorn, which has a great horn on its forehead. And there are also many lions. And when the lion sees a unicorn, it draws him against a tree, and the horn pierces so deep into the tree it cannot pull it out again, and then the lion comes and kills the unicorn—but sometimes the matter is reversed. . . .'

"During my many years of study, I never saw one of these magnificent creatures fight with another animal, except of his own kind, and even then only sea unicorns were observed in combat. Both in the Gir Forest of India and in Abyssinia, I have observed them on several occasions slake their thirst not more than fifty feet away from drinking lions, whom they seemed to ignore.

"During the Middle Ages when Bestiaries, collections of moral tales about real or fabulous animals, were in vogue, the unicorn was given a new role. Most of these were drawn from a well-known book called *Physiologus*. No wonder, with this sudden odious fanfare, the surviving ones became even shyer and more suspicious of man. Texts varied according to local and religious influences, but all recounted the most famous of all legends about the unicorn—its capture by a virgin. According to this tale, the unicorn is too fleet, fierce and well-armed to be taken by hunters. Only a virgin seated alone under a tree in a forest can capture it; because it is irresistibly attracted by the odors of virtue, the unicorn approaches the virgin, lays its head in her lap, and permits itself to be caressed into sleep.

The four basic unicorn "written" communications as first identified by Rudolf Springer (prior to 1836).

stag seeking doe

doe seeking stag

danger

safe forest

She grabs its horn, the dogs leap, the huntsman pounces, and the unicorn is taken to the palace of the king.

"Details vary, vividly, from text to text; in some, the unicorn indulges in familiarities remarkably unsuited to virginal virtue, and in others the virgin is a boy in disguise. Although the legend, of unknown provenance, is transparently erotic, it was twisted into ill-fitting Christian significance. The treacherous virgin was identified with the Mother of God, and the unicorn with Christ, and also, despite its dubious familiarities, with purity. The single horn was said to symbolize the unity of Father and Son, as well as the 'horn' of the cross, the upright beam projecting above the transverse. The huntsman became the Holy Spirit acting through the Angel Gabriel, and the king's palace was heaven. The dogs represented truth, justice, mercy and peace, despite the fact that their function was to tear the unicorn to pieces; they were said to couple at the beast's death, signifying that, though seemingly irreconcilable, truth, justice, mercy and peace were now one. To some, however, the unicorn symbolized other things—principally death and violence. In a twelfth-century rulebook for nuns, he is described as 'wicked, wrathful, an emblem for violent people.'

"Another famous legend concerns the virtues of the alicorn, the beast's horn, as an antidote to poison. The animals gather at sunset to quench their thirst and find the 'great water' poisoned with venom discharged by a serpent. Unable to drink, they await the unicorn. The beast approaches, either makes the sign of the cross with its horn or dips it into the water, and, instantly, the pond or stream is cleansed. The horn supposedly symbolizes the cross, the serpent the Devil, and the poisoned water stands for the sins of the world.

"As a result of this legend, drinking cups made from horn were commonly found on banquet tables of the Middle Ages and the Renaissance as a defense against death by poisoning, a common hazard besetting those in high places. The horn was said to sweat in the presence of poison. Alicorns, bought and sold at formidable prices, were rated among the most precious items of princely and papal treasures. In 1605, Johannis Baptista Silvaticus reported in his *De Unicornu Bezoar* that Paul III had paid 12,000 gold pieces for a horn to be used against pestilential fevers; and another horn is said to have sold in Dresden for 75,000 thalers. While the rich had cups made from alicorn, or pieces of it, the poor had to be content with scrapings of horn or *l'eau à la licorne*, water into which the horn had been dipped. Apothecaries kept an alicorn chained to their counters, for it was considered to be the most effective panacea for a variety of evils. Finally, it was claimed to raise the dead.

"Since the unicorn does not shed his horn nor does it retain its form after death, a veritable library of learning has been built up in search of the beast providing the 'true alicorn.' The 'magical' ivory-colored material, in fact, came from rhinoceros, antelope, mammoth tusk, and the tusk of narwhal, a marine mammal, and *never* from a true unicorn.

"Unicorns held a high place in the religion and sacred writing of Persia: '. . . the three-legged ass . . . stands amid the wide-formed ocean . . . its feet are three, eyes six, mouths nine, ears two, and horn one. Body white, food spiritual and it is righteous. . . . The horn is, as it were, of pure gold and hollow. . . . With that horn, it will vanquish and dissipate all the vile corruption due to the efforts of noxious creatures. . . .' However, the one-horned ass is frequently thought to have been imported from an older culture. It is felt that the single-horned beast that haunts the high snows of the Himalayas has the most ancient tradition; and many authorities cite Tibet as the most likely source of unicorn legends, though there was a time in history when the so-called Mountains of the Moon, heaving high over Abyssinia, held pride of place. The tradition was long and strong, as it should have been, since in Tibet I found and studied for more than nine months three unicorns of the snow, and in Abyssinia I have spent the past ten years observing first-hand a half dozen unicorns (four stags and two does) of the Mountains of the Sun. With these creatures making their home here, it is not surprising that four brazen unicorns dominated the court of Abyssinian kings.

"The unicorn exists because it exists. Such an animal does not come from nothing. If only those, unfortunately many, pseudo-scientists would have the sense and imagination simply to deduce that there is a unicorn legend—because there are unicorns! Do not most of these same self-righteous zoologists hypocritically profess belief in Jesus Christ, relying as their only form of proof of his existence on that same Old Testament that says: 'God brought

them out of Egypt; he hath as it were the strength of a unicorn.' (Numbers 23:22) 'His glory is like the firstling of his bullock, and his horns are like the horns of unicorns.' (Deuteronomy 33:17) 'Will the unicorn be willing to serve thee, or abide by thy crib? Canst thou bind the unicorn with his band in the furrow?' (Job 39:9–12) 'Save me from the lion's mouth: for thou hast heard me from the horns of the unicorns.' (Psalms 22:21) 'The voice of the Lord breaketh the cedars; yea, the Lord breaketh the cedars of Lebanon. He maketh them also to skip like a calf; Lebanon and Sirion like a young unicorn.' (Psalms 29:5–6) 'But my horn shalt thou exalt like the horn of an unicorn.' (Psalms 92:10) 'For the Lord hath a sacrifice in Bozrah, and a great slaughter in the land of Idumea. And the unicorns shall come down with them, and the bullocks with the bulls.' (Isaiah 34:6–7)

"In Tibet, antelope horns—substituted for the real thing—were used for magical and ritual purposes for centuries, particularly the horn of a fierce fleet antelope known as *Antholops hodgsoni*, named for a British resident of Nepal who identified its horn. In profile, the beast looks single-horned, but nothing at all like the actual unicorn. After my field study in Nepal and India, where unicorn populations are quite large, I was not surprised to find that it is frequently depicted in the paintings and sculptures of Buddhist temples; the circle containing the body of a dead lama was drawn with the horn of the antelope, which, in truth, represented that of the real sacred animal. From Tibet, the unicorn of legend is assumed to have spread to China.

"While, in fact, the living Chinese unicorn differs only slightly from those I have studied in other parts of the world, legend has drastically changed its appearance and character. It does not have the fierce temperament of its counterpart further west; it is so gentle that it will not tread on so much as a blade of grass, has a sweet bell-like voice, and in sculpture and graphic representations its backward-sweeping horn is fleshy-tipped, indicating that it was not used for attack. The expression on its face, however, can only be described as severe and vicious. Called the *k'i-lin*, the Chinese unicorn of myth was believed to appear at the start of a benevolent reign or the birth of a man equal to an emperor in stature; traditionally, it announced the birth and death of Confucius. But there is more to the legend than that. The 'key' to the beast lies hidden in its Chinese name: *k'i* ('male'), *lin* ('female').

"Until now, the rare and seldom seen unicorn's most vital function has been as a symbol, whether of power or virility, or purity, or the combination of opposites of the male horn and the female body. Many modern interpreters regard this last role as the crucial one and relate it to the symbolism of the soul as the spark of divine light in the darkness of matter and evil, the body, and to the concept of the hermaphrodite as the perfect union of opposites.

"This explains the unicorn's place in the symbolism of alchemy. The 'great work' of alchemy was an attempt to liberate the divine spirit of light from the prison of darkness by transforming base metal into gold by means of the philosophers' stone, and by transforming the alchemist himself into the psychic equivalent of gold, a spiritually purified being who had liberated the god within himself. Mercury, the 'male-female,' the androgyne, was an essential element in the work, and the personification of Mercury as the precursor of triumph, proclaiming victory over darkness, was the unicorn.

"The moment for which every alchemist labored is illustrated in *The Book of Lambsprinck* (1625) by a picture which shows a deer and a unicorn meeting in a forest, with the text: 'In the forest (body) there is a soul (deer) and spirit (unicorn). . . . He that knows how to tame and master them by art, and couple them together, may justly be called a master, for we judge rightly that he has obtained golden flesh.' Another of the many symbols of Mercury as androgynous god and precursor to triumph was the green lion wounded on the lap of the virgin. Because both were figures for Mercury, green lion and unicorn were often considered one, and certainly the image echoes with familiar resonances for those acquainted with the legend of the 'virgin capture.'

"So we come to the end of the information that I have been able to gather until now, 1836, on the unicorn in myth and legend. If these numerous fantasies—the saccharine or putrid fruit of imaginations of persons who had never seen a real unicorn, those who needed an innocent symbol upon which to hang their own tortured religions and philosophies—were not enough, now I understand that there is a scientist—at least he calls himself that— in France, a certain Baron Cuvier, who has announced that the unicorn does not exist because 'beasts with cloven hooves have cloven skulls, and

no horn could grow in a cleft.' Tell that to your parlor crowds of snuff-sniffing ninnies, my dear Baron, but don't waste your words on the likes of me, who have spent more than half a lifetime studying animals of flesh and blood, not of printer's ink and paper in some stuffy university library, or made of cynical dreams from the acid minds of skeptics over a bottle of red juice in a Paris café. No. My unicorns are living animals observed under the sun or illuminated by the moon in places that the soles of your dainty slippers will never tread: Siberia, Mexico, Canada, Africa, Arabia, and Nepal.''

And with those words, Rudolf O. Springer terminated the chapter in his journal on the history of unicorn legends.

Page 9 This peacock, practically hidden in deep foliage, had just screamed to warn a unicorn of my presence in a forest of southern Nepal. In a similar setting on the other side of the world, in Mexico, I first came face-to-face with the protagonist of this book. The story of that encounter, and the events leading to it, are related here:

With the passage of time in Seville, I again began to wonder: What unicorn? Economically, I had no choice but to stay there and finish the work at hand. While Springer's notes on unicorn life were explicit, he didn't pinpoint—most certainly on purpose—the exact locations of his field work. In his chapter on unicorns of the forest, for example, he simply stated that studies were done in Central Mexico, China, southern Nepal, in the Oregon Territory, in the Black Forest of Germany, in England's New Forest, in the Pyrenees, and in certain forests of Sweden, Holland, and Austria. Work on unicorns of the Mountains of the Sun was done in Abyssinia, Persia, Egypt, and the New Mexico Territory. Snow unicorns, he wrote, were observed in Norway, Japan, Siberia, Tibet, northern Italy, Switzerland, Africa, and somewhere on the Canada-Maine border. And while he did mention the Sudan, Australia, and Syria as countries where dune unicorns had been studied, there was absolutely no clue as to where observations had been made in the ocean (except the Sargasso Sea) or among flowers.

While a week seldom passed that I didn't reread Rudolf Springer's journal until I almost knew it by heart, I seemed no closer to seeing my first unicorn than I had been after meeting Miss Veronica Tudor-Williams. Nor for almost ten years—with the exception of several days spent taking

Unicornus deserti smocking dates from oasis palm.

136

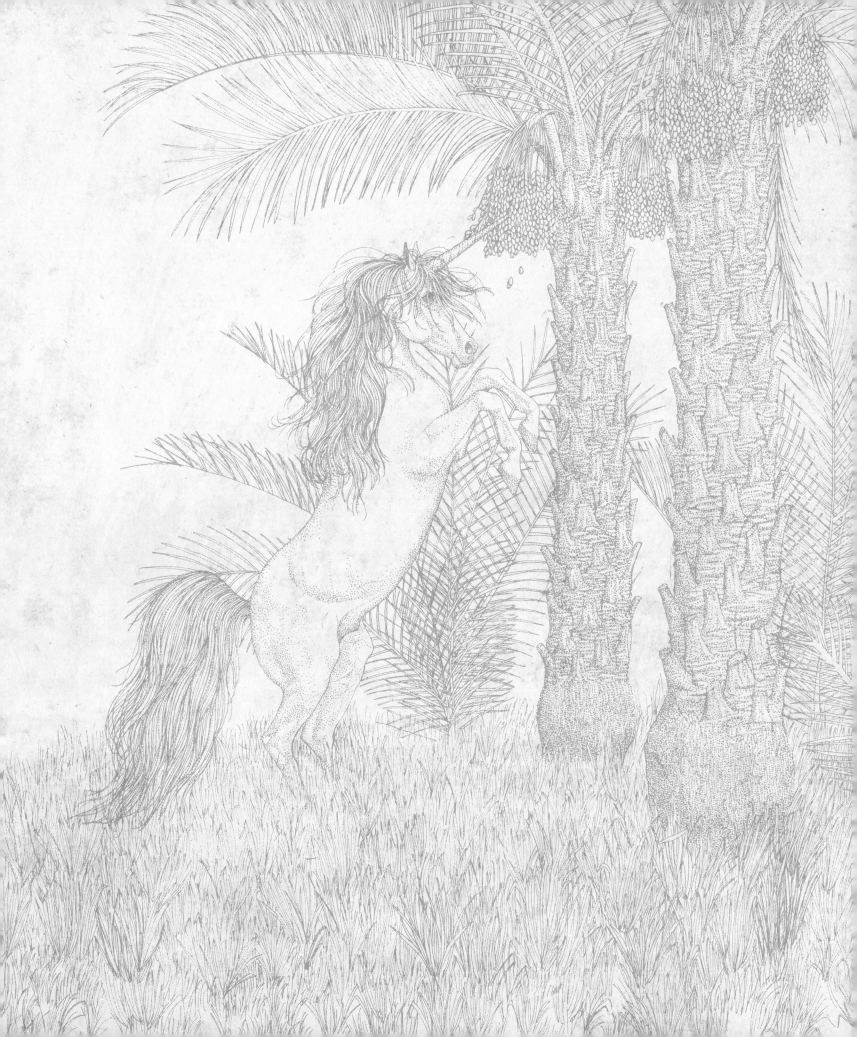

pictures for the James A. Michener book *Iberia* at the foot of the Pyrenees—did I find myself near any area mentioned by Springer as a site of his observations. Even if I could afford to travel to the places he mentioned, I wondered how one went about finding a unicorn. The jungles of Central Mexico and Germany's Black Forest were immense.

While Springer did go into specific detail about unicorn behavior, such as courtship and feeding, he did not indicate how man should behave in order to encounter his subject, except to mention that the unicorn behavioralist should absolutely not wear any kind of leather product or have on his person objects crafted from the bodies of dead animals. He also noted that perfumes and colognes, while pleasant to human nostrils, are highly offensive to unicorns. "The unicorn is a creature of nature," he wrote, "and, thus, only that which is natural appeals to it."

Finally, in the spring of 1966, I did find myself in unicorn country—Central Mexico—quite possibly near where Rudolf O. Springer or Bernal Díaz del Castillo had seen "a white animal the size of our horse, with a double mane that falls practically to the knees and from whose forehead extends a horn some three palms in length." However, on this occasion it wouldn't be the unicorn that I would encounter, but another creature whose description had fascinated me for years.

Early one evening I was driving along the old Pan American Highway near Tamazunchale when suddenly, as darkness fell, pinpoints of light began to appear among the vegetation on either side of the road. When I stopped the car, got out, and stepped into the night, it seemed as though the heavens had joyfully cast every star in the sky into that Mexican forest, each shining and twinkling slowly along its erratic course to illuminate the creepers and moss that hung from an apparently endless canopy of treetops. It was, indeed, the loveliest sight upon which my eyes had ever feasted. Under that tropical roof that shut out the moon, parrots squabbled going to roost, an owl hooted, and somewhere far away, but close enough to be heard, a jaguar called, while all around me insects fiddled and strummed, and the fireflies pirouetted in the night.

The honking of a car horn pulled me from the seductive setting of that rain forest. Eagle Pass was a long way off, and my driving companion had become restless and was summoning me back to the human world. Retracing my steps through the damp overgrowth, I vowed to return to this jungle paradise as soon as I could, not only to see the fireflies, or because Tamazunchale is one of the world's prime bird-watching spots, but because some strange feeling inside of me attested that at that moment, for the first time in my life, I was actually close to a live unicorn.

Months later, when I was back in Seville rereading Rudolf Springer's journal, this premonition was strengthened: While I had not seen a unicorn in Mexico, I had observed dozens of brilliant emerald beetles and the metallic blue Morpho butterflies that both Bernal Díaz del Castillo and Springer describe as inhabiting the rain forests where unicorns are found.

My depressed economic situation anchored me to Seville for another two years, and it was not until 1968 that I again set out for Mexico and what I hoped (nine years after my introduction to the unicorn by Veronica Tudor-Williams) would be a face-to-face encounter in the wild. By this time, I had also traded the awkward 2¼ × 2¼-format camera that I had first taken to Spain for a 35 mm Nikon, which, being smaller and carrying three times as many exposures, was more versatile and practical for wildlife photography.

In my absence, the jungles around Tamazunchale had been little changed by civilization; if anything, they were lovelier than I had remembered them. With the intent of seeking out any kind of clue that might lead me to the object of my quest, I allowed myself ten days for exploring the area.

The mist was still on the ground early that first morning when, with camera equipment and lunch in my backpack, I hiked along the highway, trying to put some distance between me and Tamazunchale before cutting into the bordering forest which was as close to Eden as anything I could imagine. Following a deer trail that led into the jungle itself, I found myself alone in a world as primitive as it might have been eons ago. At almost every step there was some new distraction to delight eyes, ears, nostrils. It took effort to remind myself to mark the trail with pieces of red yarn, which I tied to the shrubbery at fifty-yard intervals.

Late in the afternoon, at the edge of a clearing I squatted, hunched over, watching a metallic green beetle as large as a walnut meander across the trail. Suddenly, in the trees overhead the grackles stopped chattering. Just as I raised my head, an Indian appeared among a patch of low ferns some

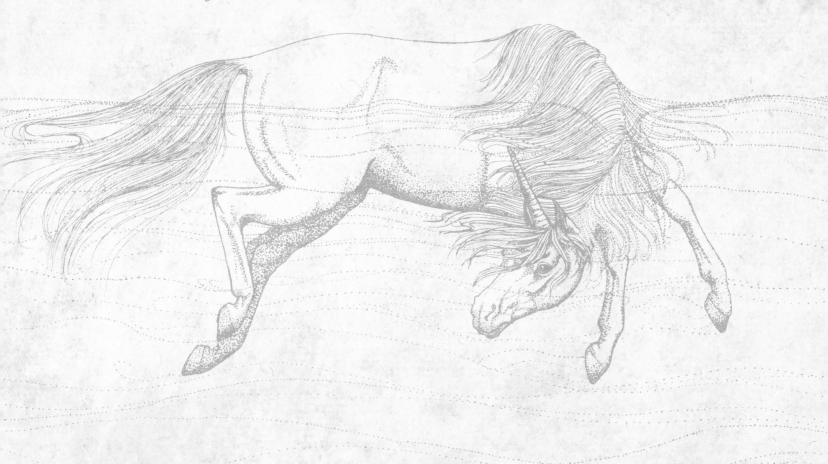

Unicornius marinus searching for sea lions off the coast of Southern California.

fifty feet away. In his hand he held a slim branch upon which was perched a lovely creature that resembled a hummingbird.

"*Buenas tardes,*" the Indian greeted me, in a voice so soft and melodious it almost could have come from his feathered companion.

"*Buenas tardes,*" I answered. "What sort of bird is that?" Now I could see that the creature's feet were glued fast to the stick with some sort of white substance.

"A *chupa rosita*—a rose sucker," said the Indian with a smile.

"How did you catch it?" Though the answer to my question was obvious, I wanted to make conversation.

"I put this white paste on a branch where I see the bird every day. He comes back to it. Lands. And sticks there. Now he's mine."

"Do you also trap animals?"

"Yes." The Indian smiled, looking toward a stream that tinkled and glistened between the ferns on the far side of the clearing.

"Are there large animals in this forest?" I asked.

"*El tigre*—the jaguar."

"Anything larger?"

"Nothing larger," he answered. "There are monkeys, but not many of them, and they are hard to see."

I then took off the backpack, and while the small bird fluttered pathetically and the Indian hunter stared curiously, I withdrew and unfolded a photocopy of one of the drawings from Rudolf Springer's journal.

"Have you ever seen this?" I held up the picture of the unicorn.

For a moment the Indian gazed at it, then looked at the fluttering bird, turned, and dashed to the stream. I ran after him, leaving the opened backpack on the trail. The Indian had placed the branch in the water, just deep enough to wet the bird's feet and soften the paste that held it prisoner. Gently the brown fingers worked the white substance until it softened, and in seconds the *chupa rosita* was gone. 139

"Why did you do that?" I asked. "You could have sold that *chupa rosita* to me." (I had intended to buy the bird and, when the Indian had gone, release it.)

"Because . . . because now he is free, and so am I." The perspiration glistened on his forehead as he turned to go.

"And you've never seen this animal?" Again I held up the picture of the unicorn.

"It is that he has now seen me."

And before I could protest or plead, all that was left of the Indian was the breeze his passing raised in the parting ferns. The excitement I felt at that moment, I have felt few times in my life. The unicorn did exist! And in this forest!

Now the sun was so low that it no longer flashed like a school of golden fish through the leaves overhead. Before long, it would be impossible to retrace my steps, guided by the pieces of red yarn which, if they hadn't been removed by some bird, would lead me back to the paved road that wound through the mountains to Tamazunchale.

By the time I had calculated that the highway must be not more than half a mile away, the first fireflies had begun to sparkle about. I stopped walking, and though I knew the result would probably be negative, I gambled. Pulling a camera from the backpack, I loaded it with 400 ASA color film and prepared to shoot off a few frames of the fireflies.

No sooner had I focused the 105 mm lens on one of the insects which had lit on a nearby leaf than it took off again. I followed the firefly through the lens for maybe forty feet, until it appeared tiny in the viewfinder, rising above a stand of ferns to weave in and out of the dark leaves of a philodendron. Suddenly, in the viewfinder there was another flash of color.

Blue. Not shiny or as intense a blue as that of a Morpho butterfly.

Momentarily I lost both the firefly and the blue object. The lens searched the patches of darkness among the scalloped leaves.

Blue flashed again in the darkness of the camera. My hands shook.

Blue!

Sparkling, glistening, unblinking blue.

A sparkling, glistening blue eye! I took a breath and pressed my elbows into my ribs, trying to stabilize the trembling hands that held the camera. The eye was there. Large. Unblinking. Circled by light pink hair.

Slowly I lowered the camera from my face until I was staring at the patch of jungle before me. There was the eye. Above it, concealed here and there by the screen of leaves, was a slim object, over a foot in length, sparkling green in the darkness like a jeweled wand. I squinted, but it was too far away to be distinguishable. Again I slowly raised the camera, hoping that its short telephoto lens would magnify the object and reveal its identity. The eye was still there. So was the brilliant object above it. With all my concentration, I tried to steady the camera, took another deep breath and again pressed my elbows to my sides. There were beetles, dozens of them, emerald green, moving slowly along the . . . the . . . the horn.

The horn!

It *was* a horn above the blue eye! It was! At last! It was a unicorn!

Then my only thought became, *I must get a picture of it. If not, I'll be like the rest and no one will ever believe me.* Slowly I moved my hand to focus the lens, and as I did so, the unicorn blinked and expanded its nostrils, sucking the air with such force that I could hear him inhale. My trembling fingers had somehow opened the lens to its widest aperture and turned the shutter speed knob to 1/30 of a second, so that the light-meter needle was straight up. The camera was ready to fire. And just as my finger was about to press the shutter release, the marvelous creature in front of me turned and fled, but not before the Nikon curtain slid open to capture the blurry image that appears on page 5 of this book.

That night, back at the small hotel in Tamazunchale, I marveled in ecstasy at my discovery and, strangely enough, had no desire to share the news with any of the middle-aged American tourists, many of them bird watchers, who sat in the dining room thirsting for conversation with anyone who spoke English.

Later, in bed, I tried to determine what had caused the unicorn to take flight. Perhaps just my strangeness, or the white-man smell. Then I remembered page 17 of Springer's journal in which he mentioned odors—man-created scents. I turned on the light, got up, and went to my shaving kit. There was a stick underarm deodorant. I tossed it into the wastebasket. A can of scented shaving foam joined it, along with a tube of peppermint-flavored toothpaste (I could use table salt for my teeth). What else might there be that stood between me and the unicorn? My tennis shoes were rubber and plastic. Cloth socks, jeans, and shirt. A cloth belt. Cloth watchband. On the nightstand was a red and yellow plastic bottle—insect repellent. I glanced up at the mosquitoes circling the light bulb and then dropped the repellent into the wastebasket.

In the morning you will be ready, I told myself. And indeed, that thought proved to be true, as the final preparations were made for what would be the beginning of the greatest photographic adventure of my life.

Pages 10–11 The azure eyes that unicorns are born with, and which darken shortly after the age of twelve months, become blue again following the animal's one-thousandth birthday. The stag in this picture is approximately 1,200 years old. Note that the animal's skin seems to have a rose cast, which some observers attribute to magic but which, in truth, is the result of hair loss caused by advanced age. The pink is merely skin exposed and made more obvious by balding. This photograph was taken in the jungles near Tamazunchale, not far from where I saw my first unicorn.

Page 12 Middle-aged unicorns, like this stag (the same one shown on the previous page), were seldom observed in the dunes, sea, Mountains of the Sun, or flowers, but mostly in the dark silent places of the forest and, on three occasions, in the snow, which may indicate that their skin is sunsensitive. On the other hand, like humans who have passed the mid-life experience, these older stags and does may prefer the more staid and secluded life that the forest offers.

Pink and violet flowers were commonly seen in the forelocks and manes of blue-eyed stags, but

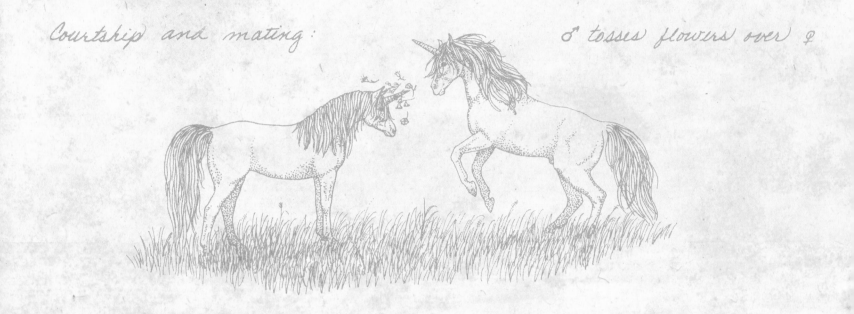

were rarely observed in the head and neck hair of dark-eyed younger animals, except during the spring forelock-, mane-, and tail-decorating contest (see pages 102–118). However, I never was able to determine exactly how the blossoms were fastened to the blue-eyed unicorns' hair or by whom. Once, through a telephoto lens, it appeared that some had been tied with hair and others affixed with spider webs, which would cause me to believe that this was partly the work of bee-eaters, who are often seen gliding with silver strands of web in their beaks.

This stag is uttering a low warning threat, not a very pleasant sound to human ears, and comparable to the grunt of the Arabian oryx. Having been charged numerous times by Spanish, French, and Mongolian stallions while doing my behavioral study on horses, I was surprised to find that stag unicorns do not utilize aggressive rushes to frighten intruders.

Pages 14–15 If a forest unicorn (*Unicornuus memorensis*) feels threatened by humans, he will either disappear or strike his horn against tree branches, as this young stag is doing on the slope of one of the Virunga volcanoes in Zaire (formerly the Congo). The sound, in its rapidity of rhythm and startling effect, can best be compared to the noise made by a small child clattering a stick at top speed along the pickets of a lengthy fence, below one's bedroom window at dawn of a Sunday morning.

It is this unicorn threat display, using branches, which undoubtedly gave rise to the myth that the creature could be killed by lions or captured by humans if he could be tricked into charging. Once the unicorn had attacked, the enemy would at the last minute jump aside to escape being pierced by the horn, which would spike into a tree and remain stuck there, leaving the stag or doe defenseless.

Vincent Le Blanc, who in 1567 embarked on travels that took him to the Orient, wrote of the unicorn: "That there are still persons who doubt whether this animal is to be found anywhere in the world, I am well aware; but, in addition to my own observations, there are several serious persons who bear witness to its existence." A Brahmin told Le Blanc that he had watched the capture of a very old unicorn, which fought so fiercely that it not only wounded the king's nephew but broke off its horn on the branch of a tree before it could be captured and taken to a palace, where, gravely wounded, it died a few days later.

Shakespeare refers to this legend in *The Rape of Lucrece*, and in *Julius Caesar* when Decius Brutus remarks that Caesar "loves to hear that unicorns may be betray'd with trees."

Numerous European authors indicate that this method of capturing unicorns was first related in "a letter written in Hebrew by the King of Abyssinia to the Pope of Rome." Expert on unicorn lore Odell Shepard says that this seems at first a rather obscure reference, and one has not much hope of discovering the source. A text written in Latin appears to have been the inspiration for all of the later European versions. Edward Topsell, in 1607, tells us:

". . . as ever a Lion seeth a Unicorn, he runneth to a tree for succour, that so when the Unicorn maketh force at him, he may not only avoid his horn but also destroy him; for the Unicorn, in the swiftness of his course, runneth against a tree, wherein his sharp horn sticketh fast." Even in *Grimm's Fairy Tales* a humble tailor wins the hand of a princess by capturing a unicorn, nimbly stepping aside when it charges at him and plunges its horn fast into a tree.

Obviously, somewhere in time a wide-eyed human caught a fleeting glimpse of a unicorn involved in threat display, banging his horn between two thick tree limbs, which, from the angle of observation, might have given the impression that the beast had stuck his horn into a single branch and was trying unsuccessfully to withdraw it. Thus evolved the unicorn-tree legend.

Page 16 Having failed to frighten an unfamiliar human observer, this adolescent stag (280 years old) continues to clatter its horn against the branches. (Note double mane, which here can be clearly seen.) In such a situation, the unicorn will manifest its feelings by reacting in one of three ways: (1) striking its horn against branches with the hope that the surprise effect will be enough to cause the usually terrified human to panic and run off, leaving behind a trail of broken branches and bent grass; (2) vanishing—that is, disappearing on the instant, if the human either is not scared off or is armed; or (3) in a play tactic, fleeing zigzag through the forest in a unicorn game of hunt and chase, which most *Homo sapiens* take very seriously.

On the right cheek of this adolescent stag may be seen a boil or large pimple caused by a diet high in sweets. Young unicorns are extremely fond of wild honey and the sap from certain vines and trees (i.e., maple syrup) and often overindulge in either or both.

Page 17 Photographed near Sault Sainte Marie, Michigan, this young stag, having decided that the human does not mean threat, dashes off, hoping to instigate a game that will eventually leave its pursuer hopelessly lost.

The unicorn's secret of survival lies partly in its extraordinary sensory perception. The horn contains a kind of complex sonar system (not surprising, since other mammals, such as bats and whales, use sonar) which perceives a potential threat before it can approach close enough to be genuinely dangerous. It is also apparent that the unicorn's ability to vanish depends on the capacity of its sonar system to detect danger. If the threat warning is not picked up by horn sonar and allowed to reach the ears, eyes, or nose, the stress engendered in these normal sensory systems short-circuits the sonar and renders it functionless, which in turn nullifies the unicorn's ability to vanish.

Page 18 The unicorn leaping through these English woods (not more than an hour from the center of London) is traveling the same quarter-mile beat that he seemed to run almost every day at a clocked speed of eighty-four miles per hour. The time, while counted over a natural course strewn with obstacles, is more than forty-one miles faster than a horse can gallop on the straight, and fourteen miles more rapid than the sprint of a cheetah, which until now was believed to be the fastest of land animals. The speediest of antelope (pronghorn, gazelle, springbok, and wildebeest) have been

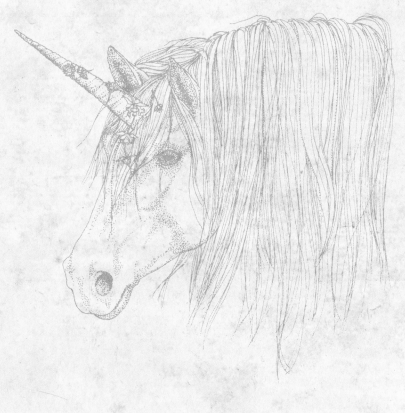

If doe is in estrus, petals stick to horn honey.

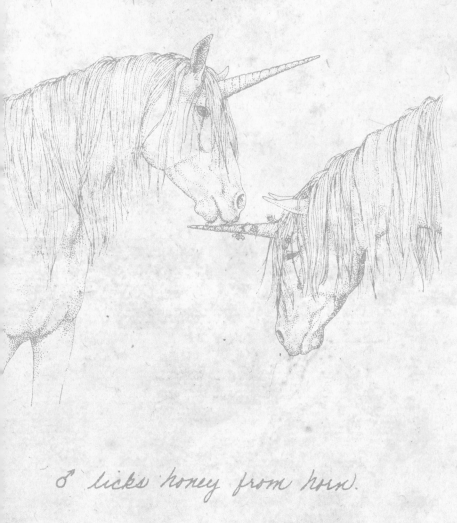

♂ licks honey from horn.

Page 19 When one studies this photograph, which illustrates this stag's jumping ability and speed, one might find it worthwhile to investigate the reasons for these extraordinary attributes. We should well remember that the unicorn has been the most desired and sought-after trophy since the moment the first *Homo sapiens* fashioned crude knives, arrows, and spears. Perhaps at that time the evolutionary process had not advanced the unicorns' horn-sensory device to its present perfection and the creatures were not yet able to vanish. Maybe thousands of years ago they had to rely on their muscles for escape. The unicorn may thus have been forced to improve its speed and jumping capabilities as a survival measure.

Not only has the unicorn been hunted because it was, and is, the rarest of animals, or for man's apparent need to kill beauty, or for its priceless horn, but also because other parts of its body were highly valued for medicinal use. Sometime in the twelfth century, Saint Hildegard of Bingen wrote:

"Take some unicorn liver, grind it up and mash with egg yolk to make an ointment. Every type of leprosy is healed, if treated frequently with this ointment, unless the patient is destined to die or God intends not to aid him. For the liver of that animal has a good, pure warmth and the yolk is the most precious part of the egg and like a salve. Leprosy, however, comes frequently from black bile and from plethoric black blood. Take some unicorn pelt. From it, cut a belt and gird it around the body, thus averting attack by plague or fever. Make also some shoes from unicorn leather and wear them, thus assuring ever healthy feet, thighs and joints, nor will the plague ever attack those limbs. Apart from that, nothing else of the unicorn is to be used medically."

With this cure, offered for what at that time was the world's most dreaded disease, unicorn harassment must have been at its zenith. When the Apothecaries Society of London was founded, in 1617, to support its coat of arms it chose a pair of unicorns, and it was not until 1746 that official recognition of the unicorn as an effective source of medication was withdrawn in England. Certainly there were witnesses to the unicorn's disappearing ability, and surely it was this so-called magic that caused man to assume that parts of the creature's "magical" body could summon up miracles. In truth, the unicorn's disappearing maneuver is no more magic than that performed by the gentleman in the circus

timed at between fifty and sixty miles per hour, which is more than twice as fast as man can run (twenty-five miles per hour).

Another record held by the unicorn (determined from hoof prints measured by my brother Ronald, who is a track coach at Grossmont College and also a naturalist) is that for the animal high jump. A stag that we studied in Oregon was more than once seen clearing a fallen big-cone spruce that was supported at the trunk by a boulder and at its tip by the forked limbs of an oak. This tree, which provided a natural jump, cleared the ground by eighteen feet. Until our discovery, the kangaroo had held the high-jump record at ten feet six inches, trailed closely by both the impala and Thomson's gazelle at ten feet. The long-jump record is held by the kangaroo with a forty-two-foot bound, previously followed by the Thomson's gazelle (thirty feet) and the impala (twenty-five feet). Measurement taken of the Oregon unicorn's jumps, from the point he pushed off with his back hooves to where his front hooves touched, testified that he sailed over the grass in forty-foot leaps.

who pulls doves from a hat or the Las Vegas showman who succeeds in vanishing an elephant or tiger before our "very eyes." The secret to the disappearing unicorn is little more complex than that of the pea that vanishes from under the walnut shell. Often the simplest riddles are the most difficult to solve.

Page 20 There are numerous references to the unicorn's horn as "luminous," "brilliant," "shining," "iridescent," "glowing"—descriptions that I at one time foolishly assessed as products of overactive imagination. However, when I saw my first doe in Mexico, before I could determine exactly what it was, my eyes told me that above its head was a "wand" that appeared to be glittering with emeralds. I should have known better, having already read in Springer's journal that, during the spring, doe unicorns' horns exude a honeylike substance that attracts not only stags but also beetles. Springer commented that, depending on the geographical area of his study, he observed does' horns that appeared to be covered with rubies, black diamonds, sapphires, gold, or emeralds, depending upon the indigenous insects.

The photograph on page 20 is unusual in that a mixture of insects, instead of a single type of beetle, crawls this dozing doe's horn. The bugs did not seem to bother their hostess unless they accidentally crawled or flew too close to her eyes, and then the doe would shake her head in much the manner of a horse shooing flies.

In this photograph, we may see that the length of the horn, scaled against the size of the beetles, is approximately fifteen inches long (average for a doe; stag horns can be three to four inches longer), a measurement that contrasts quite drastically with some of those recorded in the past. Ctesias gives the length of the horn as one cubit, or eighteen inches; Aelian, as a cubit and a half; Pliny, as two cubits; Solinus and Isidore of Seville, as four feet; Girolamo Cardano, as three cubits; Rabelais, as six or seven feet; and Albertus Magnus, as ten feet. Odell Shepard tells us:

"At this point, the growth of the horn was checked, for the animal that bore it was obviously becoming top-heavy and needed, as several skeptics pointed out, to be as big as a ship merely to carry such a formidable bowsprit. Arabian writers showed less restraint, for al-Damîrî, among others, asserts that the unicorn, for all its great strength, is unable to lift its head because of the great weight of its horn. Other Arabian authorities inform us that he often carries about on this horn the bodies of several elephants which he has 'perforated.' Although the spoils went to the victor in these contests, they were frequently—as in human affairs—quite as lethal as defeat, for Alkazuwin says that when once the unicorn has gored the elephant, he is unable to remove the corpse from his horn, so that he either starves or dies of the putrefaction. (Here was material for a powerful pacifistic allegory, if the Arabs had been given to such things.)"

While the horns observed by me and described by Springer did vary in tone and texture, depending on the age and habitat of the animal studied, they generally were much the same in appearance as the one in the photograph.

Page 21 This photograph, taken in the Cooch Behar forest, is almost as unusual as the preceding one, for it is rare to encounter more than two male peafowl clustered as closely together as are these seven. However, in the jungles of Asia, the peacock is to the unicorn what pilot fish are to the ocean's great sharks, what the cattle egret is to the elephant, and what the tickbird is to the rhinoceros. Like the

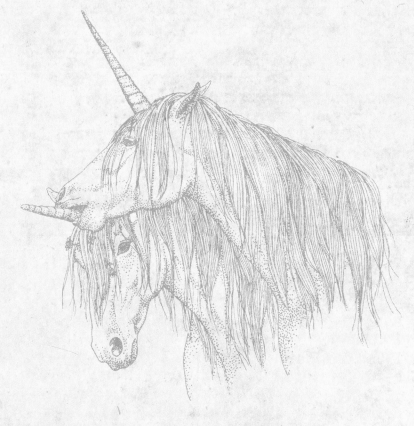

smaller member of these other "odd couples," the peacock is practically inseparable from its partner. Strangely, neither Springer nor I observed a peahen within a hundred yards of a unicorn. Escorts of male peafowl always accompanied forest does and stags. One stag in India's Corbett National Park had an entourage of sixty-seven of these splendid birds. However, the average peacock-to-unicorn ratio is about six to one.

To explore this relationship under controlled conditions, my brother and I took a pair of peafowl to Volcan Mountain in southern California, where we had studied a forest stag who, after many hours, would allow us to observe him from a distance of about thirty yards. Upon locating this animal, we first removed the peahen from its gunnysack and released her in the direction of the unicorn. The bird ran into the clearing, stopped when it saw the stag, honked twice and then, after a few fast steps, sprang into the air, opened its wings, and sailed out of sight into a stand of incense cedars, never to be seen again—except for some of her green feathers, which a week later were encountered alongside a gray twist of coyote excrement.

When we released the male he also dashed into the clearing, to find himself face-to-face with the unicorn. The peacock stood for several seconds as if hypnotized, staring at the animal. It must be remembered that this was a pen-raised bird who was probably fifty or more generations away from the jungles of Asia and his natural instincts. The peacock took several steps toward the stag, screamed four times, and raised his tail, the feathers of which vibrated so that from a considerable distance we could hear them rattling. Tail fanned to its full spread, the bird stiff-stepped around the unicorn in the nuptial display so characteristic of its species, pausing now and then to shake the white quills of its plumes.

While the unicorn had been attentive to the displaying bird and the dozens of feather eyes that shimmered at him in the afternoon sunlight, he finally lowered his head and, with his pink lips, daintily started plucking wild strawberries. At this point the peafowl folded his tail and began also to eat the tart red fruit, as well as silver-winged insects that were shying up from the unicorn's hooves.

That was four years ago, and not too many months have passed since Ron wrote to tell me that he had recently by chance encountered the same peacock perched on an oak limb, under which the unicorn was resting, on Mount Palomar, which is twenty miles west of Volcan Mountain.

The mystery of the peacock-unicorn relationship I cannot logically unravel—that is, if there is anything at all to unravel.

Pages 22–23 This stag, escorted by three peacocks—two with spread tails, and one of which (on the left) is calling—was photographed in a jungle in southeastern India. This was the only time (except during the spring flower-decorating contest) that I would see a dark-eyed forest stag with blossoms in his forelock and mane. Scenes like this, though they were common during hours of unicorn observation, never failed to strike me as literally breathtaking in their beauty. James Huneker so perceptively writes: "The enchanting unicorn boasts no favored zone. He runs around the globe. He is of all ages and climes. He knows that fantastic land of Gautier, which contains all the divine landscapes ever painted."

Page 24 The unicorn mating call cannot be compared to the amorous beckonings that roll or rumble from the throats of most hooved and horned herbivores. As this photograph shows, the stag does lift his head, assuming the attitude of a bellowing bull elk; however, his call is more like a low A played in unison by a cornet, oboe, and mellophone, lasting maybe twenty seconds before sliding up to a higher A, at which time it is broken in three or four (never more) short bursts, the duration of each being not more than three seconds. The 846-year-old stag that lifts his head here was photographed in Germany's Black Forest.

Page 25 Surprisingly enough, this stag and doe were photographed in a forest not far from Sault Sainte Marie, Michigan, the site of the world's only organized annual unicorn hunt, which is usually held sometime in the fall.

However, since the participants in this affair exercise none of the precautions essential to catching even a fleeting glimpse of white among the trees, there is little danger to the Michigan unicorns, who treat the hunt as lightly as do the humans.

Springer, taking into account his limited opportunity of observation, could only assume that at

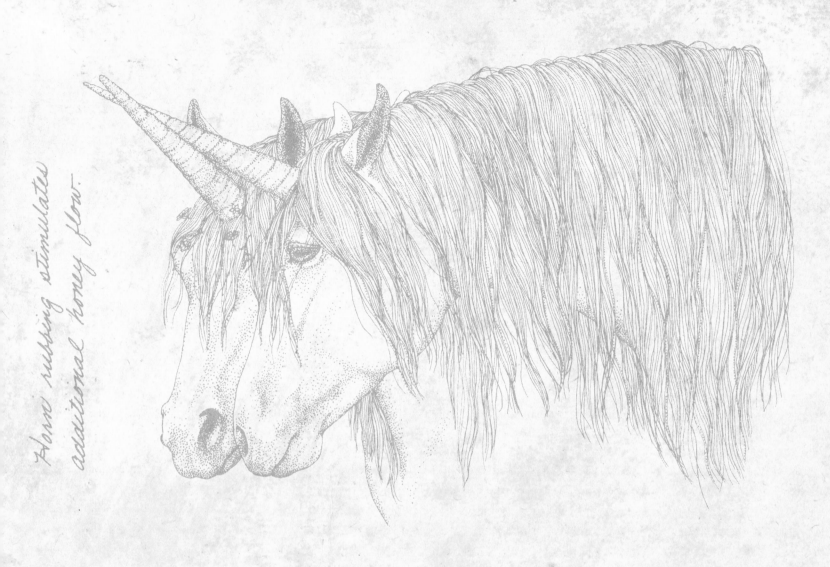

Horn rubbing stimulates additional honey flow.

the age of two to three hundred years forest stags are mature enough for mating, while the does seem slower to develop. The extremely small unicorn population would indicate that forest stags and does probably do not mate more than once every fifty years, the doe's gestation period being three years, four months, and two weeks to twenty days. Birth seems to take place on the first dark (moonless) night after the 1,229th day of pregnancy.

While the human observer is allowed to watch unicorn courtship, actual mating always occurs in thick vegetation or, if in the snow, dunes or sea, in the black of night. The rituals I have witnessed were always the same. The stag would be attracted to the doe by the perfume of her horn honey, a thick syrupy liquid that exudes from the horn during estrus. Once a stag locates the doe, to confirm her state of receptiveness he tears a clump of flowers from the earth (often roots included) and tosses the plant, or plants, into the air, usually with a backward, then frontward, horn flip, executed with such force that

petals are shaken from the blossoms. If the doe is at the peak of estrus, the honey is thick and the drifting petals adhere to it.

The stag then moves closer and tenderly begins to lick the horn which the doe has lowered, her eyes half closed in submission. The taste of the honey is so exciting to certain stags that they grip the horn in their mouths. Once the existing honey has been removed, most stags will rub their own horn against the doe's to stimulate more honey flow. Though I have often smelled the honey when stalking a doe (the odor is similar to that of carnival cotton candy), I have only tasted it once (from a honey-smeared leaf), and disappointingly, it had no flavor to my tongue.

The stag then moves to the doe's side and lightly begins rubbing his horn from her shoulder to her flank in a caress that reminds me of one human drawing his or her finger down another's back; and, judging from the expression on does' faces, it elicits a similarly pleasant sensation. It is at this moment 147

that both animals glance at the human observer and move off into a section of the forest where vegetation is densest, especially the sort of growth, such as blackberries, that is covered with torturous thorns.

On a number of occasions I was able to observe horn tips during lovemaking, which lasted for as long as five hours. Mating continues, with one- to two-hour rest intervals, for about ten days. During this time the doe and stag feed exclusively on the leaves of wild mint and on rose hips, passing the majority of their relaxed moments cooling off in secluded streams or in a pond, but only if it is fed by fast-running cold water. During lovemaking, unicorns were never seen bathing in still ponds or lakes.

Page 27 The young doe in this photograph is just over three years in fawn. During the last months of gestation, does generally adopt somewhat unusual behavior. Some acquire a sudden urge to eat mushrooms, a plant that most unicorns avoid—in fact, stags have a strict aversion to them. This doe's pregnancy fetish was manifested by rolling in the charcoal left by a burnt tree (notice her tail is still dirtied gray), after which she bathed in a river near Victoria Falls in Central Africa. Explorer David Livingstone, who believed in unicorns, may have seen one not far from where this photograph was taken.

Page 28 On the night of the last full moon before the birth of a fawn unicorn, the stag, or stags, of that forest are transformed from generally mild-mannered creatures to animals that seem caught up in a frenzy—rushing, leaping, and rearing about. To see such a stag as the one pictured here in full display is to see an animal that, in movement and physical appearance, is without equal in beauty. It also causes one to wonder, as did Odell Shepard, "How could anyone mistake the nose-horned beast of India, lumpish and gross and mud-wallowing, for the delicate unicorn?"

Page 29 In Spain's Doñana National Park, cattle egrets, great white herons, spoonbills, gray herons, purple herons, and night herons roost and nest in the branches of a cork oak, under which a stag was about to commence the pre-birth celebration

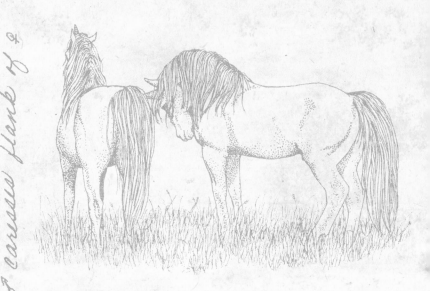

With horn tip ♂ caressed flank ♀

display. Unicorns are almost nonexistent in southern Spain, an area whose human population until recently was entirely hostile to wild creatures, and where there was little concern for nature and conservation. The stag that was about to perform under this tree was one of only three unicorns that I have observed during my half a lifetime in Andalusia. On the other hand, on a number of occasions James A. Michener and I have observed these rare creatures moving about in the mists of a Pyrenees forest near Roncesvalles.

Page 30 Springer reported that while he never witnessed the actual birth of a unicorn—the does always conceal themselves in heavy undergrowth—he was able to observe numerous fawns and their mothers seconds later. My experience has been similar. Unicorn births always take place at the moment of daybreak.

This photograph was shot in a German forest, possibly not far from where a unicorn was reported to have been seen by a man with one of the keenest minds in history: Julius Caesar.

I had been following a pregnant doe for weeks when, finally, the moon waned and at last the completely black night arrived that heralded the birth. All through the darkness I sat shivering, close enough to the doe that I could hear her breathing. On the other side of the glade a stag unicorn waited. At last, with the sun, rose the stag's horn and call, celebrating the arrival of the fawn that lay white and wet at its mother's side in a thicket of blackberries.

The attitude of the stag in this photograph is similar to that of unicorns seen on royal crests and coats of arms. Odell Shepard tells us:

"The unicorn of heraldry was devised by men who had rather more confided in the classic writers of antiquity than they had in the Bestiaries, and, therefore, their animal has more of the horse than of the goat in his composition; yet the prominent position of the unicorn in heraldry is primarily due, of course, to the moral attributes that he acquired from the *Physiologus* tradition. Primarily, but not entirely. Several streams of influence converged to make him the chief emblem of purity: the identification of Christ and association with the Virgin first of all, but, in addition, the water-conning (purifying) trait and the world-wide reputation of the horn as a drug and magical prophylactic. Considering that chastity was one of the foremost chivalric virtues, we are not surprised to find the unicorn figured on many knightly seals and coats of arms.

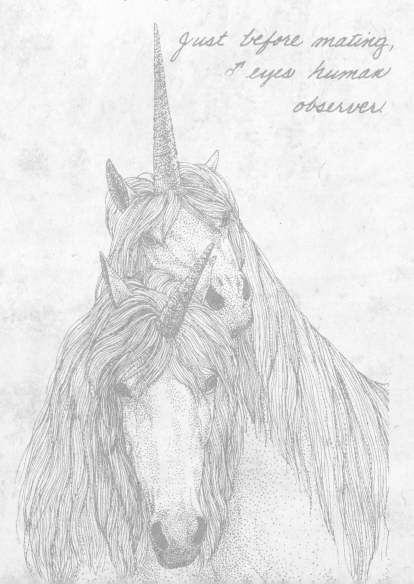

Just before mating, eyes human observer.

There was something essentially aristocratic about him. His kinship to the horse, always associated with knighthood, was suggestive, but more important was the headlong enthusiasm of his devotion to beautiful women. He was fierce and proud and dangerous to his foes, as a knight should be, and he was also gentle; he had the dignity of solitude; he was beautiful and strong; most significant of all, he was a protector and champion of other beasts against the wiles of their enemies. In all the range of animal lore, there is no other story conceived so completely in the aristocratic spirit as that of the unicorn stepping down to the poisoned water, while the other beasts wait patiently for his coming, and making it safe for them by dipping his magic horn. Here was a perfect emblem of the ideal that European chivalry held before itself in its great periods—the ideal according to which exceptional power and privilege were balanced and justified by exceptional responsibility. The lion, for all the heroic courage falsely attributed to him, the panther with his sweet breath, the bear with his mighty strength, had no such chivalric significance as the unicorn, which might almost seem to have been imagined precisely to serve as an emblem of the 'verray parfit gentil knyght.'"

Pages 32–33 Unicorn fawns are born without horns. At the spot from which the horn will sprout, directly in the center of the forehead, is a hard wax-like substance about the size of a half dollar. Once a fawn has slid from a doe and she has finished cleaning him, she turns her attention to his forehead. Most fawns seem actually to push their foreheads toward their mother and against her tongue as she licks, which would cause one to believe that the area under the seal must itch, an annoyance that will lessen once the wax has been removed and the horn is allowed to sprout.

When the wax seal—which Springer likens to a marigold pressed in paraffin—is gone, the horn can literally be seen to grow before one's eyes. Since there was no way this growth could be estimated except by the eye and from a distance, my figures may not be exact, but they do coincide within one half to three quarters of an inch with those offered by Springer.

Ten minutes after the removal of the wax seal, the horn has sprouted to about one inch from the

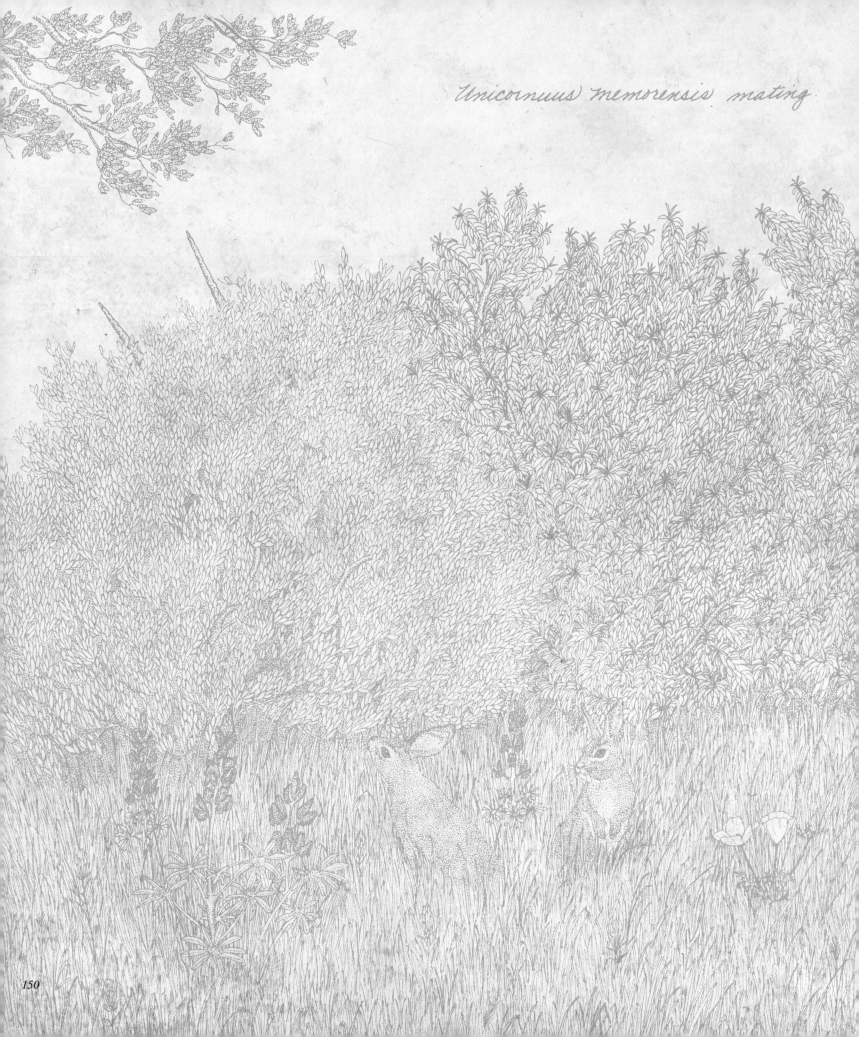

Unicornuus memorensis mating.

150

forehead. Twenty minutes after birth, it is one and a half to two inches long, and when the fawn is half an hour old, the horn is roughly three inches in length. Growth then slows considerably, so that a week-old fawn will have a horn that is four inches long. At one month the horn will be about six inches in length. The yearling horn is eight inches long, and from then on it grows roughly one inch every fifty years until it reaches its maximum length of eighteen inches, when the unicorn is five hundred years old.

The doe and ten-day-old fawn in this picture were photographed in northern Australia.

Pages 34–35 In this picture, taken in upper New York State, we see most clearly a fawn's beard, the fleeting glimpse of which in some forest hundreds of years ago laid the foundation for what was to become one of the greatest of unicorn misconceptions—that of the caprine unicorn, which, as we have been told, sprang from the *Physiologus*. Seeing this week-old fawn, one can naturally understand how, at some time in history, a surprised person saw such a creature and gave rise to the legend of the mythological unicorn with beard, cloven hooves, and the often offensive goatlike appearance that contrasted markedly with the noble equine beast described by Ctesias, Aelian, and Pliny. Even Aristotle reported that unicorns have solid hooves, which can be substantiated by the many photographs in this book.

The fine, relatively long beard sported by the fawn in this photograph will be shed by the time he is a year old, at which moment his eyes (in the reversal process of that of the African gray parrot) will go from light to dark. Though he will not be completely weaned from his mother until he is fifty years old, the fawn has already begun to nibble at blackberries, as can be deduced from the stains on his muzzle.

Page 36 Unicorn fawns, as may be judged from this photograph, are some of the loveliest of baby animals, appearing more like stylized porcelain figurines than creatures of flesh and blood. With its rear hoof, this fawn is trying to scratch at its horn, which must, in this first sprint of rapid

development, be growing so fast that high concentrations of blood cause the skin around it to itch. Baby unicorns were constantly observed hoof-scratching their horns or rubbing them against willow shoots.

Page 37 The speed of this ten-day-old unicorn I would judge as comparable to that of a racehorse. If one is fortunate enough to see a baby unicorn, it will not be while he is galloping full out, a speed that reduces him to a mere blur of white among the green leaves of the forest.

Pages 38–39 Few visual experiences are as satisfying as watching fawns at play. These were photographed at the edge of a forest in southern France. The setting sun appears to hold a special attraction for young unicorns: They could frequently be seen running westbound, suddenly leaping toward the sun with the apparent expectation that their jump would carry them on and on into the sky. Young unicorns were rarely observed in play with members of their own sex. Almost always, as Springer corroborates, a pair of fawns—male and female—would be observed in these running, jumping, and rearing games.

Page 40 This fawn and doe were crossing a meadow at sunset. Forest unicorns spend daylight hours hidden in the deep woods, not venturing out into open areas until approaching darkness offers cover. Deer and rabbits are frequently blamed for crop damage that is more often the doing of unicorns, who relish apples, apricots, strawberries, and grapes, being particularly fond of kiwis. Certain blue-eyed stags are also extremely taken with avocados and rhubarb.

Pages 42–43 In his journal Rudolf Springer referred to the "Mountains of the Sun" as any area that had sun-red earth and was characterized by rough terrain and hornlike spires, such as those that appear, frosted with snow, in this photograph taken in Ethiopia. I encountered Mountains of the Sun inhabited by unicorns (*Unicornuus montium solis*) in Ethiopia, northern Arizona, central Colorado, Afghanistan, Egypt, Israel, and Jordan. These landscapes were Wagnerian in their immensity and in their dramatic and continually changing light and color. They are indeed a proper setting for the unicorn, and it was a challenge to scale such lofty spires, often at considerable physical risk, in order to capture these images on film.

Pages 44–45 The height of this rock formation in Arizona cannot be properly judged unless the reader is told that trees at the front of the base of this formation looked as tiny as the pines that can be seen behind and to the right of the unicorn's perch. From where these photographs were taken, the immensity of this particular geological structure was breathtaking, and the unicorn was practically lost, appearing no larger than a grain of sugar against the redness. These pictures were taken with a 300 mm and a 500 mm lens at a distance of half a mile from their subject. The late afternoon light plays on scenes like this to make them ever-changing (these photographs were taken only several minutes apart). The human observer is so enraptured by the beauty about him that at that moment he wishes never to leave the Mountains of the Sun. Rudolf O. Springer, in his final years, was an object of that magnetic force; only death could liberate him from the red spires that rise high over Ethiopia.

Page 46 While vegetation is sparse on the Mountains of the Sun, now and then one encounters greenery and a lovely pond or small lake, such as the one that shimmers in the background of this photograph taken in Ethiopia at an altitude of twenty thousand feet. The stag in this photograph was blue-eyed and alive before the birth of Jesus Christ. This sight causes one to wonder again with Odell Shepard: ". . . what is the connection between the rhinoceros and the unicorn . . . how is it possible to identify an animal of such delicacy and refinement as the unicorn's with the gross, grunting, slime-wallowing rhinoceros? One hesitates to think of him related to that beast, even in the way that the water-lily is related to the mud."

Page 49 A creature like this doe (photographed in Arizona's Mountains of the Sun) may well have changed the course of history. Ssanang Ssetsen, in *Geschichte der Ost-Mongolen und ihres Fürstenhauses* (St. Petersburg, 1829), tells us:

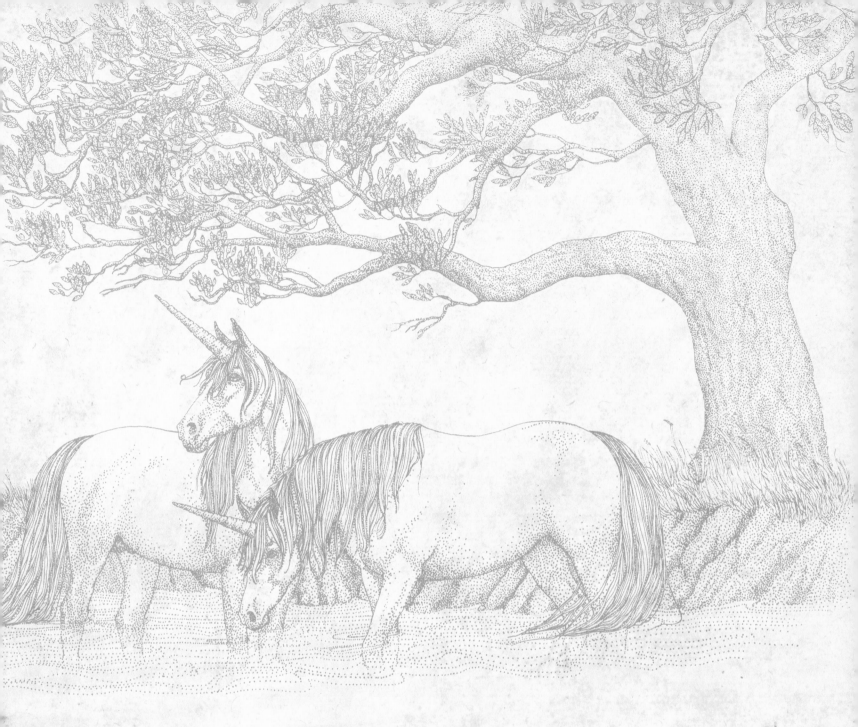

During mating season stag and doe remain together about ten days.

"In the year 1206, the conqueror Genghis Khan set out with a great host to invade India. His army had marched for many days and had climbed through many mountain passes, but just when he reached the crest of the divide and looked down over the country he intended to subjugate, there came running towards him a beast with a single horn, which bent the knee three times before him in token of reverence. And then, while all the host stood wondering, the Conqueror paused in his march and pondered. At last he said, 'This middle kingdom of India before us is the place, men say, in which the sublime Buddha and the Bodhistwas and many powerful princes of old time were born. What may it mean that this speechless wild animal bows before me like a man? Is it that the spirit of my father would send me a warning out of heaven?' With these words, he turned his army about and marched back again into his own land. India had been saved by a unicorn."

153

Pages 50–51 Without a doubt, the rarest photograph in this book is this one. During half a century of observation, Rudolf Springer never saw more than three unicorns together. It is extremely unusual to sight more than a single animal at one time. This photograph of a band of stags and does was taken on a high red plateau in Egypt. The purpose of their meeting remains unknown. Sleuthing through dozens of museums, libraries, churches, and private collections, I viewed literally hundreds of engravings, woodcuts, sculptures, paintings, mosaics, cast-metal figures, and tapestries, and among these I discovered only five works in which three or more unicorns were depicted: (1) Shortly before journeying from Spain to England to meet Veronica Tudor-Williams, I had visited the Prado Museum in Madrid almost every Sunday. There, apart from the Goya etchings, the work I found most fascinating was the Hieronymus Bosch (1450–1516) altar painting in which a number of strange unicornlike animals appear. (2) "Ladies and Unicorns," a painting by Gustave Moreau (1826–1898), contains three unicorns and is found in Paris in the Musée Gustave Moreau. (3) In the City of Antwerp Gallery of Copperplate Engravings is found a graphic by J. Collaert (1545–1622?), after J. van der Straet (1523–1605), titled "Unicorn Hunt in India," in which four unicorns (with solid hooves) are depicted. (4) In an engraving by Samuel Bochart dated 1663, London, five unicorns appear. (5) The most famous work by the American painter Arthur B. Davies is a 1906 canvas entitled "Unicorns," which, except for the incorporation of two human figures, is one of my favorite pieces of unicorn art. Obviously, Arthur B. Davies had seen the unicorn proper, a conclusion with which the reader will agree if he or she visits the New York Metropolitan Museum of Art, where this painting hangs, and compares its animals to those on pages 50–51. It occurs to me that certain honorable men, such as Davies, added fantasy (in this case, two women) to their renditions of a beast they had actually observed, motivated by the noble desire not to betray the true unicorn by revealing his existence in what would be widely viewed works of art.

Page 53 Before the advent of modern transportation, what stories must have been told by travel-weary men sitting around a campfire, drowsy, uncritical, pooling all they had heard and

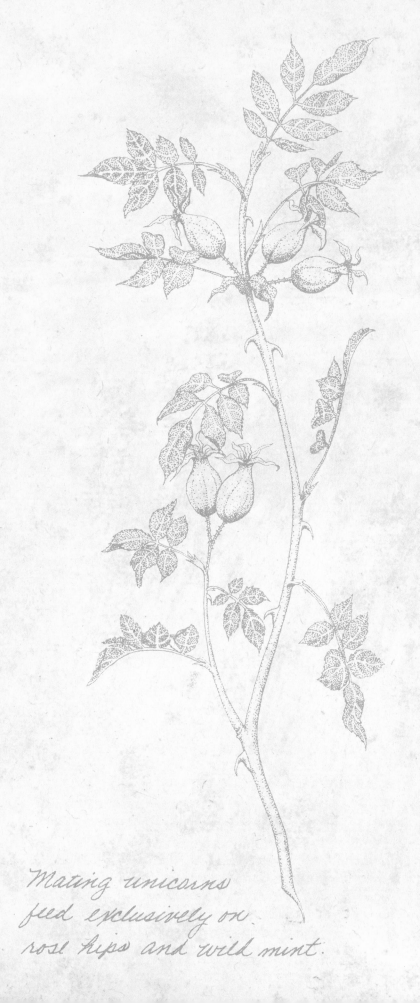

Mating unicorns feed exclusively on rose hips and wild mint.

seen. One might have tracked a rhinoceros at a distance of half a mile; another might have chased a dust-swirled herd of wild asses; another had caught a quick look at an oryx silhouetted against the moon; or, by even greater fortune, one of these adventurers may have seen a Medusa-headed unicorn rearing in defiance of the setting sun. It is then not strange at all that a multitude of unicorn myths, mixed with small doses of truth, found their way back to the castles of Europe and the palaces of the East, and that man's version of this creature became not one, but a mixture of several animals. Perhaps the finest example of this "unicorn stew" is served up by Rabelais: "I saw there two-and-thirty unicorns. They are a cursed sort of creature, much resembling a fine horse"—fortunately he got that straight—"unless it be that their heads are like a stag's, their feet like an elephant's, their tails like a wild boar's, and out of each of their foreheads sprouts a sharp black horn, some six or seven feet long." (Pliny, whom Rabelais uses as a point of reference, had the horn only three feet in length.) "Commonly it dangles down like a turkey-cock's comb; but when a unicorn has a mind to fight or put it to other use, what does he do but make it stand, and then it is as straight as an arrow." Springer, in reference to this text, simply noted in his journal, "No comment."

The rearing stag in this photograph was blue-eyed, approximately 1,800 years old, and patrolled a territory of roughly two hundred square miles in central Colorado which included the Garden of the Gods. *Unicornuus montium solis* seemed to exist on a diet of stone, as well as sage, rosemary, buckwheat, and wild lavender blossoms or similar plants, depending on the food supply in their particular habitat.

Page 55 This turbulent water was caused not by a tropical storm but by a unicorn submerging, shortly before sunset, twelve miles off the coast of Java. It is precisely at this time of day—that is, during the two hours before sunset—that most *Unicornuus marinus* were sighted. It should be clarified that the label *of the sea* is not intended to mean that these animals never appear on land. On the contrary, at least a quarter of their lives is spent out of water.

It may seem unnatural to some readers that a hoofed animal, such as this species of unicorn, so

enjoys the sea. However, we will do well to remember that it was once commonly believed that all cats despised the water, when in fact, studies have shown that both the tiger of India and the jaguar of America delight in taking long baths in tropical ponds and streams.

Page 57 These stags were photographed seventeen miles off the coast of Tierra del Fuego at the tip of South America.

If sea unicorns do not utilize their natural vanishing ability to avoid a human in a boat, they merely submerge, having the capacity to remain in the deep for as long as eight minutes before surfacing, which is a relatively short time when one remembers that the dive of a sperm whale can keep him below water for almost two hours before he has to come up for air. Although this information may seem more like fantasy than fact to a few readers, it should be remembered that many of the world's mammals—seals, manatees, walruses, and dolphins—are equally equipped to remain submerged for long periods. These creatures lack limbs and appear more like fish than mammals, but we could cite the "water horse," or hippopotamus—not to mention the otter, nutria, and beaver—which, like the unicorn, has four legs and a tail and can remain underwater for four to six minutes at a time before surfacing.

Springer notes that sea unicorns appear to have wider chests than their land-limited cousins. He also remarks that certain of these amphibious animals seem to have oversized hoof diameters, which would aid in swimming. While my observations did show markedly wider chests, I saw not one example of the enlarged hoof that he describes.

In these pages, two references have already been made to Noah and the unicorn. One Jewish version of this story informs us that the unicorn, or *Re'em*, was too immense to board the ark and had to be towed by his horn. Odell Shepard tells us:

"The question regarding the room available in the ark exercised several acute minds. Sir Walter Raleigh spent some of his leisure in the Tower making a mathematical calculation that set his own doubts at rest; he shows that the ark contained forty-five thousand cubic feet of space, that there were only eighty-nine non-aquatic species to be got into it, that the total number of individual beasts it carried—including many very small ones—was

only two hundred and eighty, so that there was room, and to spare, both for them and for their provender. He would have seen no justification for the statement of the Talmud that the Re'em had to be towed behind by a rope tied to its horn.''

A Polish legend relates that ''when Noah let a pair of animals aboard the ark, he also admitted the unicorn. However, when it jostled all the other animals, Noah unhesitantly drove it into the flood.''

A Ukrainian folktale blames birds—the very creatures that we have seen to have such a close relationship with the unicorn—as having been responsible for his supposed extinction: ''All the beasts obeyed Noah when he admitted them into the ark. All but the unicorn. Confident of his strength, he boasted, 'I shall swim!' For forty days and forty nights the rains poured down and the oceans boiled as in a pot and all the heights were flooded. The birds of the air clung onto the ark, and when the ark pitched, they were all engulfed. But the unicorn kept on swimming. When, however, the birds emerged, they perched on his horn and he went under. And that's why there are no more unicorns now!''

Page 58 For several hours I had been observing this stag as he fed in a kelp bed a mile off the coast of Baja California. When his picture was taken, just after midnight, he was coming ashore. At moments like this, far from civilization, where city lights make star-watching impossible, I often turned my attention from the earth's unicorns to that celestial one that, in February, is most visible in the darkness of the southern night sky. Even in those late winter months, Monoceros was impossible to see with the naked eye (binoculars or a long lens had to be used), for the constellation is composed of stars of the fourth magnitude. Its nocturnal habitat places it between Canis Major, Puppis, Pyxis, Cancer, Canis Minor, and Orion. This constellation first appeared in print in 1624 in the writings of Jacob Bartsch, who states, after making various references to unicorns in the scriptures, that the group of stars may have been labeled *a recentioribus*, ''more recently'' than the time of the Bible. This indicates that Bartsch himself did not christen the celestial unicorn.

Page 59 In this photograph, the sea stag from the previous page prances the beach, assuming an attitude in which the exaggerated width of his chest may be appreciated. Springer also observes that *Unicornuus marinus*, which continually dash about while on land, appear hyperactive in comparison to the other species. He felt that since they are seldom observed at rest floating in the water, their constant swimming programs them for almost continual activity, which they are unable to quell ''when on terra firma.''

Pages 60–61 A stag, followed by a doe, steps onto an African beach, possibly not all that far from where the first sea unicorn sighting was reported in 1568 by Garcias ab Horto and recorded in a popular book he wrote on the drugs and spices of India. Here we have the description of an amphibian unicorn which the author says he had ''had from men worth of belief'': ''Between the Cape of Good Hope and the promontory commonly called Currentes [Cape Corrientes, opposite the southern end of Madagascar], there are to be seen certain animals that live on the land, yet take pleasure also in the sea. Although they are certainly not seahorses, they have equine heads and manes. This beast has a horn two palms in length, and the horn is movable so that it can be turned right or left and raised or lowered at will. The animal fights fiercely with the elephant, and its horn is considered good against poison.''

Pages 62–63 Here is the pair of sea stags from page 57, seen coming ashore in the late afternoon. In this photograph one can see quite clearly the length of the horn, which is the standard fifteen to eighteen inches. Knowing that the horn disintegrates moments after death, making it irretrievable, one naturally questions the source of the numerous alicorns that were said to have existed, some of which may be seen in museums and churches to this day.

At one time in history, few were the dukes, princes, or kings of the world who had not either seen or possessed a unicorn's horn and considered it the most precious of his belongings. It is definitely known that they were owned by Popes John

VI, Julius III, and Clement VII; by British Kings James I, Charles I, Edward I, Edward IV, and by Queen Elizabeth I; by Scottish rulers James I and Mary Queen of Scots; by Christian V of Denmark; by King Philip II of Spain; by Pietro de' Medici and Lorenzo the Magnificent.

Odell Shepard tells us:

"By the year 1600, Europe and England contained at least a dozen famous alicorns that were known to all travellers, were frequently exhibited on state occasions to the people, and were carefully described again and again. Most of these were kept in great churches or monasteries. They were regarded as sacred objects, and were sometimes used as pontifical staffs.

"Best known of all was the horn of St. Denis, near Paris, seven feet long and weighing thirteen pounds. This was included in the monastery's inventory of its treasures, together with other sacred relics, and was one of the 'worthies' of Europe. Even John Evelyn speaks of seeing it—'a faire unicorne's horn, sent by a K. of Persia, about 7 foote long.' . . . How this alicorn was acquired, we do not know, but it was lost during the general looting of old treasures, particularly those of the Church, during the Revolution of 1793. It was kept in a dark vault of the sanctuary, one end of it resting in water. We hear that 'this water is given to drink to those that go under the hollow arch, and so soon as they have drunk, they suddenly fall into a great sweat.'"

Dr. Edward Browne, son of Sir Thomas, in his book *Travels* wrote, "But of these Unicorns' Horns no man hath so great a collection as the King of Denmark; and his Father had so many that he was able to spare a great number of them to build a magnificent Throne out of Unicorns' Horns." Shepard tells us:

"This alicorn throne of Denmark was in its time one of the chief wonders of Europe, and if Edward Browne mentioned it to show how cheap the material had become, he did not choose a good example. It was begun by Federic II and was long used as the coronation chair, the legs and arms and all the supporting pieces being made of alicorn. (If the construction of such thrones was at all common in the remoter past, then it is clear why all captured unicorns were led at once 'to the palace of the king.') Christian V was crowned in this chair in

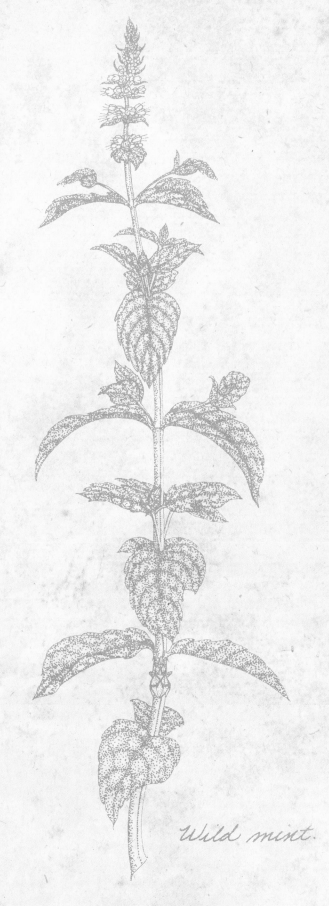

Wild mint.

1671, and the officiating bishop remarked: 'History tells us of the great King Solomon that built a throne of ivory and adorned it with pure gold, but your Majesty is seated on a throne which, though like King Solomon's in the splendour of its materials and shape, is unparalleled in any kingdom.' Whatever might be said of the learned professions, Church and State had not abandoned the unicorn.''

What beast, then, if not the unicorn, provided those many pieces of sharp-pointed spiraled ivory that measured several feet longer than the horn of the protagonist of this book? What pitiful creature was slaughtered en masse because of man's belief in black magic—that the alicorn was a cure-all for the infirmities of the earth—and for his insistence that it could be retrieved after the animal's death? These questions shall be answered further along.

Pages 64–65 Two sea stags battle on a sandbar three quarters of a mile off the coast of Chile. Ctesias (416 B.C.) tells us that the unicorn fights "with horn, teeth, and heels." Aelian (A.D. 200) reports: "With beasts of other species that approach, it is gentle, but it fights with those of its own kind, and not only do the males fight naturally among themselves, but they contend even against the females and push the contest to the death." Edward Topsell (1607) observed that the unicorn "fighteth with the mouth and with the heels, with the mouth biting like a lion and with the heels kicking like a horse."

Stags bent on fighting face each other front-on from about fifty feet apart and remain in that position for as long as half an hour, roaring back and forth at one another. The sound can be compared to the rumblings of a pride of lions on the Serengeti. Next they move forward simultaneously until they are within a horn's distance of each other. The older of the two will then extend his horn, the tip of which he clacks three times against the left side of his opponent's horn, about midway down. (A clack to the right side indicates he has decided not to fight.) If the challenge is accepted, the opponent then strikes the tip of his horn twice against the right side of his older adversary's horn.

The challenge thus offered and accepted, both animals take one step backward, lower their heads, and extend their necks until their horns touch tip-to-tip, pressing firmly against each other. Bodies rigid, muscles flexed, slowly and with great caution they push all their weight against each other until one of the horn tips slips from the other and the battle begins.

On occasion these jousting matches are so furious and the sea so churned up by hooves that it is practically impossible to see the stags. Blood, however, is never drawn. The stags in this series of photographs had been fencing for approximately four hours and were beginning to show some signs of fatigue. Interestingly enough, Ctesias, Aelian, and Topsell agreed that biting and rear-leg kicking were the tactics most used in these combats. Springer's and my studies coincided with them in that we never observed unicorns rear and strike horse-fashion with their forelegs.

The animals in this picture, double manes spreading like dragons' neck shields, mouths open, eyes glaring, horns slashing, foam boiling, and spray curtaining the air, make it easy to understand how, from sailors' split-second glimpses of such combats, the sea unicorn-monster legend evolved.

Pages 66–67 Few sights could be more lovely than that of this doe galloping through the La Jolla surf off the coast of California. Other moments like this in nature are engraved on my mind forever: a wedge of snow geese piercing fast-moving clouds against the moon, above the Imperial Valley's Salton Sea; a school of dolphins rising and disappearing among the whitecaps, which in the distance touched the setting sun on the Pacific coast of Mexico; a pod of whales blowing, not far from Nova Scotia, their black, mysterious tails slapping the dark valleys of those mountainous ground swells, while foam blew like snow from the crests of the waves.

The sea is earth's only true remaining treasure chest of natural mysteries, and it was one of her creatures that provided most of the alicorns. It seems incredible that so much space in history and legend has been dedicated to the significance of these pieces of ivory which, in fact, never came from true unicorns. For the telling of this story, I rely again on Odell Shepard's pen.

"The zoologists of four-hundred years ago believed that every terrestrial form of animal life had a marine counterpart. When men began to think, in the seventeenth century, that the land-surface of the

globe had been fully explored and yet no unicorn was anywhere discovered, it was natural, therefore, that they should seek the animal beneath the ocean waves. They were justified by at least a partial success: the alicorn, whose origin had been concealed so long by the mists and dangers of the northern seas and by that old fear of the Atlantic sedulously propagated two thousand years before by Phoenician merchants, was traced at length to its source.

"Near the end of an exceedingly dull history of Iceland, I find a vivid passage relating how Arnhald, the first Bishop of that country, was wrecked off the west coast of it in the year 1126, barely escaping with his life. There is a marsh on the mainland, the narrator tells us, near the spot where the shipwreck occurred, and this marsh was in his time still called the Pool of Corpses because of the many bodies of drowned sailors washed ashore there after the disaster. 'And there also were found, afterward, the teeth of whales (*dentes balenarum*) very precious, which had gone down with the ship and then had been thrown on shore by the motion of the waves. These teeth had runic letters written on them in an indelible red gum so that each sailor might know his own at the end of the voyage, for they had apparently been tossed into the hold helter-skelter as though intended merely for ballast.'

"To one reader, at least, that passage is not merely vivid, but thrilling, for these 'whales' teeth' were indeed very precious. Shakespeare's Clarence saw no greater wealth in his gorgeous dream of the under-sea than this that went down with the Bishop of Iceland eight-hundred years ago and was found again in the Pool of Corpses. The fact that each man had his name written on the teeth he owned shows that they were already valuable, but this was in 1126; their market value was to increase for five centuries until they were worth ten times their weight in gold. The 'whales' teeth' found in the Pool of Corpses were the 'true unicorns' horns' of kings' treasuries.

"How many cargoes such as this were brought safely to port in later years, no one can say, for they belonged to a business in which it did not pay to advertise. There were not enough of them, at any rate, to glut the market, nor did they come in frequently enough to attract the slightest attention in Europe. Four hundred and fifty years after Arnhald's shipwreck, there were scarcely more than twenty famous alicorns in Europe, and although these were very famous indeed, no one had the faintest notion of their origin. If the situation had been planned and prepared by a master of salesmanship, it could not have been arranged more admirably.

"Four hundred and fifty years pass by, and in 1576 Sir Humphrey Gilbert presents to Queen Elizabeth his famous argument to prove that there must be a north-west passage to Cathay. He has to meet the arguments in favour of a north-east passage made by Anthonie Jenkinson, one of which is that a unicorn's horn has been picked up on the coast of Tartary. Whence could it have come, Jenkinson asks, unless from Cathay itself? Sir Humphrey replies: 'First, it is doubtful whether those barbarous Tartarians do know an Unicornes horne, yea, or no: and if it were one, yet it is not credible that the Sea could have driven it so farre, being of such nature that it will not swimme. . . . There is a beast called Asinus Indicus (whose horne most like it was) which hath but one horne like an Unicorne in his forehead, whereof there is great plenty in all the north parts thereunto adjoyning, as in Lappia, Norvegia, Finmarke, etc. And as Albertus saieth, there is a fish which hath but one horne in his forehead like to an Unicorne, and therefore it seemeth very doubtful both from whence it came and whether it were Unicorne's horne, yea, or no.'

"In the following year Martin Frobisher set forth on his second voyage to discover a north-west passage, and during this voyage his men discovered, in the words of Master Dionise Settle: 'A dead fish floating, which had in his nose a horn straight and torquet, of length two yards lacking two inches, being broken in the top, where we might perceive it hollow—into the which our sailors putting spiders, they presently died. I saw not the trail thereof, but it was reported to me of a truth, by the virtue whereof we supposed it to be a sea-unicorne.'

"The dead 'fish' found by Frobisher's company belonged to the same species of whales from which the 'teeth' collected by Bishop Arnhald's sailors had come, and that was, of course, the narwhal—*monodon monoceros*. The adult males of these marine mammals, from ten to eighteen feet in length, have single teeth or tusks of pure ivory extending for half of their length from the left side of the upper jaw, pointing forward and a little downward. (Now the fact is that the narwhal has only two teeth; in the young and females, both are rudimentary, and 159

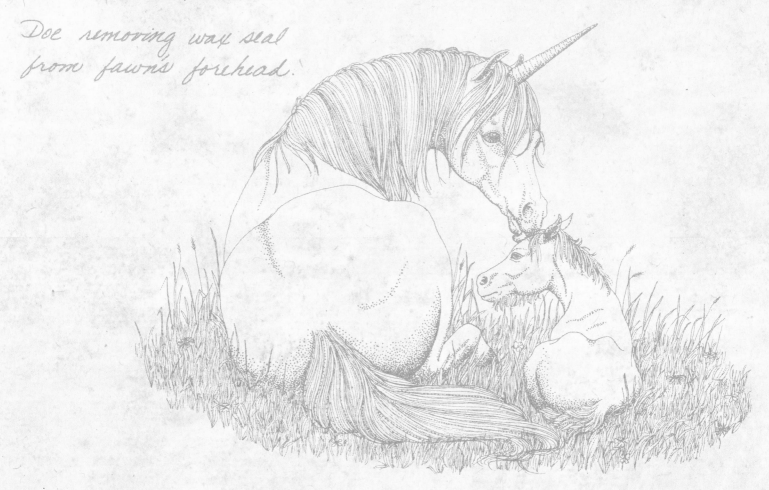

in adult males, one is enormously developed into the tusk.) The fact that they are seldom seen south of Greenland explains the success of Scandinavian fishermen in keeping their lucrative secret for at least five centuries. Even after these animals had been closely examined and described by scholars of Copenhagen and Amsterdam, curious misapprehensions concerning them held on well into the eighteenth century. In particular, it took over a hundred years to quell the belief that the narwhal's tusk was a 'horn' and that it sprang from the middle of the forehead. One may judge what progress knowledge of the narwhal had made in England by the year 1721 from this definition: '*Unicorn Whale*—A fish eighteen feet long, having a head like a horse and scales as big as a crown piece, six large fins like the end of a galley oar, and a horn issuing out of the forehead nine feet long, so sharpe as to pierce the hardest bodies.'''

Shepard then tells us that the man who gnawed into the so-called ''golden apple'' was a Dane with a seemingly appropriate name:

''This man is Ole Wurm, Regius Professor of Denmark and a zoologist and antiquarian of high attainment. Perhaps the most important event recorded in unicorn lore was his public delivery at Copenhagen in 1638 of his Latin dissertation on the narwhal's tusk. The dissertation was called forth by a dispute among the merchants of Copenhagen about the true nature and origin of the substance they were selling as unicorn's horn—a quaint and antique situation indeed, when it is considered that the learned Professor was appealed to, so far as one can see, not for purposes of advertisement, but actually to decide the question. If any of the alicorn merchants of the city expected Professor Wurm to put patriotism before truth and to 'remember who paid his salary,' they must have been grievously disappointed, for his remarks were decidedly 'bad for business.' He began with a careful description of the alicorns to be seen in his time all over Europe, everywhere regarded and highly treasured as the horns of unicorns. So far are they from being such, he then says, that they are not horns at all. They have neither the substance nor the shape of horns, and they are not set in the animal's cranium as horns are. He asserts that they have all the characteristics of teeth and that teeth they must be called. In his third section Ole Wurm declares that the alicorns of Europe are the teeth of narwhals, citing as evidence the cranium of a narwhal, which he has recently examined. This cranium he describes, and

also the tusk projecting from the left side of the upper jaw, with painstaking exactness. He concludes by saying that in the future those who do not care to deny the authority of witnesses, and even of their own senses, will be obliged to admit that the alicorn is really the tooth of the narwhal.

"One might suppose that after such a public statement of the facts, iterated as it was by the author himself and by many others, the vogue of the alicorn would have ceased and the whole unicorn legend would have begun to die away. On the contrary, the dissertation seems to have had little more effect at first than such productions usually have. Public faith in unicorns was unshaken. The trust of physicians and princes in the alicorn remained. . . . All the little that may have been lost in British and European markets by Ole Wurm's unpatriotic disclosures was made up by new markets in Russia— or rather by old Russian markets first developed by the Scandinavian overland traders. When these were gone, there were still others, as we shall see, in lands much farther off where Latin dissertations were never read.

"For all this, the difficulties encountered in selling the tusks at anything like the old prices did certainly increase as the seventeenth century wore on. . . . Evidence that the market was rapidly falling is found in de la Peyrére's *Relation de Groenland*, which first appeared in 1647. 'Tis not long since,' says this garrulous writer, 'that the Company of New Greenland at Copenhagen sent one of their agents into Muscovy with several great pieces of these kind of horns, and amongst the rest one end of a considerable bigness, to sell it to the Great Duke of Muscovy. The Great Duke being greatly taken with the beauty thereof, he showed it to his Physician, who, understanding the matter, told the great Duke, 'twas nothing but the tooth of a fish,' so that this agent returned to Copenhagen without selling his commodity. After his return, giving an account of the success of his journey, he exclaimed against the physician who had spoiled his market by disgracing his commodities. '"Thou art a half-headed fellow," replied one of the directors of the Company, as he told me since. "Why didnst thou not offer two or three hundred ducats to the physician to persuade him that they were horns of unicorns?"' If we have been right in saying that there

was no conscious deceit in the earlier history of the traffic in tusks, that period is now definitely past."

Pages 68–69 Of all the photographs in this book, I feel perhaps the most affection for this one, which is almost a copy of numerous old paintings and engravings depicting a unicorn purifying water with its horn.

The Dutch priest and writer Johannes van Hesse of Utrecht, who was witness to the Water Prodigy in Palestine in 1389, describes it: "Near the field Helyon in the Promised Land is the river Marah, whose bitter waters Moses made sweet with a stroke from his staff and the Children of Israel drank thereof. To this day, it is said, malicious animals poison this water after sundown, so that none can thereupon drink it. But early in the morning, as soon as the sun rises, a unicorn comes out of the ocean, dips his horn into the stream and drives out the venom from it so that the other animals may drink thereof during the day. This, as I describe it, I saw with my own eyes."

Commenting on the particular testimony, Shepard remarks:

"One may point out in passing the strange coincidence that John of Hesse should have seen this rare spectacle at just the spot made famous by the miracle of Moses, to which it provides so striking a parallel. For the bitter waters of Marah in the Bible story, we have here the water poisoned at night by unclean animals; Moses and his staff are matched by the unicorn and its horn; the Children of Israel are represented by the clean animals waiting beside the stream. The two stories correspond in every essential detail, so that John's statement amounts almost to a declaration that he saw the ancient miracle re-enacted symbolically upon the spot—But this is one of those mysteries into which the lay mind may not hope to pierce."

So, we have the basis for the alicorn's ability not only to detect poison but to cleanse the world of its evils. From Zurich, in connection with the studies of zoologist Dr. Konrad von Gesner (1516– 1565), we learn: "This horn is useful and beneficial against epilepsy, pestilent fever, rabies, proliferation and infection of other animals and vermin, and against the worms within the body from which children faint."

Since these priceless horns were naturally often faked, the Gesner papers tell us of a test for verifying authenticity. "Some people test for genuine natural unicorn horn as follows: Give some arsenic to a pair of doves, and give one of these a short drink of unicorn horn; if this dove remains alive, the horn is genuine and the other dove will die."

Regarding one of the more interesting of these tests, Odell Shepard tells us:

"A full account of the alicorn tests would fill many pages. . . . One of the most curious passages concerning them is that given by one David de Pomis, who describes himself, with no false modesty, as 'a Hebrew physician and philosopher of the Tribe of Juda, and a member of the noble family of Pomaria which the Emperor Titus led captive from Jerusalem to Rome.' His book is, at first sight, somewhat bewildering. The fact that it is written in three languages—Hebrew, Latin and Italian—contributes something to this effect; it is paged backward, the indexes run backward, and the title-page stands at the end; David uses the full-stop only when he is quite through with a topic, to mark a period in the exact sense, and he employs the comma for all other punctuation. All this is darkened rather than illumined for me, in the only copy I have seen, by the numberless marginalia in the hand of Isaac Casaubon, who improves upon his polyglot author by adding a vocabulary in Arabic. But it is precisely in such 'quaint and curious volumes of forgotten lore' as this—How Edgar Allan Poe would have loved it!—that we have to delve for unicorn lore, and David of the Tribe of Juda does not disappoint one.

"He says: 'The unicorn is a beast that has one horn in its brow, and this horn is good against poison and pestilential fevers. But one is to observe that there is very little of the true horn to be found, most of that which is sold as such being either stag's horn or elephant tusk. The common test, which consists in placing the object in water to see whether bubbles will rise, is not at all to be trusted, and, therefore, wishing to benefit the world and to expose the wicked persons who sell worthless things at great prices, I take this occasion to describe a true test by which one may know the genuine horn from the false. The test is this: place the horn in a vessel of any sort of material you like, and with it three or four live and large scorpions, keeping the vessel covered. If you find four hours later that the scorpions are dead, or almost lifeless, the alicorn is a good one, and there is not money enough in the world to pay for it. Otherwise, it is false.'

"The physician Jordanus, in his book *De Peste*, speaks of seeing a Jew enclose a spider in a circle drawn on the floor with an alicorn, and says that the spider could not cross the line, and starved to death inside it.

"There is no more pitiful record in the world than that in the scores of books composed during the Middle Ages on methods of avoiding and curing the Plague. It is a record both disgusting and ludicrous, but one's prevailing mood in reading it is that of compassion. Unicorn's horn is certainly the most pleasing of the *materia medica* mentioned in it, and it is as effective as most. I take up the *Monumenta Sinoptica de Peste Preservanda et Curanda*, written long after the Middle Ages had closed by John Collis, and published in 1631. This book names thousands of drugs sold over the counters of England and Europe less than three centuries ago as the best means known to science of saving the lives of one's family and friends from the pestilence that never quite died out. Many of these drugs are too foul to name and others too ridiculous to believe in. Hooves of asses and elks, horns of wild goats and of stags, viper's flesh and Mathiolus's celebrated oil of scorpions, dust of scorpions, powdered swallow's heart—one hardly knows whether to laugh or to weep. For the thought will emerge, as one reads, that although these people held views about *materia medica* which we have abandoned—quite recently—yet they loved their children somewhat as we do ours. It was by such means as these that they tried to keep them."

Pages 70–71 The photograph of the two stags on these pages was taken well after sunset, where Alaskan tundra meets the gray waves of the Bering Sea. While the forest and flower photographs of this book could certainly be set to music by Ravel or Debussy, moments like this one suggest the deep, ominous sounds that Mahler would compose. Although the modern conception of the unicorn projects a poetically light, romantic aura around him, this is only one side of his nature. There also exists that dark, mysterious aspect captured perhaps more

clearly on pages 70–71 than in any other picture in this book.

There were moments in the forest and flowers when I wished to approach close enough to a unicorn—especially the fawns—to touch. With the unicorns of the sea, however, I was content to be a distant observer. These creatures summon up the same enigmatical feelings one experiences in the presence of whales and other inhabitants of the ocean, the "vasty deep" which, though it covers most of the surface of the earth, is yet so unknown, so uninviting, so inhospitable to humankind. One Greek fisherman told me that sea storms are the result of enormous gatherings of unicorns, who fight and stampede about in such numbers and with such violence that the restless water "is stirred up into hurricanes." Hearing such peasant lore made it easy to imagine how stories of the *Physiologus* were invented and embroidered.

The stags in this image were both old (that is, over two thousand years each) and were often seen in each other's company. This relationship runs contrary to the popular misconception that unicorns are *absolutely* solitary animals. While to find two such stags or does together is extremely unusual, both Springer's and my observations show that such friendships do exist.

Pages 72–73 This stag and doe were photographed in a secluded cove on the northeastern coast of Kauai, one of the Hawaiian Islands, where they had been feeding on mineral-rich kelp, their primary source of food. Springer felt that unicorns were also able to eat plankton, sifting it through their teeth in much the manner of the whale shark (the largest fish in the sea), but I was never able to determine if this speculation was correct. The feeding habits of unicorns of the forest and flowers were obviously much easier to study than those of the ocean animals.

While sea unicorns were often observed playing with dolphins, and now and then with a whale, they seemed to have little contact with other ocean creatures except for flying fish and sea lions. Not far from Catalina Island off the coast of California, when equipped with rubber fins and mask, I often saw a young doe playing beneath the water with a trio of sea lions. These games of chase usually took

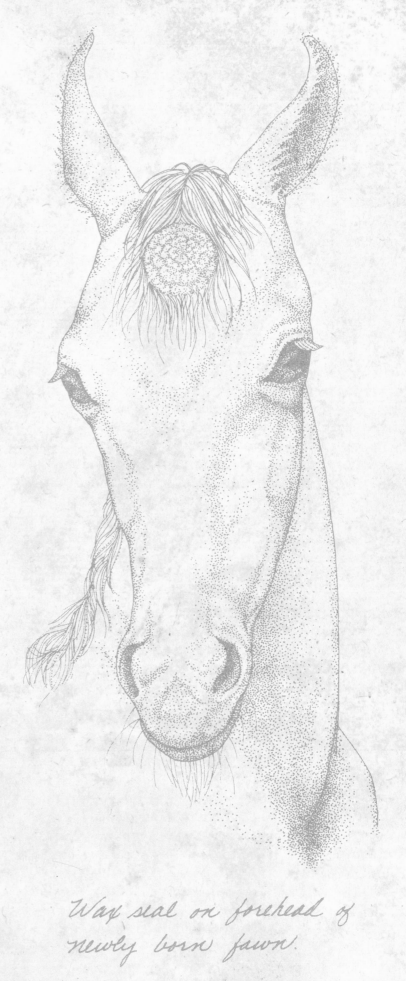

Wax seal on forehead of newly born fawn.

163

place at a depth of about twenty feet and offered some of the most delightful moments of unicorn observation I was to experience. Spotlighted by rays of blue light filtering through the kelp, the doe would turn somersault after somersault while the sea lions playfully nipped at her heels, and several large garibaldi (gilded orange fish) darted through the centers of her underwater pirouettes.

The play of the flying fish, on the other hand, took place above the surface of the water; schools composed of up to a dozen individuals were often seen sailing through the air over the heads of stags or does.

Unicorns were often studied in shark-infested waters, and it was here that their horn sonar seemed to be of use other than to elicit the disappearing reaction. If the menacing black fin of an aggressive shark cut the water within twenty feet of a sea stag or doe, the unicorn would tip its horn toward the approaching fish, and the shark, as if hit by a bolt of electricity, would turn sharply and flee.

Pages 74–75 Two unicorns search this Florida beach for fresh halothila grass deposited by high tide on the sand.

Such a pair of animals were, and still are, supporters of the Scottish Royal Arms. Rudolf Springer has already informed us that in 1603 one of the Scottish stags was transplanted to England. Odell Shepard offers a more in-depth account of the transformation of the British Arms:

"Before the accession of James I to the throne of England, a great variety of 'supporters' had been used for the Royal Arms, but a lion had for several generations been one of the two. Henry VI used the lion and the antelope; Edward IV, the lion and the bull; Richard III, the lion and the boar; Henry VII and Henry VIII, the lion and dragon; Mary and Elizabeth, the lion and the greyhound. On the Royal Arms of Scotland the unicorn had been employed as consistently as the lion in England. It is often said that the lion and the unicorn were chosen as supporters of the British Arms because of the belief in the natural animosity of these two beasts and as a symbol of the reconciliation between England and Scotland. James I was a learned man to whom such a symbol might well have been interesting, but the presence of these two historic foes in the British Royal Arms is really no more than a fortunate accident. James kept his Scottish unicorn, and he chose the English lion merely because it had been the most persistent supporter of the English Arms before his time."

One obvious question that might occur to the reader is "Where do sea unicorns sleep?" Most likely, not in the water. My studies showed that the reason stag and doe sightings often took place near or after sunset was because it was then, with the cover of approaching night, that unicorns came ashore to rest. Generally chosen for sleeping quarters were sea caves or sheltering rock formations. On numerous occasions, however, these creatures were seen in the water at night, but usually no farther than two miles from shore.

It is interesting to note that unicorns of flesh and blood are not the only one-horned animals to haunt some of the world's caves. Sir John Barrow, a well-trained observer and highly educated traveler of the nineteenth century, found in the caves of South Africa examples of Bushman paintings in which appeared again and again a one-horned antelopelike creature.

Page 76 Like a deity from the deep, this stag wades the Mediterranean shallows off the western coast of Crete. The unicorn served more than once as a metaphor for God. "Who is this Unicorn," spoke Saint Ambrose, "but the only-begotten Son of God."

"The unconquerable nature of God," wrote Saint Basil, "is likened to that of the unicorn."

Page 78 The photograph of this doe, her breath frozen in the high air of the Swiss Alps, was taken at daybreak. It is a reminder of the discomfort, indeed the hardship, that accompanied the making of these pictures of *Unicornuus niveus*. Once, in Canada, the chill factor was 54 degrees below zero and I literally feared for my health as I stalked a stag for hours, while fresh in my frostbitten ears echoed the radio warning that it was unsafe to be outside for more than six minutes at a time. My cameras froze up, and the film became so brittle that it continually broke in my numbed hands, made awkward by gloves which could not be removed and by severely frostbitten fingers, as I struggled to thread roll after roll of film.

Contemplating the picture of the doe on this page, it is not difficult to imagine how such a sight, at once beautiful, mysterious, and menacing, could touch the deepest soul of any startled traveler of the ancient world, striking in him both wonder and terror, and transforming the unicorn into the most magical creature that has ever pranced the earth. Small wonder, then, that the supposed horn of the unicorn was deemed almost as precious as life itself. Odell Shepard emphasizes the value of the alicorn:

"The cost of 'the true unicorn's horn' (*verum cornu monocerotis*) in its best period was a little over ten times its weight in gold when sold in small pieces or in powder, but whole alicorns sometimes brought twice as much as this. . . . The famous alicorn belonging to the city of Dresden [ordinarily] was kept on display, strongly protected, in the museum which was known to the more leisured classes as *exotikothaumatourgematatameion*, and there was a strict municipal regulation that whenever scrapings were taken from it for medicinal uses, two persons of princely rank should be present in the room. . . . The Republic of Venice, in 1597, offered for a whole horn the sum of thirty thousand ducats—ten times the price of Shylock's pound of flesh—and did not get it. . . .

"One source of the supply of alicorns is revealed by Hector Boëthius in his *History of Scotland*, where he asserts, after a grotesque account of walrus hunting, that the tusks of the beasts are straightened artificially and sold in Europe as unicorns' horns. . . . This great fish, he says, swims about for a long time without taking any sleep; but at last, overcome with drowsiness, he turns to the shore, finds a convenient bush or tree, hooks his down-curving teeth over a bough, and falls into a deep slumber. Then the hunters approach and bind him with ropes, and after cutting off his teeth, set him free to grow another pair. . . . André Thevet affirms that he has actually seen this artificial straightening performed by clever Levantine artisans on an island in the Red Sea, distributing station for both East and West. . . . For powdered alicorn, the common substitutes seem to have been burnt horn, whalebone, various kinds of clay, the bones of dogs and pigs, lime-stone, and, most important of all during the later history, stalactites and the bones of fossil animals. Edward Topsell, with

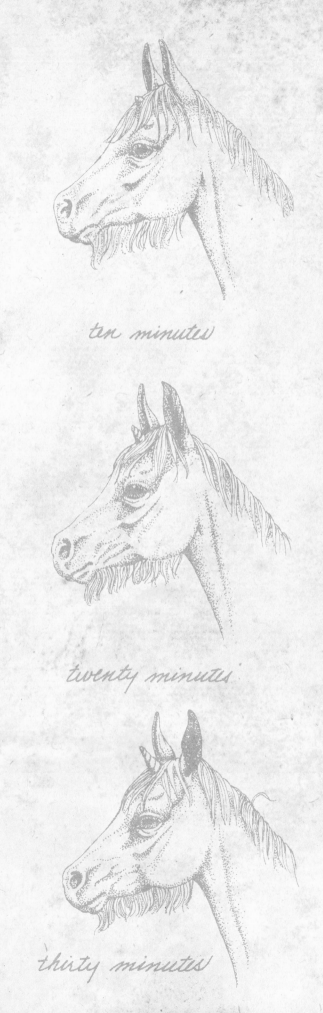

Approximate rate of horn growth after removal of wax seal.

ten minutes

twenty minutes

thirty minutes

Firm bonds that form between deer and unicorn fawns usually terminate at the deer's first rut.

all these facts in mind, advises that alicorn be bought 'out of the whole horn if it may be done, or of greater crums, and which may describe the figure of the horn.'"

Page 79 Could any voodoo witch doctor on a moonless night summon up as haunting an image as that of this blue-eyed stag photographed ten thousand feet up on the south side of Kanchenjunga, in Nepal, the third highest mountain in the world? Here, the unicorn seems almost to exude omniscience; and it was this interpretation that, in part, made possession of his supposed horn literally essential to the survival of persons wealthy, powerful, or famous enough to have enemies. In the Middle Ages it was thought that the most successful antidote to poison was an even more potent venom; and the horn of this creature, the symbol of purity to many, was believed to contain the most lethal of substances.

"We have already learned," writes Shepard, almost paraphrasing Rudolf Springer, "that the poison in the unicorn's body is not dispersed, but is concentrated in the horn—the single horn. It seems natural, then, whenever the unicorn goes to the water to seek relief from an excess of poison, if that is indeed his motive, that he should dip the horn alone. Furthermore, it would follow naturally from the poisonous quality of the horn that whatever venom there might be in the water would be dispersed. This, at any rate, is the explanation of the water-conning trait that Laurens Catelan, a learned pharmacist of the seventeenth century, seems to have had in mind, for he says that the unicorn's well-known fierceness is caused by the great pain he suffers constantly on account of the poison in his horn, and that he knows no other way of obtaining relief except that of returning to the poisoned stream by which his pain is partly caused. (There has never been any lack of allegorical possibilities in the unicorn legend; the difficulty is avoiding them.) The alicorn is clearly one of the most poisonous substances in the world, and with these facts in mind, Catelan submits, no sensible man can fail to believe the marvels related of it. The alicorn sweats when standing near poison, he thinks, because of a desire to mingle with its like, and when taken as a drug it overcomes and carries off such feeble poisons as arsenic and corrosive sublimate

by virtue of its own more powerfully poisonous nature. Why it is that so deadly a substance as this does not kill the patient instantly, how it happens that it can be brought into contact with one's food and drink or worn at one's neck as an amulet with impunity, Catelan and his fellows neglect to inform us."

Again and again we are told that the alicorn sweats in the presence of poison. John Swan's (1635) account is typical of these numerous descriptions: "This horne hath many sovereign virtues, insomuch that being put upon a table furnished with many junkets and banqueting dishes, it will quickly descrie whether there be any poyson or venime among them, for if there be the horne is presently covered with a kind of sweat or dew." What persons, other than saints, could then not afford to have one of these pieces of spiraled ivory on the table at breakfast, lunch, and dinner? It must be remembered that this was a period in history when poison was, so to speak, the chosen way of sweeping one's enemies under the carpet. Horns were tested for validity with scorpions and spiders and doves. James I of England, who was qute fittingly called "the wisest fool in Christendom," purchased an alicorn for somewhere around 10,000 pounds (today equal to many times that amount) and, to test its efficiency, gave one of his servants a draught of poison with the alicorn powder. When the man dropped dead, the king matter-of-factly declared that the horn was obviously not genuine.

The histories of several of the many practitioners of the art of poisoning impress upon us that the alicorn was of absolute necessity to the rich and famous. Shepard informs us:

"Those who think that our northern ideas of Italian poisoning are chiefly due to misinterpretations of Machiavelli and to diseased fancies, such as those of Webster, Tourneur, and Beddoes, may be recommended to study the career of the Milanese poisoner Aqua Toffana, who, although she lived long after what may be called the best period of her art, is said to have disposed of more than six hundred persons during her half-century of practice, before she was publicly strangled at the age of seventy. When cases of poisoning were traced to her, she took refuge in a convent—as her only dangerous rival, the Marquise of Brinvilliers, also did in like straits—and from that point of vantage, the

convent authorities refusing to give her up, she went on selling her Acquetta di Napoli for twenty more years. And on every bottle of this deadly poison—tasteless, odourless, without color—there was painted the image of a saint.

"All the arts blossomed somewhat later in France than in Italy, and it was not until after the middle of the seventeenth century that the Marquise de Brinvilliers, by slaying with poison, and chiefly for money, her father, her husband, her sister, and her two brothers, threatened Italy's 'bad eminence.' With better luck, or if she had not stolen out of her convent to meet the 'lover' who was really an officer of the law, she might have gone as far as Aqua Toffana. The steady increase of criminal poisoning led Louis XIV to establish a committee, the so-called *Chambre Ardente*, which sat for three years investigating what had become almost a major social problem. But France has never rivalled the secret society of women, mostly young, discovered at Rome in 1659, the sole purpose of which was to kill by poison the husbands of all the members. There, women are said to have met regularly at the house of one Hieronyma Spara, who found the drugs and gave directions for the dosing. An archaic touch in the story of this quaint sisterhood, which takes it quite out of the atmosphere of our more chivalrous modern times, is that twelve of the lot were hanged and most of the others publicly whipped through the streets of Rome.

"England was still more backward than France at the time of the Renaissance. The art of poisoning was not one of those brought back by the 'Italianate Englishman,' although among those that Roger Ascham feared, and if it had been, it would have found scant encouragement at home. An Act of Parliament, passed in 1531, made poisoning treason and provided that those proved guilty of it should be boiled to death. The first person to suffer this penalty was a certain cook named Richard Boose, convicted of trying—unsuccessfully—to poison the Bishop of Rochester, and two other persons at least were executed in this way at Smithfield before the Act was repealed in 1547. Even in England, however, rumours of poisoning in high places were always flying about. There were several such tales of attempts upon the life of Elizabeth; James I was suspected of having poisoned Prince Henry, and Charles I of having poisoned his father; it was

thought by many that Cromwell himself was supposed to have died of poison. Several of the fourteen physicians who waited upon Charles II gave the opinion that he had been poisoned, and many tales were current as to the culprit.

"One has no difficulty in understanding, therefore, how the demand for the alicorn, as for several other articles used to detect the presence of poison, was built up and maintained, and the prices paid for alicorns no longer seem incredible when we think of them with the history of poisoning in mind. All a man hath will he give for his life, and it is a safe inference from what we know that more than one Italian city already groaning under taxation had to melt its silver spoons so that its lord might pay some northern merchant the sum he asked for an alicorn. The naïve device of employing pregustators, or 'tasters,' which had been sufficient for the ancient Romans, had to be abandoned in a time when, according to general belief, a clever poisoner could compound a drug that would kill in an hour, a week, or a month, as pleasure and convenience might dictate. Belief in the poisoner's powers reached fantastic heights. . . . There was no real security unless one could find a means of detecting poison the instant it was brought near one, and upon this task, therefore, huge erudition and great sums of money were for a long time expended.

"The description of the furniture used at the wedding dinner given by Edward IV for his sister and the Duke of Burgundy illustrates one method of using the alicorn. Like the horn of the cerastes, the snake's tongue, the aëtites, and other objects, it was simply set upon the table, or near it, so that any change in its appearance might be instantly seen. We may imagine that the gaiety of medieval feasts was somewhat sobered by the necessity of keeping the eyes fixed upon such objects, and that the grisly suggestions of the vulture's claw might somewhat impede the flow of soul; but the Middle Ages seem to have liked strong contrasts. . . . Even the inventory of the Emperor Charles V refers to '*une touche de licorne, garnie d'or, pour faire essay*'—certainly an interesting article to find in the possession of a man who seems to have eaten himself to death.

"Two hundred years before the ceremony was abandoned—with the heroic assistance of Madame Guillotine—Chapelain, physician to Charles IX of

France, had said 'that he would willingly take away that custome of dipping a piece of Unicorn's horne in the King's cup, but that he knew that opinion to be so deeply ingrafted in the minds of men that he feared it would scarce be impugned by reason.' Many physicians, he continued, who had themselves no belief in the alicorn felt obliged to prescribe it because, if they did not do so and their patients died, they never had any peace from the surviving relatives."

With the tremendous sums of money known to have been paid for alicorns by many of history's most prominent men and women, surely there must have been some testimony to support its effectiveness. And indeed there was. The following account by Odell Shepard is almost a duplicate of the text from Rudolf Springer's journal:

"We hear that the inquisitor Torquemada always kept a piece of alicorn on his table as a precaution against the wiles of his numerous enemies; it was carried by Spanish and English explorers of America as conscientiously as quinine is carried today by travellers in tropical countries; Cabeza de Vaca writes that during his journey down the Paraguay River in 1543 there were three attempts made to poison him with arsenic, but that he foiled them all with a bottle of oil and a piece of alicorn. When the Elizabethan adventurer, Edward Webbe, was at the point of death from poison administered to him by 'some lewd gunners'—one sympathizes with those gunners, for they were probably worn out by the man's outrageous lies—'his phistian gave him speedily Unicorne's horne to drinke,' with the deplorable result that he lived on. A whole ship's company of Englishmen were poisoned in Elizabethan days 'by the roots of Mandioca, but by a piece of Unicorne's horne they were preserved.' It seems probable that even Francis Bacon, reputed 'father of the experimental method,' shared the belief of his time in the alicorn, although he admits that the general confidence in it was in his day declining."

Having traveled these roads of the lore of unicorn legends and mythology, it is now time to leave the damp, dark buildings of Europe and step out into the crisp air, not to the unicorn of witches' pots and the troubled minds of men, but to the animal that exists in much the way that the common sparrow exists, in the natural world around us.

Pages 80–81 It is incredible how unicorns like this doe of the snow photographed in Afghanistan could, from great distance, sense the intentions of human observers. Sights such as this, quite common if I was alone, were ruined if the trusted observer was accompanied by anyone who provoked the slightest suspicion. The unicorn would simply disappear. Generally, all over the world, the persons I have met who have seen unicorns were either very young (seven years old and under) or well into their late seventies. While this particular doe was always calm in my company, the stag that accompanied her apparently felt insecure in the presence of humans and was forever disappearing and then reappearing on the same spot.

Pages 82–83 The whiteness of a snow unicorn against that of the drifts provides one of the most delicate and sensitive sights that eyes can behold. In legend, the unicorn has always been envisioned as a white animal, a representation probably based on occasional actual sightings, but also on the symbolic religious equation of white with purity. With the unicorn proper, however, as with other creatures of the natural world, there are always exceptions, and perhaps the only sadness I feel with the publication of these photographs is that, hard as I tried, I was not able to stalk close enough to black unicorns (three of which were observed, each in a distinct part of the world) to photograph them. If the existence of such a creature comes as a surprise to some readers, it would be well to remember that until some years ago all tigers were believed to be orange-striped and yellow-eyed—until a white-striped male with blue eyes was captured in India and later bred and crossbred to provide the world's zoos with these rare animals. Not too long ago all gorillas were thought to be black (although mature males have quite a bit of gray hair, especially on their backs), until Copa de Nieve, a blue-eyed snow-white specimen, was captured in what was then Spanish Guinea. He may now be seen in the Barcelona zoo. And if that weren't enough, lions, which we have always known to be golden or tawny in color, can be otherwise, as Chris McBride discovered in South Africa with his cotton-white yellow-eyed lions of Timbavati.

The black unicorn—especially those of more than a thousand years of age, which like their white

169

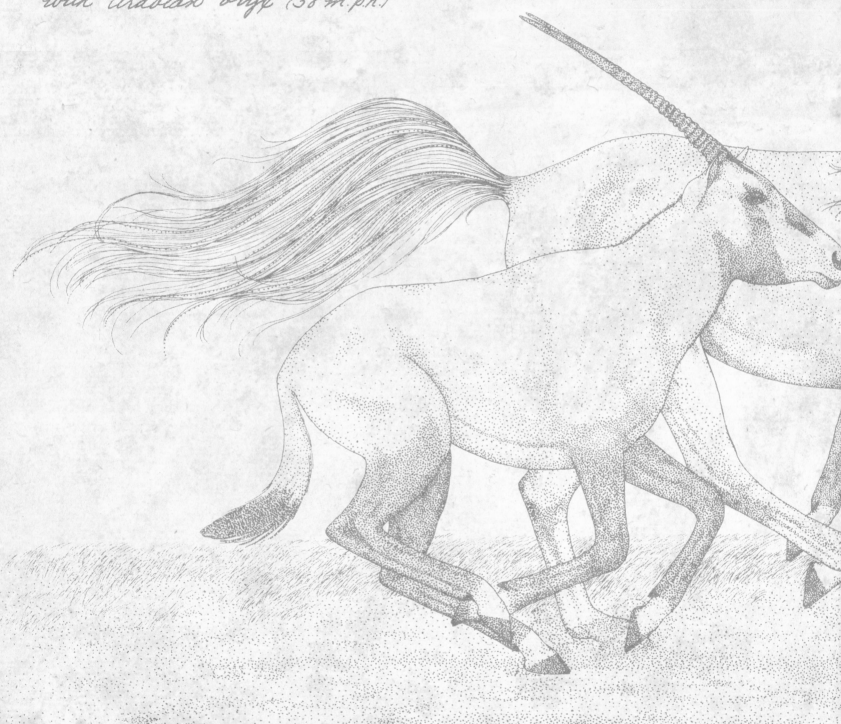

Unicornuus deserti (84 m.p.h.) racing
with Arabian oryx (58 m.p.h.)

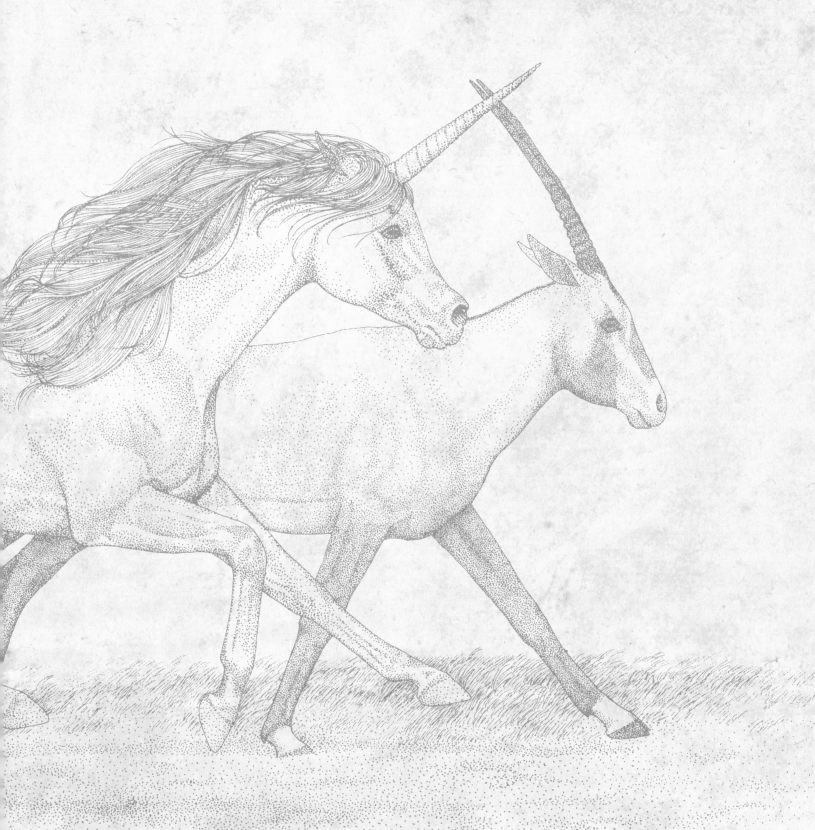

relatives have blue eyes—is beautiful beyond the wildest imaginings. Springer mentions having spotted four black animals, never together but each in a distinct habitat. Neither he nor I ever saw a stag or doe whose short body hair was any shade but pure white or jet black.

The doe in this photograph is shaking the snow from her back, sparkling the air with it in a meadow skirting the Black Forest in Germany, where she has been eating snow. Stags and does of frozen areas more remote and barren than this seemed to feed primarily on the bark of certain trees and on soft rocks, as well as on the snow itself. It may seem odd to the reader that while the doe of the photograph on page 80 did not touch the vegetation around her, she had been seen gnawing on the red-colored stone that formed her world. Many of the blemishes and pits in the boulders were the result not of weather erosion but of unicorn predation.

Springer was also of the opinion that minerals are much more important to the health of unicorns than are vitamins. Unicorns of the sea, for example, feed almost exclusively on kelp, which contains few vitamins, is in its natural state indigestable to humans, but is rich in potassium, phosphorus, iodine, and calcium. Springer's ocean observations were often made in the Sargasso Sea (within the "Bermuda Triangle"), which is represented graphically in his journal with a full-page drawing of a stag surfacing with sargasso weed moustaching out from his mouth. Sea stags and does also feed heavily on stone, and many of the hollows we see in tidal pool rocks have been eaten away not by the waves and wind but by unicorn teeth.

While unicorns of the forest and flowers were observed dining on certain berries, blossoms, buds, bark, farm crops, honey, and sap, clean-washed river stones formed an important part of their diet. Those living in areas where there were caverns were repeatedly seen or heard gnawing on stalactites and stalagmites. Dozens of times, while storms drenched the forest with rain and beat it with wind, I shivered, curled up in my sleeping bag in some deep cavern, where the only sounds were the drip of water, the occasional high-pitched squeal of a bat, and the grating of unicorn teeth against stone.

If it comes as a surprise that stones and pebbles form such an important part of the unicorn's menu, it is true that most ungulates are quite addicted to certain minerals. Horses are often seen eating earth in which not a blade of grass or a root exists.

Hooved animals obtain some minerals from natural salt licks and by chewing bones, although not once in Springer's and my combined eighty years of observation did we see a unicorn show the slightest interest in bones.

Page 83 It can be said with some certainty that while several readers have seen unicorns such as this doe, none have witnessed the phenomenon captured in this picture: the shadow of a living creature cast upon a curtain of falling snow. Skeptics will suspect that the image has been manipulated, but close inspection by an expert in photography will demonstrate that the picture is just what my camera saw. At the moment the picture was taken, the setting sun illuminated the doe on her Tibetan mountain perch from so low an angle that her shadow was cast, as if upon a wall, against the light snow that had begun to fall between us.

It is important to confess that at the time the shutter release button was pressed, I was aware only of the silhouetted unicorn. During my many years of photography, the only similar incident I can remember happened under like circumstances, except that the curtain was formed by dust (and then only a foot or so above the ground) which rose from the hooves of a large herd of Spanish horses, also silhouetted on a ridge by the last rays of the sun. As I looked through the camera, I was aware of dark reflections moving in the rising dust at their feet—the shadows of horses' hooves and legs cast against the curtain of dust particles in the air.

Pages 84–85 The photographs on these two pages were taken on the Maine-Canadian border, perhaps not far from where Dr. Olfert Dapper, in 1673, reported a unicorn sighting. For an interesting historical account of the unicorn in America, I turn to Odell Shepard:

"One of the rare titles in the 'Americana' that have so strongly attracted the cupidity of book-collectors in recent decades is a well-printed and brilliantly illustrated volume called *Die Unbekante Neue Welt* by Dr. Olfert Dapper. The most accurate pages in this entertaining book are those that deal with New Amsterdam and the present site of New York City, so that a casual reader is the more surprised when he finds, immediately after those

pages, a lively representation of the American unicorn in its native haunts—the suggestion is that they must have been in the general region of the Bronx—with an unmistakable American eagle upon its back. In the accompanying letterpress, however, and under the appropriate rubric *Selt-same Tiere*, the Doctor places this unicorn some-what farther afield. 'On the Canadian border,' he says, 'there are sometimes seen animals resembling horses, but with cloven hooves, rough manes, a long straight horn upon the forehead, a curled tail like that of the wild boar, black eyes, and a neck like a stag. They live in the loneliest wildernesses and are so shy that the males do not even pasture with the females except in the season of rut, when they are not so wild. As soon as this season is past, how-ever, they fight not only with other beasts but even with those of their own kind.'

"But it had not been reserved for Dr. Dapper to discover the American unicorn. His account is more than a hundred years too late for that, in addi-tion to the fact that it has a strong smell of the lamp. We are told in legends of the conquistadors that Friar Marcus of Nizza set out from Mexico in 1539 with Stephen the Negro to find the 'Seven Cities of Cibols,' and that when he got there, the inhabitants showed him, among other wonders, 'an hide halfe as big againe as the hide of an Oxe, and said it was the skinne of a beast which had but one horne upon his forehead, bending toward his breast, and that out of the same goeth a point forward with which he breakes any thing that he runneth against.' Fur-thermore, Sir John Hawkins writes in his account of his voyage of 1564: 'The Floridians have pieces of unicornes hornes which they wear about their necks, whereof the Frenchmen obtained many pieces. Of those unicornes they have many; for that they doe affirme it to be a beast with one horne, which comming to the river to drinke, putteth the same into the water before he drinketh. Of this uni-cornes horne there are of our company, that having gotten the same of the Frenchmen, brought home thereof to shew. . . . It is thought that there are lions and tygres as well as unicornes; lions especially; if it be true that is sayd, of the enmity betweene them and the unicornes; for there is no beast but hath his enemy . . . insomuch that whereas the one is the other cannot be missing.'

"This page helps one to see how notions of a new country's fauna developed even in the minds of intelligent men less than four centuries ago."

When Sir John referred to felines in America, most certainly he had in mind the jaguar (*tigre*, in Spanish), which once roamed well into what is now the United States, and the American mountain lion.

Pages 86–87 With this photograph of a doe eating snow in the foothills of Mount Fuji in Japan, one is reminded that the unicorn has long been im-portant to Oriental literature, painting, and thought. "Chinese writers do not assert that the unicorn or ki-lin is a native of their land," Shepard tells us:

"The ki-lin is supposed to spring from the cen-tre of the earth, and perhaps he was originally a rep-resentative of the earthly element as the phoenix represents fire, the dragon air, and the tortoise water. All commentators enlarge upon the excel-lence of his character. He knows good from evil, is reverential towards his parents and piously at-tached to the memory of his ancestors; he is harm-less, beneficent, and gentle, the fleshy tip of his horn indicating clearly that that otherwise formida-ble member has only symbolic aesthetic uses. Like the Western unicorn, he keeps the dignity and mys-tery of solitude, never mingling promiscuously even with those of his own kind and never treading upon soil tainted by the human foot unless he comes on a mission. He is not violently haled by hunters into the court of the sovereign, but arrives as one king visiting another. Unlike the Western unicorn, the ki-lin has never had commercial value; no drug is made of any part of his body; he exists for his own sake and not for the medication, en-richment, entertainment, or even edification of mankind.

"We must infer that this Oriental unicorn was conceived on a higher plane of civilization than that which produced the European legend. Our Western unicorn does us credit in many ways, but when we compare him with the ki-lin we see that there is after all a good deal of violence and deceit and calculation implicit in the stories we have told of him. The ki-lin legend was developed by men who had got beyond fear and calculation in their attitude toward wild nature—by men not unlike those who painted pictures or wrote poetry of the Sung period in which nature is loved for her own sufficient self almost a thousand years before the West learned to look at her without terror.

"Distinct as the ki-lin seems at first to be from the Western unicorn, and especially from the uni-corn of *Physiologus*, it is hardly possible to think of

him at last as an entirely independent creation. . . . Like all Western unicorns, he is solitary, and he cannot be captured. The Chinese are so certain of this last characteristic, indeed, that they never go forth against him with virgins for bait. It seems likely, therefore, that the ki-lin and the unicorn of the West have a common ancestor.

"The ki-lin, moreover, does not show the tendency to sink down and fade away into the rhinoceros which is so deplorable in the Western unicorn, for the Chinese know the rhinoceros perfectly well and describe it accurately as a totally different species."

Page 89 Fifty years ago, when nothing was known of the unicorn's vanishing ability or of the sonar in his horn, could the devoted observer have betrayed as lovely a creature as the Austrian doe in this picture by revealing her existence and whereabouts to the trophy hunters of the word? Odell Shepard's book on the lore of unicorns in legend and mythology was first published in England in 1930. If the reader sifts through the fascinating material in *Lore of the Unicorn*, he will find clues leading to the obvious conclusion that its author believed in unicorns because he had seen one. Early in his study, Shepard makes the statement, "Like most of my predecessors, I have hunted unicorns chiefly in libraries. . . ." The word *chiefly*, meaning not exclusively, is the first clue. Later he remarks, "Whether there is or not an actual unicorn—and this is one of the questions upon which I shall merely quote the opinions of others . . ." Why does he not give his own opinion? Admirably, to protect the unicorn.

Shepard's usually controlled objective tone could not, for all his discipline, contain several outbursts revealing his true feelings when the unicorn is compared with the rhinoceros. At this point, Odell Shepard raises his voice to defend the "delicate," "refined" unicorn of his unconfessed, but obviously firsthand, observations. Though before presenting this last bit of evidence, in one section of his study he cunningly indicates that others, and not he, feel this resentment: He quotes Andrea Bacci as having described the rhinoceros horn as "black, thick and vulgar," adding that Bacci seems to have regarded the beast "with contempt."

Andrea Bacci's description seems benevolent when one listens to Shepard on the subject of the rhinoceros. If "gross" and "mud-wallowing" were not damaging enough, he refers to the "nose-horned" beast as "ugly," "grunting," "slime-wallowing," "lumpish," and finally "deplorable." These words could only come from a man who could not bear to have the unicorn—"so glorious, so virtuous, so beautiful"—compared to an animal which, in his eyes, was the negation of the aesthetic.

In conclusion, we will leave the final word on Odell Shepard's belief in unicorns to him: ". . . the unicorn is so credible a beast that it is difficult to understand why anyone should ever have doubted him. Compared with him, the giraffe is highly improbable, the armadillo and the ant-eater are unbelievable, and the hippopotamus is a nightmare. The shortest excursion into palaeontology brings back a dozen animals that strain our powers of belief far more than he does."

Page 91 Meadows of flowers like this one in Greece, which once colored a good part of the earth, are essential to the survival of the *Unicornuus floreus*. Sadly, however, floral habitats are disappearing as rapidly as are the world's great rain forests, whose indigenous residents are being pushed toward the precipice of extinction. When money is the element of power among the earth's human population, what force can halt the exploitation of nature by industry?

This was the only photograph I was able to take of this most sensitive and lovely of all animal premating foreplay. The poppy petals drifting down over the doe's head, captured here by the camera at 1/1000 second, have been shaken from plants torn from the ground and tossed into the air by the stag's horn. Careful study of the photograph will show, midway along the doe's horn where there is a blotch of yellow (wild mustard blossoms), a glistening which is horn honey.

This is also the only photograph in my possession in which a blue-eyed animal appears with a younger dark-eyed one. The azure-eyed doe pictured here was just under two thousand years old and the stag was slightly over five hundred. It was his first experience with love. The blossoms in the manes of these unicorns are the remnants of a flower-decorating contest. While unicorns of the flowers do prefer secluded areas, they may occasionally be encountered feeding cautiously on

Unicornuus memorensis releasing fox from trap.

petals and buds of wild plants that have chanced into cultivated fields.

Pages 92–93 The stag from the previous photograph is seen here alone in the same field, three days after the blue-eyed doe abandoned him. This image brings to mind another of Shepard's statements, in which he tries to disguise the unicorn as a creature of fantasy—a protective tactic, since it seems certain he was aware of its existence. What he has to say is an interesting comment on Western man:

"For the most part, we have made the beasts of fancy in our own image—far more cruel and bloodthirsty, that is to say, than the actual 'lower animals.' The dragons of the Western world do evil for evil's sake; the harpy is more terrible than the vulture, and the were-wolf is far more frightful than the wolf. Almost the only beast that kills for the pure joy of killing is Western civilized man, and he has attributed his own peculiar trait to the creatures of his imagination. There are a few exceptions, however, to this rule that our projection of ourselves is lower than the facts of Nature, and the unicorn—noble, chaste, fierce yet beneficent, altruistic though solitary, strangely beautiful—is the clearest exception of all."

By the position of his head and the roll of his eyes, the stag in this picture indicates that his horn sonar has detected a threat—in this case, a goatherd about two miles away.

Pages 94–95 As this stag grazes on poppy and daisy petals, also in Greece, we are provided a fairly close view of his horn. Rudolf Springer comments on this, and Odell Shepard says:

"By far the strangest thing in the history of opinion about the alicorn's appearance is the age and persistence of the belief in the natural spiral twistings or striae. These are clearly delineated in every picture of the unicorn that I have seen in mediaeval manuscripts, some of which were drawn in the twelfth century. It is possible that Aelian meant to describe them in his phrase ἑλιγμούς ἔχον τινὰς καὶ μάλα αὐτοφυεῖς, for the word ἑλιγμούς may mean either 'rings' or 'spirals.'"

It is also interesting to note that the alicorn was highly regarded as an aphrodisiac—"A treasured love potent," as Rüdiger Robert Beer tells us, "a restorative for sexual potency, and with its pronounced phalloid shape also as a vigorous love symbol."

Pages 96–97 The stag dashing through this field of poppies in southern France displays some of the beauty that has made the unicorn so appealing to graphic artists. Representations of unicorns appear in the work of Leonardo da Vinci, Albrecht Dürer, Hieronymus Bosch, Jean Cocteau, Gustave Moreau, Salvador Dalí, Tintoretto, and Raphael. Benvenuto Cellini almost applied his talented hands to such a representation—but did not. Cellini tells us that Pope Clement VII commanded him and his arch rival, Tobbia:

"To draw a design for setting an unicorn's horn, the most beautiful that was ever seen, and which had cost him seventeen thousand ducats: and as the Pope proposed making a present of it to King Francis, he chose to have it first richly adorned with gold: so he employed both of us to draw the designs. When he had finished them, we carried them to the Pope. Tobbia's design was in the form of a candlestick: the horn was to enter it like a candle, and at the bottom of the candlestick he represented four little unicorn's heads—a most simple invention. As soon as I saw it, I could not contain myself so as to avoid smiling at the oddity of the conceit. The Pope, perceiving this, said, 'Let me see that design of yours.' It was a single head of an unicorn fitted to receive the horn. I had made the most beautiful sort of head conceivable, for I, in part, drew it in the form of a horse's head and partly in that of a hart's, adorned with the finest sort of wreaths and other devices; insomuch that no sooner was my design seen but the whole court gave it preference. However, as some Milanese gentlemen of great authority were witnesses of this contest, they said: 'Most Holy Father, if you propose sending this noble present to France, you should take into consideration that the French are an undiscriminating tasteless people and will not be sensible of the excellence of this masterly piece of Benvenuto's. But they will be pleased with these grotesque figures of Tobbia's, which will be sooner executed; and Benvenuto will in the meantime finish your chalice.'"

Pages 98–99 Unicorns, like the stag pictured here racing through a Grecian field, have stirred the

imaginations of many literary figures: Cervantes, Shakespeare, Edmund Spenser, Lewis Carroll, W. H. Auden, Federico García Lorca, T. H. White, Rainer Maria Rilke, Dylan Thomas, William Carlos Williams, Thomas Mann, Rabelais, Tennessee Williams, and William Butler Yeats.

Some of my most wonderful days of observation were spent with *Unicornuus floreus*, as I rose with them at dawn to stroll the fields, as drenched in color as they were in dew; to follow till the sun was well overhead and the droning of insects, coupled with the seductive perfume of the pollened air, made me heady, and I lay down in the blossoms to laze through the warm afternoon hours while, nearby, a trusting unicorn drowsed.

Pages 100–101 To my knowledge, the only creatures that feed on sunflower petals, apart from several varieties of insects, are unicorns. This photograph of stag and doe was taken in what must remain an undisclosed location in Russia. Its combination of blossoms and unicorns recalls the most famous of the tapestries of the Unicorn Hunt series in New York's Metropolitan Museum of Art. This most treasured example of all unicorn art was at one time on the verge of being destroyed or lost. Quite early the series of tapestries must have come into the possession of the La Rochefoucauld family, for it was listed in 1728 in the inventory of Verteuil, their castle in southwestern France. The tapestries were confiscated during the French Revolution, and those containing any token of royalty were mutilated. It has been said that they were even used for carrying potatoes and for concealing these and other vegetables during crop shortages. Later, the tapestries were returned to the La Rochefoucaulds and housed in Verteuil until sometime in the 1920s, when they were purchased by John D. Rockefeller, who in 1937 donated them to the Metropolitan Museum of Art. This gave America not only a priceless piece of beauty, but the single most treasured example of unicorn art in the world.

Page 102 One of the most fascinating phenomena related to the unicorn is that of his relationship with birds in an activity that Rudolf Springer has termed "the flower decorating competition." In this photograph, a hoopoe, poppy in beak, is seen circling a doe, trying to lure the animal to a secluded field of wild mustard. In this behavioral pattern, the bird, with its low abnormal flight and loud singing or screeching, attracts the unicorn's attention until the stag or doe follows it to the designated spot. Once there, the unicorn stretches out on the ground, allowing the bird or birds to create floral designs in its mane and/or tail. This activity was witnessed again and again by both Springer (as his notes and sketches testify) and me.

Page 103 The doe in this photograph (taken in southern France) had turned to look at a nightingale which, daisy in beak, was singing and hopping about on a branch above my head, obviously trying to attract the unicorn's attention. The nightingale eventually lured the doe to a clearing of tall grass, where the unicorn lay down and permitted the bird to weave a floral design in its mane.

This is not the only example in nature of a larger animal being lured through forest and flowers by a bird with an ulterior motive. In Rudolf Springer's unicorn journal, his notes on the behavior of other creatures that inhabited the sites of his studies were just as fascinating and complete as those on his primary subject. For example, he compares the honey guide's relationship with animals to that of the unicorn with the birds that lure him to the spring decorating contests.

"Honey guides," he tells us, "are nondescript birds in size about that of a sparrow or thrush, gray to brownish above the lighter below and variously mottled and streaked. These birds, which I found mostly in Africa, are also represented in an Asian variety. The honey guide's favorite food, along with beeswax, is insects, among which their choices are bees and wasps. Once I found a dead bird, and it had a very tough skin which seemed impervious to insect stings; some honey guides also have a foul body odor (like the hoopoe) which, I think, acts as an insect deterrent. I must say that I have never seen them in districts where there are no wasps or bees.

"In Africa, I have again and again borne witness to the honey guide's unique mutual assistance relationship with animals, which facilitates the bird's access to bees' nests. It is my opinion that the honey guide's interest in the hives is not for honey, or eggs or larvae, but for the wax in the comb. I had the opportunity to verify this at close range when, in the foothills of the western Himalayas, I watched one of these amazing creatures eat only the wax from a bees' nest that had been opened by a Himalayan bear. In Africa it is the ratel, or honey badger,

Unicorns munching making holes
for squirrels planting acorns.

and indigenous man that these ingenious birds seek as their partner. Of the nine species, the one I observed with most frequency was the black-throated, or greater, honey guide. The bird would start chattering very loudly to attract the ratel's or native's attention. Once the attention was gained, the bird would vocalize with even more force, fluttering about and then flying off a short distance. (Appropriately, its scientific name is *indicator*, because of the manner in which it indicates the way to the bee's nest.) Once the bird was sure the ratel or man was following, it would repeat this maneuver until it had led its ally close to the hive, usually somewhat less than a quarter mile away. The bird would then quietly sit by, waiting for the badger or man to dig out the nest and take most of the honey. Then it would fly down and start pecking away, feeding on the honeycomb.''

Page 104 Viewing this photograph, it is evident that the artist who did the original design for the seventh and last tapestry, the unicorn in captivity, of the Hunt series (found in the Cloisters of the Metropolitan Museum of Art in New York City) must have seen, at a distance, a real stag in a similar attitude. The famous lone unicorn in the Cloisters rests in flowers under a pomegranate tree. At some

time in the execution of the tapestry, several caprine features, such as the beard and cloven hooves, were added, certainly influenced by the *Physiologus*. The creature in this magnificent work is, without doubt, an example of *Unicornuus floreus*. (The floral area under and around him is the subject of a book titled *On the Flowers of the Unicorn Tapestry*, published by the Bronx Botanical Society.)

Though some readers may have been acquainted with the alicorn's power to purge poisons and cure illnesses, few are unaware of the virgin-unicorn legend, perhaps the best known of all mythical human-wild animal associations. Though earlier in this book both Rudolf Springer and Odell Shepard have covered this relationship briefly, it is deserving of more investigation.

In North America, whenever I mentioned what I was setting out to photograph, there were always jokes: "What about a virgin? Are you going to use one to attract unicorns?"

As we have learned from existing texts of the *Physiologus*, hunters take a virgin into the forest, leave her there, and hide to await the arrival of the unicorn, which, when he sees the girl, runs to her and lays his head in her lap. She fondles him and he falls asleep. The hunters then emerge from hiding to capture or kill the animal, and then take it to the king's palace.

Before, during, and after the Middle Ages and into the Renaissance, the unicorn of story was not the only victim of feminine cunning. Rüdiger Robert Beer, an exceptional researcher, tells us:

"Hanging in a basket between heaven and earth is the Roman poet Virgil. He had an assignation with a young woman, possibly even an emperor's daughter according to some versions, who hauled him part of the way up a wall towards the window of her room. There he stays suspended in mid-air, a laughing stock for the world at large, and when eventually the osiers give way, down he will fall through the bottom of the basket, only to realize then that the girl literally dropped him. In a story of Indian origin, Aristotle apparently became so enamored of a woman of doubtful reputation that he willingly allowed her to ride him piggy-back. Samson, the mighty slaughterer of Philistines, lay on Delilah's bosom and lost his strength when she cut his hair."

Regarding the unicorn-virgin legend, Odell Shepard writes:

"Some light may be thrown upon that account by the allegorical interpretation that usually follows, though in varying forms, the story itself. In its simpler versions, this interpretation likens the unicorn directly to Christ: its one horn is said to signify the unity of Christ and the Father; its fierceness and defiance of the hunter are to remind us that neither Principalities nor Powers nor Thrones were able to control the Messiah against His will; its small stature is a symbol of Christ's humility and its likeness to a kid of His association with sinful men. The virgin is held to represent the Virgin Mary and the huntsman is the Holy Spirit acting through the Angel Gabriel. Taken as a whole, then, the story of the unicorn's capture typifies the Incarnation of Christ.

"Thus we see the unicorn caught up into the fervours and ecstasies of Christian symbolism and into the very worship of the Virgin. There could be no limit, once this had happened, to the glory of his career. For this reason, one is all the more eager to discover, if possible, the origin of the remarkable story upon which the symbolism is based.

"The widest variations from the typical unicorn story to be found in what may be called, with caution, the primitive texts of *Physiologus* are those to be seen in the Syriac and Provençal Bestiary, composed under the Waldensian influences. The 'properties' of many of the beasts are changed, and the unicorn is made to represent the Devil, the signification of the virgin-capture being that evil can be overcome only by virtue. . . .

"A story similar to that in Syriac is found in Arabic literature of the fourteenth century. Al-Damîrî says that 'a virgin or a beautiful girl' is put in the way of the unicorn, and that as soon as he sees her, he leaps into her lap making signs for milk, of which he is naturally very fond. After he has been suckled, he lies down drunk, as though with wine, and at this moment the hunters rush in and bind him without resistance. This Arabian unicorn has fallen even below the poor creature of *Physiologus*, for he is captured because he is drunk—and on milk! Equally interesting is the implication that if no virgin is available, any beautiful girl will do as well. Now, it seems remotely possible that his Arabian version is a degraded form of the Christian

story and that virginity has been subordinated because the Mohammedans have never laid quite the Christian emphasis upon chasity; but it is certainly far more probable that we have here, and in the Syriac version, the relics of an older story, which the Christians of Alexandria shaped to their purpose. The mention of the virgin in the Arabic tale is due, no doubt, to Christian influence, but her presence is so incongruous with the tale itself as to suggest that she has been imported from another form of the story.''

In the Syriac version, ''the Christian interpretation is forced upon a tale not fully prepared to receive it; old and incongruous elements—or so one might say, if disposed to beg the question—have not been deleted here as they have in the other versions. The Syriac version seems to represent an idea about the right method of capturing unicorns, which is older than *Physiologus;* it suggests a possibility that the origin of the virgin-capture story, if it can be found, will turn out to be non-Christian and will rest more heavily, or at least more obviously, upon sexual attraction than the Christianized form of the story usually does.

''This element was not entirely ignored in later Christian writing about the unicorn. Hildegarde of Bingen and Thomas of Cantipré, among others, enlarge upon the animal's skill in detecting a virgin at sight, and in some stories we are told that when the huntress is not really a virgin she is killed by a beast—a fairly obvious intrusion of the virginity-test theme. Furthermore, it was held by some that the hunt was more likely to succeed if the virgin was naked, and several insist that she must be beautiful. Alanus de Insulis, who flourished at the end of the twelfth century, gives a curious explanation of the story in which the sexual interpretation is made in terms of mediaeval science. He concludes that the virgin's power is due to a radical difference in 'humours,' the *calidissima natura* of the unicorn being drawn irresistibly to its opposite, the *femina fridida et humida.* The unicorn, he says, has an excess of fervent spirits or humours which dilate his heart, and when he comes into the pure moist air surrounding the virgin, he feels such relief and is so delighted by that feminine atmosphere that he lies down in her lap. In several early versions, moreover, and notably in the Ethiopic Bestiary, the virgin is not wholly passive, but adds certain calculated blandishments to the natural attraction of her charms.

''The virgin-capture story is not, for all its interest, a pleasing one, and in its later ramifications it becomes positively painful. When he strayed into *Physiologus,* the unicorn entered a region not worthy of him. A creature imagined nobly as terrible, solitary, with the beauty of power, was transformed under Christian influence into a little goat-like animal eating out of the hand, going to sleep in maidens' laps, and serving as a symbol of virginity. Nietzsche could not have asked for a more brilliant illustration of 'slave morality.'

''In all this rather aimless beating up and down, one may learn much about the mental habits out of which the virgin-capture story arose, but the actual source eludes one. The suspicion grows upon the seeker that he is looking for the origin of a belief which has never had any single beginning, and that all the success he can hope for will be like that of one who looks for the source of a great river—and finds it in half a dozen different springs separated, it may be, by hundreds of miles, or in the rain-wind, or in the wandering cloud. And just as it is a hazardous thing to say that the Nile or the Mississippi or the Amazon springs out of precisely this or that hillside, so it would be rash to assert that the virgin-capture story must have had just this or that origin and no other. Such confident assertions are seldom made by those who have looked long into the mists of the primitive imagination, where vague shapes are constantly forming and dissolving again.

''And yet, though the ultimate origin of the story remains hidden, we have already traced that story somewhat behind the form it took on in *Physiologus.* It is possible to take one long step farther still, and then we shall have done what we can.

''Most of the Jesuit travellers to the Court of Prester John have something to say about the Abyssinian unicorn, and Father Lobo had a great deal. From one of them, Fray Luis de Uretta, we get an unmistakable clue to the original nature of the virgin-capture story. This clue is found in a book packed with unheard-of matters and quite worthy of its noble title: *Historia de los Grandes y Remotos Reynos de la Etiopia, Monarchia del Emperador llamado Preste Juan.* Well beyond the middle of it, *181*

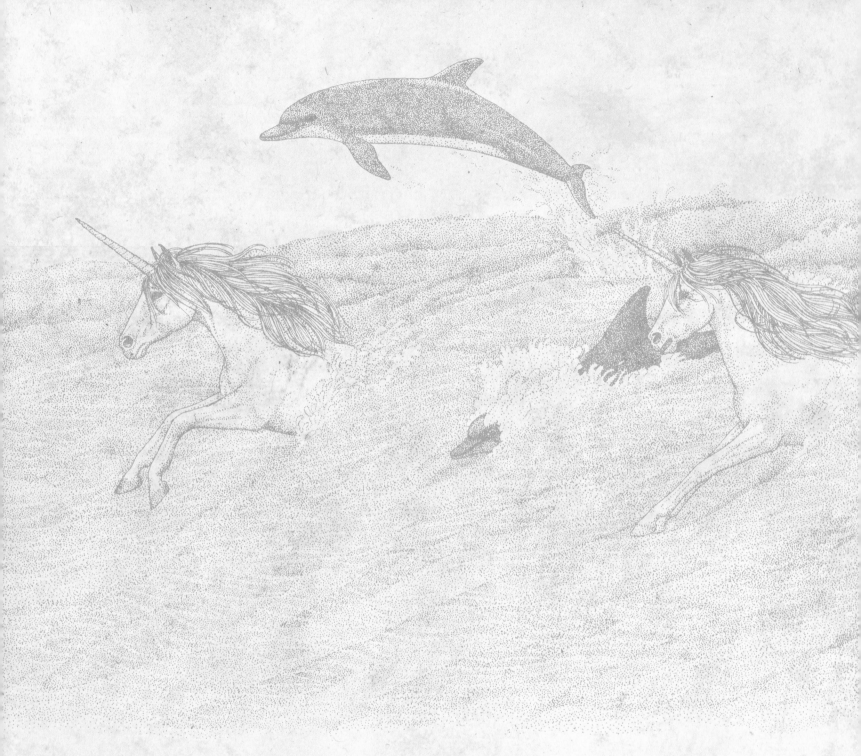

there is a clear description of the rhinoceros, which Fray Luis says has been made familiar to Europe by many pictures. He describes it as an extremely wild animal, very fierce and brave and proud, and so powerful that it can be killed by one ruse or trick. The way of killing is this: The hunters go into the province of Goyame, which is at the base of the Mountains of the Moon whence the Nile springs, for there alone, in all Africa, are these beasts to be found. When they learn that one is near at hand, they load their muskets and they take a female monkey, which they have trained for this kind of hunting, and bring her to the place. She begins at once to run about looking for the rhinoceros, and when she sees him she leaps here and there and dances as she goes toward him, playing a thousand monkey-tricks. He is much delighted in watching this entertainment, so that she is able to approach until she can throw one leg over his back. Then she begins scratching and rubbing his hide, and this gives him keen pleasure. At last, jumping to the ground again, she starts to rub his belly, and then the rhinoceros is so overcome with ecstasy that he stretches himself out at length upon the ground. At

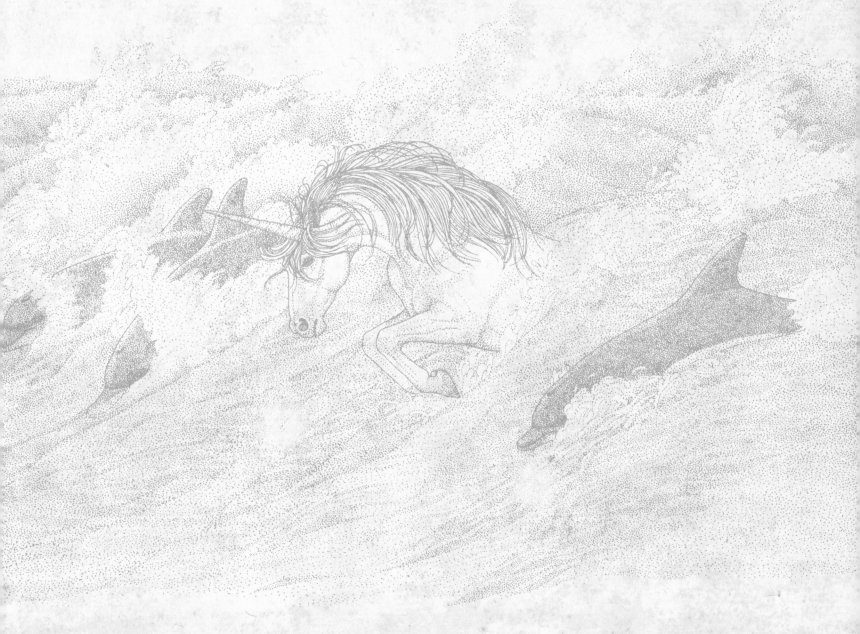

this point, the hunters, who have been hidden all the while in some safe place, come up with their cross-bows or muskets and shoot him.

"Here is such a tale as hunters may have told round campfires, time out of mind, as a matter-of-fact statement of the method by which a valuable animal, too tough for darts and arrows, might be killed. One who lays the two side by side will have little doubt, I think, that the tale reported by Fray Luis springs from the same root as the virgin-capture story, for they correspond not merely here, but at every point. With regard to the question as to which of the two is probably older, one sees that Fray Luis's relation, as compared with the other, verges everywhere toward the probable, even the realistic. Instead of the unicorn, we have here the rhinoceros, his grossly actual *Doppelgänger*. In place of the virgin, we are given a monkey—a female monkey, be it observed, and one specially trained in the appropriate feminine blandishments. Instead of depending upon such vague lures as the odour of chastity or the power of the eye, this decoy sets to work with seduction of the most physical kind. Instead of the sleep of the unicorn, which is 183

Woodpeckers tent on hun drilling do not endear themselves to dozing unicorns.

usually left unexplained by the narrators of the other tale, we have here the natural stretching-out of the beast to enjoy itself to the fullest extent.

"We must conclude, then, that the tale told by Fray Luis is not derived from the account of the unicorn in *Physiologus*. But the two stories are related to each other, and closely related. Either they spring separately from a single root or else the Christian legend is the product of a more or less deliberate allegorizing of the heathen belief. The second of these possibilities seems to me to harmonize with the little we can safely surmise about the methods and purposes of the shapers of *Physiologus*. There may have been some intermediary forms of the story that are now lost, and there were probably some forms of the monkey-capture story more primitive and even less pleasing than that related by Fray Luis, for early Arabian tales about the monkey were often obscene. To pursue the story into the jungles of Siam would be an absorbing adventure, no doubt, but it would not advance our knowledge of unicorn lore. We have traced the Christian legend of the unicorn back, if not to its source, at any rate to a form as primitive, in all likelihood, as that in which the early Christians found it, and this should be sufficient."

The stag that appears in this Grecian poppy field had been lured to this spot by a group of bee-eaters. At this moment, he is about to stretch completely out on the ground so that they can begin to decorate his mane with flowers.

Pages 106–107 This doe in northwestern Italy sports flowers that have been placed individually and in garlands by hoopoes in an explicit example of avian beak-craft. Anyone who has seen the impeccable mud construction of a swallow's nest or the intricately woven homes of Baltimore orioles will not be surprised at the deftly twisted garlands of poppies and daisies shown in this photograph. Many wild creatures possess basic creative skills far superior to those of man.

If the examples of the swallows' and orioles' architectural accomplishments should fail to convince the reader that the floral arrangement depicted here could be the work of hoopoes, we need only look at an even more advanced avian creative effort, that of the long-tailed tailorbird (*Orthotomus sutorius*). Some readers may remember Darzee in Rudyard Kipling's *Jungle Book*, the tailorbird who helped Rikki-tikki-tavi, the mongoose, rid a garden of a menacing cobra, Nag, and his vengeful widow, Nagaina.

For a description of the incredibly advanced beak-craft of this four-inch-long warbler, which has a light-colored belly and is striped olive-green on the back, we will again rely on the observations of Rudolf Springer:

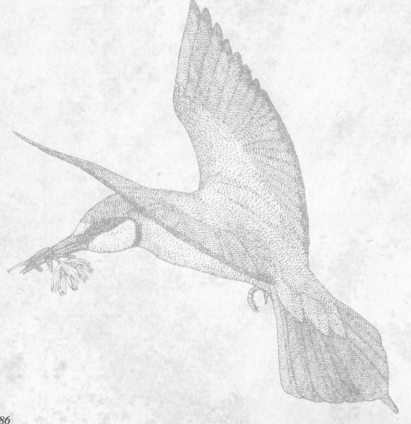

"During my years in India, southern China and Java, I often watched these friendly little tailorbirds at work. They are so tame as to appear domesticated—one pair nested in the vines around the windows of my house on the outskirts of Jamshedpur, and here they could always be found hopping about in search of insects among the plants that covered the veranda. Unfortunately, the cock had a loud persistent call, which on hot afternoons often interfered with my siesta.

"The pair of birds were virtually co-tenants of the house, which provided the opportunity to study close-up the seemingly unbelievable, but true, 'needlework' of these amazing creatures. In a vine next to my bedroom window, the birds built a nest within a cup made by sewing the edges of two large leaves together. They filled this cavity with fine grass and goat hair, but primarily with the down from plants. To sew the leaves together, the male, with the point of his beak, first pierced neat regularly spaced holes all around the outer edges of the leaves (like lace holes punched in a shoe by a cobbler's punch), after which he drew a thread made of plant fibers through the holes, knotting it on the outside to prevent it from slipping. Each stitch was made separately; and, apart from plant fibers, for thread this particular pair of birds used silk from insect cocoons and spiders' webs. Since my feathered friends were so tame, they, without the slightest concern, allowed me to inspect (with a magnifying glass) the nest which was just five feet above the floor of the veranda. Once their home had been completed, the hen laid four elongated eggs, greenish in color and boldly splotched."

It might be questioned why birds, who build nests, however complicated, for the logical purpose of laying eggs and raising young, would use these same skills in decorating the tails and manes of unicorns. We will see that there are other feathered creatures who use their talented beaks to create equally appealing floral designs for other purposes.

Page 108 One might wonder how the nightingale pictured here, flower in beak, persuaded the unicorn upon which it sits, and whose mane it is decorating, to stay still long enough for an activity that can take as much as three hours. The answer to this question is simpler than one might imagine.

Unicornuus floreus is as highly attracted to the color and arrangements of flowers as is the peahen

to bright vibrating feathers. It will follow a bird with a blossom in its beak, knowing that the bird, a natural artist, will create a floral design more lovely and intricate than anything man could paint and of profounder natural beauty than the studied groupings of flowers done by Japanese master arrangers.

The bird, however, works for more than the mere creation of beauty. It knows that if its design is successful, the unicorn will stay nearby, waiting each day for the feathered artist to produce a new creation of buds, petals, and leaves. In its free hours, once the unicorn "bodyguard" has thus been secured, the bird builds a nest. Instinct informs it that the unicorn's parental drive, especially that of the doe, is so strong that a unicorn is incapable of turning its back on a young animal or nest that has been left unguarded.

This is not an unusual situation; other birds and animals also seem to be born with an unusually exaggerated parental-protective drive. We need look only as far as the nearest pet shop to find the society finch or Bengalese (*Lonchura domestica*), a bird of questionable origin thought to have been bred in Japan over two-hundred years ago from

stock imported from China. Today these five-inch-long birds (which come in a variety of shades and combinations of brown, black, and white) are used as foster parents by breeders of rare finches. The Bengalese's parental instinct is so strong that if two males are placed in a cage together, they will build a nest, and if the eggs of a bird of similar size are entrusted to them, they will not only incubate them but will rear the young. The advantage to commercial breeders is that, once the eggs from an expensive bird such as the Gouldian finch are placed with the foster fathers, the Gouldian hen will lay again, providing her owner with three or four clutches in a season instead of one or two. A negative result of this exploitation is that the young Gouldians (in this example) will be imprinted on their foster parents and, when mature, will show no interest in other Gouldians but only in society finches—which renders them ineffective as breeders.

It is this same parental instinct that is so strong in the unicorn. I have transparency after transparency of a stag or doe standing with its head next to a nightingale or blackbird nest in low bushes; next to hollows of trees, where the hoopoe nest is found; or even guarding the bee-eater's nest, burrowed in the ground, from snakes and rodents. When one considers that in South America small tanagers and tyrant flycatchers will nest, for protection, near aggressive birds such as the kiskadee, which has no fear of raiders, and that red-tailed

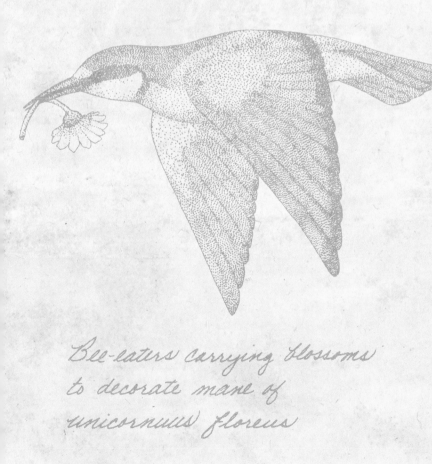

Bee-eaters carrying blossoms to decorate mane of unicornulus floreus

hawks, marabou storks, snowy owls, and pied crows act as "bodyguards" for smaller birds nesting near them, it does not seem strange that certain varieties of birds play to the unicorn's strong parental instinct. Some birds even live with aggressive insects as a defensive measure. Black-throated warblers and yellow-rumped caciques frequently build their homes among the hanging nests of hornets and wasps. Weaverbirds construct intricate dwellings that can easily be seen by enemies, and so they also live among wasps' nests. (This association helps to protect the birds, but it seems less than advantageous to the wasps. The weavers often burrow into the insects' breeding place to build nests, and sometimes even eat the wasps.)

It was Rudolf Springer's idea that since there are so many birds and so few unicorns, the floral designs are really competitions whereby the birds who weave the most stunning creations win the attention—and the protection—of stags and does, who select a feathered artist much as a woman chooses a favored hairdresser.

Page 109 This was the nightingale's completed pattern, which has been composed of narrow-leaved clover (*Trifolium angustifolium*), rabbit's bread (*Andryala integrifolia*), wild garlic (*Allium paniculatum*), common centaury (*Centaurium erythraea*), Ridolfia (*Ridolfia segetum*) and common chicory (*Cichorium intybus*).

Rudolf Springer writes:

"Even after seeing dozens of these designs, I still felt a sudden sadness when a bird would finish and the unicorn would lift his head from the ground and turn to view the completed work, which would soon be destroyed. Most animals would gaze at the flowers for as long as an hour before eventually rising to their feet; some slowly, as if not to disturb the design, others more rapidly. But, no matter how much care was taken, a few blossoms always fell to the ground. Occasionally, if a stag did not approve of a particular arrangement, he would actually shake his neck to scatter the air with flowers. Seeing this was like bearing witness to the destruction of artistic creations that, in their fresh beauty, could not be matched by the most valued paintings in the finest museums."

After seeing these magnificent creations, I also often turned my head as the unicorn got to his feet. I

wanted to remember the floral pattern as it had been created and not as it was destroyed.

Pages 110–111 These European bee-eaters are working intently on the mane of a doe in southern Spain. The use of flowers by birds as an attention-getting device has long been familiar to man, and it should come as no surprise that nightingales, hoopoes, and bee-eaters, among other birds utilize them to seduce, and secure bonds with, unicorns. The most highly sophisticated form of avian flower arranging is found in northern Australia, the Aru Islands, and New Guinea, the work of that extraordinary floral architect, interior decorator, and landscaper, the bowerbird. Rudolf Springer tells us:

"Whereas the male bird of paradise attracts his mate by displaying his outrageously showy plumes, the male bowerbird's forte is making the site of his courtship irresistible to females. The simplest but most charming bowers are those I have seen in the scrubby highland forests of northwestern Australia. They are built by the tooth-billed bowerbird, which has deep sawlike notches near the lower mandible, with which it clears courts in the undergrowth and decorates them with fresh leaves snipped from a certain kind of tree. I was fascinated to note that when this court or stage is fully carpeted, it is done with the pale side of all the leaves face up. If the wind should flip a leaf over, exposing its darker side, the bird would turn it over so that the light side again was in sight. As the leaves withered, the bowerbird would replace them with fresh ones until the court became surrounded by a circle of discarded dead leaves.

"In northern Australia I also had the opportunity to watch the satin and the regent bowerbirds use tools—paint dabbers—when decorating their intricate, partly roofed structures. One male started his bower by flooring a cleared space about four and one-half feet in diameter with a mat of well-trodden sticks and twigs several inches thick. In the center of this, he erected two parallel walls of upright sticks, firmly planted and intertwined and arched over at the top. The walls, which were eight inches high and three feet long, were just far enough apart for the bird to walk through without brushing the sides with his wings. The playground was decorated with pebbles, bleached bones, shells, leaves and flowers.

"The regent and satin bowerbirds dabbed the inside walls of their bowers with a bluish or greenish paint made of charcoal and other pigments mixed with saliva. One regent took a wad of leaves in its beak and dabbed the paint around with it while the satin male used a wad of bark."

Since bowerbirds were living practically side by side with unicorns in Australia and New Guinea, the reader might question why this master among bird flower-artists has not been mentioned as a participant in the unicorn-decorating competition. The motive for the floral competition, one remembers, is to insure the unicorn as a nest protector. The male bowerbird constructs his blossom-decorated bower not as a home, but only to attract a female, who after mating goes off by herself and, alone, builds her nest and rears her young. Never in Springer's or my years of observation did we see a male bird of a polygamous species affix a flower to the mane or tail of a unicorn. Though it may at first seem strange that there are male birds (such as the bowerbird) who do not assist in the incubation of eggs, even more unusual is the mallee fowl, also of Australia, which buries its eggs under a mound of rotting plants. This material keeps the eggs so warm that not even the mallee fowl hen has to incubate them to insure hatching. The bird instinctively knows that it must add an additional blanket of vegetation to keep the eggs warm at night, when it is cold, and remove the added plants in the morning, when the air gets warmer.

Pages 112–113 To look at these three flower designs is to recognize the distance between these natural works of art and the unicorn of myth and legend—the carvings in churches, the tapestries in museums, the faded words printed in dusty books. The design at upper left was done in Portugal by azure-winged magpies; at upper right, in Greece by hoopoes; and the full page at the right, in Spain by red-legged partridge.

It is interesting to note that insects are responsible for minor floral creative efforts seen now and then in unicorns' forelocks. Neither Springer nor I was able to determine the reason for these attempts at decoration. Bees of the genus *Megachile*, commonly known as upholsterer bees, were most often observed in this activity. They cut small, regularly shaped pieces of leaves and flowers as lining for their cells. When a number of these insects deposit their brightly colored cargoes on a unicorn's forelock, it appears as though a handful of confetti has been tossed over the animal's head.

Bees are not the only insects to have close relationships with unicorns. As already shown in a photograph at the beginning of this book (see page 20), in the spring, beetles of many kinds flock to the honey that oozes from the horns of does. I also often observed unicorns stretched out on the earth and covered with ants. This did not take me completely by surprise, since at least 160 kinds of birds are known to use "anting" as a means of cleaning their feathers. Frequently I saw, alongside one of these does or stags, a common jay that was anting: sitting with wings spread and feathers fluffed out over the insects, allowing them to stream over its body and squirt it with formic acid, which probably acts as an insecticide to kill parasites. Since a fly was rarely seen on a unicorn, unless it was one of those tiny, delicate, iridescent-winged creatures that hover like hummingbirds, it may be inferred that the formic acid from ants was used by stags and does as a bug repellent.

Pages 114–115 This floral design, created by a crested lark in southern Portugal, was woven to the mane of a doe that was accompanied by her thirty-six-year-old fawn. Generally, fawn unicorns are not weaned from their mothers until they are close to fifty years of age. Rudolf Springer felt that the reason for this lengthy attachment was the adult unicorn's fear that its offspring would be "imprinted" on another creature—possibly even a man—with catastrophic results. These fears seem justified when one takes into account the world's tiny unicorn population and the fact that fawns are not proficient in disappearing until they are well over forty years of age.

The importance of imprinting has often been demonstrated: Ducklings deprived of their mother will follow any moving object, even a human. Springer tells us that in mallard ducks, imprinting is strongest when the bird is between thirteen and sixteen hours old. By twenty-four hours later, imprinting no longer takes place. "If a male duckling, during its first two days of life, is forced to accept a strange mother, it will never learn to live with its own kind. Might this also (extending the twenty-four hours for the duckling to twenty-four years for the unicorn) be true of unweaned fawns?"

Interestingly enough, in all the examples of antique art I have studied, only once did a fawn appear with an adult animal: in the sixth and last tapestry of the "Lady and the Unicorn" series, found in the Cluny Museum. For a man who does not admit to having seen a live unicorn, Rüdiger Robert Beer, in his excellent book *Unicorn Myth and Reality*, makes an interesting observation about fawns and their horns: "Also on the tapestry where the lady is taking fruit from a dish, a graceful animal is sitting on the red background close to her head—definitely a unicorn colt. Its horn has not yet sprouted (and most probably these animals cannot be born complete with horn)."

Page 116 This tail design, composed of gladiolus (*G. illyricus*), viper's bugloss (*Echium vulgare*), corn marigold (*Chrysanthemum segetum*), and pink jerusalem sage (*Phlomis purpurea*) was created in southern Spain by a pair of nuthatches. It appeared that each species of bird used different kinds of flowers in its arrangement. That such a variety of blossoms would be available might seem questionable until one actually begins to count the distinct types of flowers in a meadow. In Andalusia, in a half-mile-square area, I once listed over forty varieties of wild flower, and I am sure that many escaped my eye.

Birds always carried flowers in their beaks when flying to unicorns, with one exception: the *Agapornis roseicollis*, or peach-faced lovebird, of southwestern Africa. These pretty little creatures, with their soft-rose tinted heads, shaded green bodies, and upper tail coverts of lustrous blue, are the only birds I know that carry nesting materials by tucking them into their rump feathers. The sight of a peach-face with a cargo of blossoms blooming from its green feathers was more like a scene from an animated film than from reality.

Not only flowers but also trees are important to all species of unicorns, except *Unicornuus marinus*. The adolescent animals are extremely fond of sweet saps from trees, and some older animals find certain kinds of fruit, blossoms, and leaves very appetizing. Unicorns of the dunes, *Unicornuus deserti*, were observed collecting dates.

Young unicorns in Africa were repeatedly seen following honey guides to bees' nests in dead or live tree trunks. The unicorn would slowly pierce

the nest with his horn, and then withdraw it so gently that the bees did not attack angrily, as they do when a badger violently rips the hive apart. When the honey had started to flow, the unicorn would put his lips to the hole, allowing the thick sweet liquid to run onto his tongue. Not once did I see bees attack a unicorn feeding on their honey.

Adolescent does and stags collect tree sap in much the same manner, sinking their horn tips gradually into the bark of a sap-producing tree. They push with all their weight, muscles strained, until a hole approximately two inches deep has been made. If the sap flow is slow, the unicorns return the following day, when they may be seen licking the liquid from the bark below the hole, much as a child licks a melting ice-cream bar.

Page 117 This is the same doe seen in the photograph on page 106. Here, she is studying the scarred trunk of an oak tree, gazing at what to the human eye appear to be mere scratches and holes but are actually messages which unicorns' horns have "written" in the bark. The most common form of indirect communication among wild creatures is the marking of territories with excrement. While felines label their hunting grounds in this way, they are also thought to do so with claw scratches on tree trunks, which seem extremely unsophisticated when one studies the horn signals etched in bark by unicorns. Whether I would alone have had the capacity to decipher these basic carved messages, I don't know. Fortunately, I was able to rely again on the findings of Rudolf Springer, whose years of study were four times mine. In his journal, three pages were dedicated to this form of communication and its symbols, which have universal meaning. For example, a parallel slash in the bark about eight inches long and four feet above the ground, with a dot punched below it, means that a doe is coming into season and, if the scars are fresh, will be waiting for a stag near that tree on the coming first full moon. If the doe returns to the tree and finds that a hole (or "dot") has been punched into the bark above her parallel slash, she knows that a stag is in the area and has accepted her invitation.

Why, one might wonder, has the unicorn had to develop such an advanced system of communication when most wild creatures use body signals,

These nuthatches used only four types of flowers for their tail design.

touch, odor, and sound? The answer lies in numbers. The unicorn population is so minute that in most areas the possibility is almost nonexistent of a doe attracting a stag with the fragrance of her horn honey. Thus, she travels the two hundred to three hundred square miles that form the average unicorn territory, "writing" on trees along the way; and the next time she reviews these areas, it becomes simply a matter of locating the tree with the stag's response and waiting for him on the evening of the full moon. While it is known that some birds and animals—Egyptian vultures, chimpanzees, and the short-billed woodpecker finches—use tools, there is no record, to my knowledge, except in the case of the unicorn, of their communicating with "written" symbols.

Of the three pages devoted to the subject in Springer's journal, two contained sketches of combinations of markings labeled "so far undecipherable." Four messages had been verified to the point that Springer was sure of their meaning. First was the doe's message of receptiveness. Second, if a unicorn stag wishes to learn if there is a receptive doe in his territory, he slashes the trunk with a line parallel to the ground, about four feet up the tree, and punches a hole above the line. It seems that the "date" of the message is determined by smelling the bark to see if the cut is fresh or old, for I often observed unicorns sniffing loudly and intensively at these slashes and dots. A novice human observer may mistake woodpecker and flicker holes for unicorn dots, but the size of a doe's or stag's dot is larger, about the diameter of a quarter and completely round.

Third, if a tree is marked with a straight up-and-down slash (the line usually eight to ten inches in length and from two to three feet above the ground), this indicates that the area is contaminated by human hunters or pesticides. And fourth, if a territory is completely safe, trees here and there will be marked with dots spaced about two inches apart in the form of a circle approximately eight inches in diameter. Perhaps one of my greatest thrills as a unicorn behavioralist was the first time I actually saw a stag stamp a message into a tree with a circle of holes which in no way could be mistaken for anything but what it was—a crude, but decided, form of communication.

Flowers from muthatchii design.

Gladiolus

Viper's bugloss;
Viperina

Corn marigold

Pink Jerusalem
sage

Page 118 Photographed in southern Greece, these young rabbits are shown snuggling in the mane of a resting unicorn. The lavender flowers are the remnants of a design created by bee-eaters.

While much has been said of the relationships of unicorns to birds, little has been written about their association with other creatures. Rudolf Springer frequently observed stags and does in close proximity to lions, both in India and Africa. One of the most delightful moments of my observations was in southern Ethiopia as, at dusk, I watched a fawn unicorn playing with a lion cub. Their wild leaps and bounds, dodging and feinting—first lion chasing unicorn, then fawn charging cub—was an expression of the exuberance of youth in its purest form.

One might wonder why unicorns were never preyed upon by any of the big cats but could be seen drinking side by side with them from the same waterhole. Neither Springer nor I could provide an answer to this mystery. My imagination tried to tell me that the land unicorn may use its horn sonar against animal predators much in the way that *Unicornuus marinus* wards off aggressive sharks. However, there was not a bit of evidence to support this theory.

Most nonpredators have some sort of alliance with unicorns. Fawns form strong bonds with young deer and other hoofed animals (except equines) which usually last until the deer is weaned. Then, both Springer's and my observations showed, there was little contact unless a stag unicorn came upon two buck deer, antlers locked in battle, in which case the unicorn would interfere to end the combat.

Stags and does seemed generally fond of small animals, and apart from being accompanied by rabbits when grazing or resting, they were with some frequency observed making holes in the ground into which squirrels were depositing acorns.

Although Springer and I repeatedly witnessed both stags and does rush forward to warn a deer, an antelope, a bird, or another small animal of an about-to-strike predator, such as a lion, wolverine, cape hunting dog, or weasel, on the other hand I often watched unicorns assist predators that had been caught in man's traps. At least a dozen times in North America I saw a doe or stag place one hoof on the release of a spring trip while its horn pried open the metal jaws to free the leg or paw of a fox, coyote, or bobcat.

While unicorns were observed grazing near cattle, never was a stag or doe seen anywhere near horses, which they obviously avoided. If a unicorn caught wind of an equine, heard or saw one, or, with its sonar, detected the presence of one, that stag or doe would vanish on the spot. I agree with Springer, who wrote: "In these many years, I have never observed a horse, wild or domestic, a zebra, kiang, onager, Nubian or Somali wild ass, burro or mule whose existence was even acknowledged by unicorns. This apprehension, I would suspect, was the instinctual fear that an unweaned fawn of limited defenses might become imprinted on one of these equines of similar size and shape, and for that reason the question of any possible association was strictly forbidden."

Contact between reptiles and unicorns seemed minimal. A very young water snake might occasionally be seen coiled around a stag's or doe's horn or leg, and young turtles and alligators in Florida were now and then observed sitting on a swimming unicorn's back. Mature alligators, crocodiles, and poisonous snakes avoided contact in what appeared to be a treaty of mutual respect.

In the long, hard winter months, *Unicornuus niveus* was, with hooves and horns, time after time seen scraping snow from forage, to offer it to smaller animals (rabbits, deer, pronghorn antelope, squirrels, chipmunks), which sat by waiting to feed. Stags and does of the forest were also frequently observed knocking fruit from trees for waiting birds and rodents.

Unicorns seemed to live in harmony with the creatures about them, except for man. There were unimportant exceptions to this, in that now and then a stag or doe might demonstrate slight irritation with some smaller creature, but never with serious consequence. Woodpeckers, for reasons I could never understand, would occasionally attempt to drill holes in the horns of sleeping does or stags. This activity naturally did not endear these birds to dozing unicorns.

Pages 120–121 The dunes have a reputation for cruelty, and it is deserved; but they were also the kindest of any of the areas I visited. I say "kind," because once, when I was caught for nearly two days in the most severe of Egyptian wind storms—visibility zero as I tried to protect my body, head, hands, and eyes from the stinging blasts of sand—I felt as though I were wandering blind, 193

except for the white glow that filtered into my squinted eyes. How many times I stumbled I do not care to remember, once rolling down a dune that must have been several hundred feet high. But never was I hurt; the soft sand always cushioned my falls. In this experience it was the wind, and not the desert, that was responsible for my discomfort.

Each of the habitats in which I studied unicorns had its own enchantment. No natural scene was ever static. In the forest the leaves changed from green to gold to brown, depending on the season. The Mountains of the Sun changed from black to red to orange to blue to purple, depending upon the time of day. The sea changed continually from silver to gold to blue to green to white, depending on the tide and the weather. It took no more than a sudden storm, or the moon or sun, to transform a snow scene from one of enchantment to one of menace. The floral habitat was a rainbow of changing color. The purple blossoms that appeared one day were a week later replaced by red or yellow, or a combination of these and more colors. But perhaps the unicorn habitat that impressed me most was the dunes, because from them I expected the least.

Not even the dramatic changes of the sea are as stunningly subtle as are those of the dunes. Early morning brings pinkish-blue to the sand, which is bleached out by midday to white. Later, the landscape again changes color as the gold and purple of late afternoon deepens. It has been said that the Mountains of the Sun produce spectacular color-and-light shows. But day after day the rocks are the same, stationary and fixed as statues. The dunes, by contrast, are ever-changing. Great mounds of sand, there one day, are blown away the next. The smooth rolling cleanness of a distant series of dunes, golden or white on the sun side and purple or blue on the shade side, are as breathtaking as any field of wild flowers I ever saw. Few sights, I think, could be as dramatic as a dune in early morning or late afternoon, shadowed deeply on one side, while from its crest the wind blows sand, backlit, like spray whipped off a golden wave at sea. In a way, the desert is like the sea, especially when the shifting sands rise and drift only a few inches above the ground to give, as they move, the feeling that one is standing in some shallow, swift, white or golden tidal current that is drifting, flowing, weaving in all directions as far as the eye can see. The patterns in the sand, the ripples and ridges and tracks of animals provide a never-ending fascination. And it is in this setting that perhaps the rarest of all unicorns lives—*Unicornuus deserti.*

When looking at the photograph on pages 120–121, one can appreciate the thrill the observer feels at first sight of a unicorn of the dunes; it seems to come from nowhere in this serenely untouched landscape. Its limpid eyes appear larger and darker than in other habitats, its mane more golden, its coat whiter, and its gait even more fluid, for here there is nothing to seduce the eye but the unicorn itself as it glides across a landscape gorgeous in its simplicity. Rudolf Springer agreed that the unicorn is seen at its best in the desert. This stag was photographed in the Sudan, not far from Abu Hamed.

Page 122 The desert stag at the top of this page was photographed near White Sands, New Mexico. Dune unicorns are extremely solitary animals. Only once in many months of tramping the deserts of the world was I fortunate enough to see more than a single animal at a time, and then for only a matter of seconds, when two stags were spotted together in Jordan. Springer reports that on just three occasions was he privileged to glimpse two of these splendid creatures prancing the sand together. The stag in this photograph appears to be sniffing or eating sand, and dune unicorns do include it in their diets, along with stones, certain cactus flowers, and palm dates. (Unicorns of the dunes were often seen in secluded oases, standing on their hind legs, front hooves braced against a palm trunk while knocking dates to the ground with their horns.) Often, however, I saw single stags or does in this attitude, touching noses with their own shade, remaining in this position for as long as an hour at a time without moving their muzzles. Springer, who also commented on this behavior, felt that dune unicorns lead such lonely and solitary existences that, thirsting for companionship, they seek it even in their own shadows.

Page 123 This magnificent stag was photographed in Iran, where he is known as the *karkadann.* For the reader whose travels may take him to areas where these animals are found, the following

words meaning *unicorn* are provided for use in different parts of the world:

unicornis, unicornuus	(Latin)
monokeros	Greece
unicorno, ilcorno	Italy
yedinorog	Russia
alicornio	Portugal
enhorn	Holland
k'i-lin	China
kirin	Japan
karkadann	Persia (Iran) and Arabia
einhorn	Germany
re'em	Israel
unicornio	Spain
licorne, lycorne	France

Pages 124–125 It is unfortunate that the three Arabian oryxes and six swifts that were racing with this stag in Saudia Arabia are out of frame in this picture. With a maximum speed of 58 miles per hour, the oryx is no match for the unicorn at 84 miles per hour. However, neither is the unicorn competition for the swift, which can fly approximately 106 miles per hour. These desert races were among the most exciting spectacles I would witness during this study. Imagine sand stretching smooth and white in all directions until it meets the sky; beneath the sky, the oryxes with their lovely, slim, dark horns, the unicorn with his ivory horn and white flowing mane and tail, and the dark-winged swifts with their piercing calls. Together, off they flew until they disappeared over a dune, leaving only a trail of dark hoofprints in the sand and the fading cries of the birds in the hot air.

Page 126 In Egypt, this magnificent stag appears over a dune not far from Farafirah.

It is interesting to note that each unicorn has a slightly different horn angle. Not all horns sprout from the brow in the right angle generally shown in storybook illustrations. While it is uncommon to see a horn that angles either to the right or to the left, some do take a more acute angle, down toward the nose, while others stand high on the head, angling toward a spot between the ears.

In Sweden Springer observed an elderly doe whose horn bent to the left, so much so that it disturbed her vision in that eye. My long hours of observation did provide glimpses of older animals

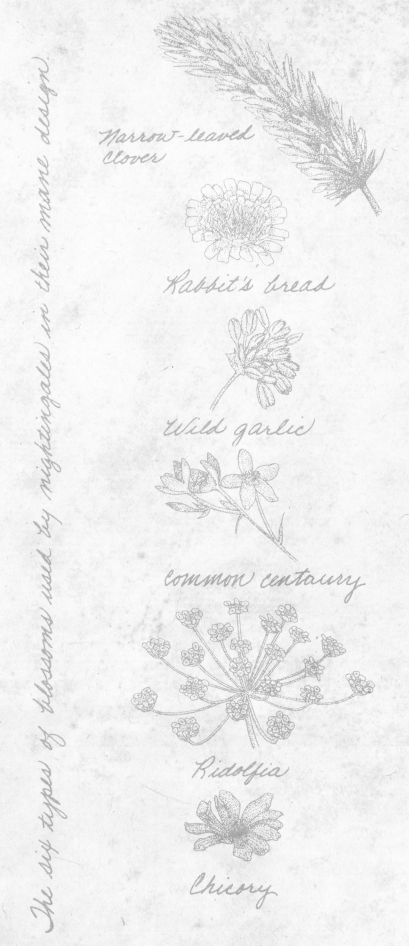

The six types of blossoms used by nightingales in their mane design.

Narrow-leaved clover

Rabbit's bread

Wild garlic

common centaury

Ridolfia

Chicory

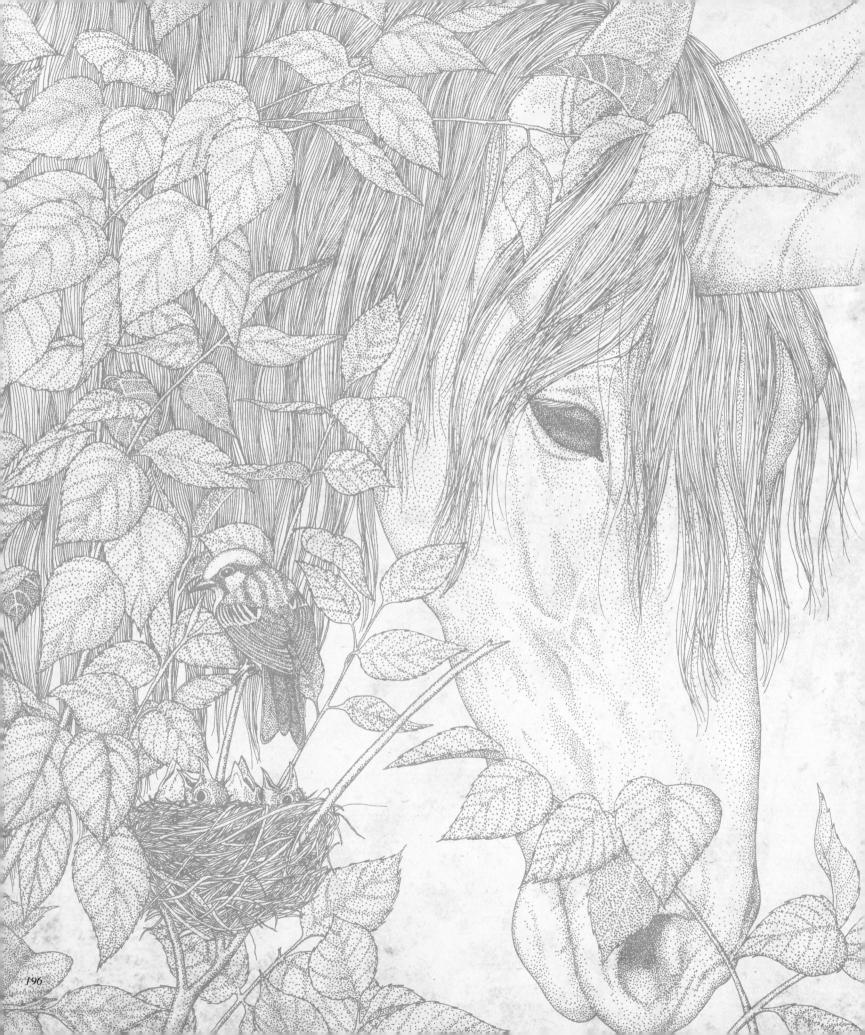

Unicornuus memorensis involved in typical nest-guarding activity.

whose horns showed a slight bend to one side or another; however, they were certainly not exaggerated enough to impair the creature's vision. One thing neither Rudolf Springer nor I ever saw was a broken unicorn horn, and it is interesting to note that the stags and does of tapestries, paintings, sculpture, and engravings are always shown with their horns intact.

Page 127 This was one of the few desert does that I was able to approach closely enough to study. The photograph was taken at dawn in Jordan, shortly after the doe had finished bathing in an oasis pool that during the day was occasionally visited by passing caravans. Her muzzle, sides, and tail are still darkened with water, which within minutes was dried by the rising sun. Since desert unicorns were so seldom seen—their individual ranges sometimes exceed five hundred square miles—it was difficult to imagine how males and females found each other for mating. Now and then one

would encounter a message scratched on a palm in an oasis, but these relatively minute green paradises were sometimes many hundreds of miles apart. Perhaps this is the reason that the *Unicornuus deserti* was the shiest and most difficult to encounter of any species represented in this book.

Page 128 This desert stag was photographed at sunset in Mongolia at the edge of the Gobi Desert. I had been following him across the desert for thirty-seven days which were much more uncomfortable for me than for him. During one severe wind, while my eyes and nose were filled with sand, the stag could close his nostrils to keep out the flying dust (as can the one-humped Arabian camel, or dromedary). And his eyes, unlike those of other species of unicorn, but like those of the camel, were protected by a double row of eyelashes. It is believed that a camel can go for nine days without water, but actually, few of them can last longer than three days, especially if they are carrying heavy loads. Nevertheless, Springer reports that a dromedary he used for travels in Syria went for thirty-four days without water. Unfortunately, when night fell, I lost track of the stag in this photograph, and in the morning, after a mild sandstorm had swept the dunes, I was unable to pick up his trail, which prevented me from verifying if he could have continued much longer without drinking. Soon I hope to return to the desert, and perhaps then this question can be answered.

Where these types of beetles and butterflies are found unicorns are almost certain to be encountered.

SUGGESTIONS FOR SUCCESSFUL UNICORN WATCHING

1. Do not use clothing or carry personal items made of leather or of the bodies of dead animals.

2. Do not use perfume, cologne, hair spray, deodorant, mouthwash, flavored toothpaste, or insect repellent, or be marked with the strong scent of tobacco or spirits. If your person has been tainted with any of these odors, grind up several fistfuls of wild mint leaves, and with the residue, scrub the body from head to foot.

3. Do not carry a gun, knife, bow and arrow, blowgun, crossbow, hatchet, or ropes or nets.

4. Do not carry, for your food, anything produced from dead animals (luncheon meat, chicken, tuna, and the like). Fruit such as avocados, figs, and kiwis may actually enhance chances of sightings.

5. Do not whistle, whisper, hum, or play a radio.

6. Walk normally, but slowly. Do not sneak like a predator or a creature who is up to no good.

7. Once near an area that unicorns are known to inhabit, do not ride, or be accompanied by, an equine. Dogs, unless very well trained, should never be taken along. Never travel in the company of more than one adult. Unicorns are much more tolerant of children; so, if these are kept reasonably quiet, the company of two or three will not limit chances of sightings.

8. Once a unicorn has been sighted, do not cry out in joy, surprise, or fear. Never call to the animal or offer food, as is the custom with bears or deer in national parks. If the stag or doe should disappear on the spot, do not run forward to search for it; it may suddenly reappear, and you will find yourself face-to-horn with a large, slightly irritated animal.

(N.B. There is no record of an unprovoked unicorn attack in the wild.)

9. Do not fish, especially using live bait, in waters where unicorns have been observed drinking.

10. Do not build a fire in unicorn territory unless you are literally freezing to death.

11. Study the ground for unicorn footprints. (Suggestion: Make a photocopy of the drawing in this book so that, once in the field, you will not be confused by similar spoor.) Never attempt to take a plaster cast from hoofprints. If you do, you will eliminate every opportunity of ever seeing a live stag or doe.

12. Study carefully the four basic symbols of communication illustrated in this book. Never alter or try to remove one of these bark scratchings or make a rubbing from it, or you will never meet the animal who etched it.

13. If, by near-miracle, you should see a fawn (which has underdeveloped horn sonar and is not yet adept at disappearing), never give chase. Not only is there not the slightest chance of catching one of these lightning-fast creatures, but you will anger any adult unicorn in the vicinity.

14. The wearing of camouflaged garments, such as those used by hunters and soldiers, is of no advantage, since what determines acceptance by unicorns is a matter of the heart, not of the clothing. The key to successful observation is believing. If positive vibrations are transmitted, some reader may well discover that there are other races, and even subspecies, of *Unicornuus*.

15. For observation after sunset, a light intensifier is extremely helpful.

ACKNOWLEDGMENTS

Of the many people all over the world whose assistance made this book possible, most have requested to remain anonymous. Other persons who helped cannot be identified, unfortunately, for the naming of them could lead to the discovery of endangered unicorn habitats.

There are several people, however, who underwent considerable hardship to aid me, and they must be mentioned. We set out together hoping only that our efforts might result in a few almost-impossible-to-obtain, poor-quality (because of severe weather and lighting conditions) photographs which would document the existence of unicorns. Good fortune, however, did shine on us, and considering the difficulty of our mission, we were able to obtain a quantity and quality of material beyond anything we could have hoped for. My debt to friends, outfitters, and guides—T.R., Debi, and Ty Walter—can never be repaid. Through sandstorms, blizzards, and snake-infested marshes, they accompanied me, as did my assistant, Joe Saccoman. Few men can boast such splendid loyal friends. Special thanks also go to Marilyn Tennent, Betty Engles, Robert Seaquist, Edla Teele, Jerry Garner, and Juan and Antonio for the part they played in pre-expedition planning.

For believing in this project since its conception, I thank Rudolf Blanckenstein; and for their encouragement, José Franco Cadena, Gloria Loomis, Larry and Rose Hughes, Howard Cady, Al Marchioni, and John Ball. Betsy Cenedella and Louise Bernikow have my gratitude for the time they spent reading the manuscript, as does Sally Stein for typing it. Elias García, José María Rosa, and the staff of Cromoarte have my thanks for the care they took with the color separations.

The list of recommended reading on the unicorn in legend and myth must be headed by that impressive piece of literature *The Lore of the Unicorn* by Odell Shepard, and for the use of material from it, I thank its publishers, George Allen & Unwin Ltd., London. Apart from Shepard's work, the most complete illustrated work is Rüdiger Robert Beer's splendid book *Unicorn Myth and Reality*. Nancy Hathaway's *Unicorn* is a lovely volume, which contains well-reproduced color works of art depicting unicorns. Her comments and interpretations of myths and legends also make good reading. Two other books which should be included on this list are *A Book of Unicorns* compiled by Welleran Poltarness and *In Pursuit of the Unicorn* by Josephine Bradley. The finest piece of fiction written about unicorns is Peter S. Beagle's excellent novel *The Last Unicorn*.

Deepest thanks in these acknowledgments go to the unicorns themselves, for confiding in me, for not rushing off in a flash or vanishing on the spot when my camera was focused but the shutter had not yet been triggered, for providing me with company on those long hot days in the desert and below-freezing nights in the snow, and finally, for not disappearing from these pages, as they can easily do at any moment (and actually have in one or two instances), thereby converting this book into simply another volume of landscape photographs. Lastly, I thank Veronica Tudor-Williams for having introduced me to the unicorn, and deepest gratitude and admiration go to Rudolf O. Springer, whose journal guided me every step of this sometimes difficult quest.

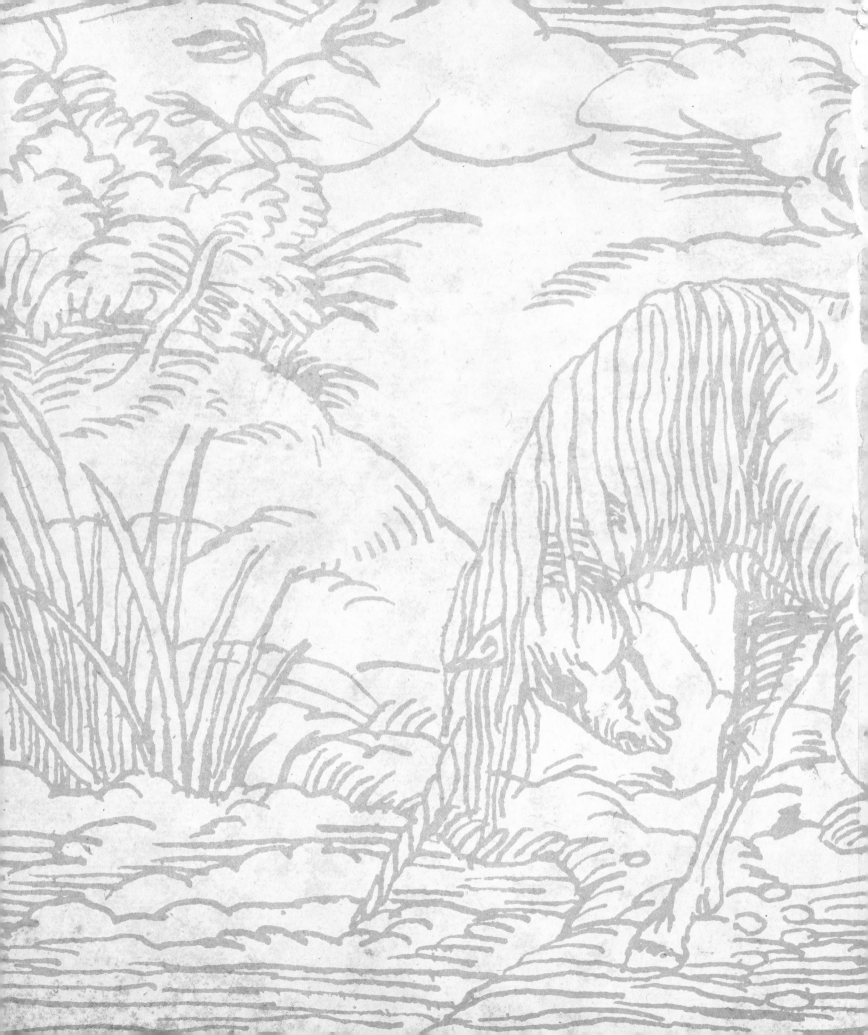